Growing up in
WARTIME SOMERSET
A Portrait in Watercolour

SYD DURSTON

The History Press

First published 2011

The History Press
The Mill, Brimscombe Port
Stroud, Gloucestershire, GL5 2QG
www.thehistorypress.co.uk

British Library Cataloguing in Publication Data.
A catalogue record for this book is available from the British Library.

ISBN 978 0 7524 6172 4

Typesetting and origination by The History Press
Printed in Great Britain
Manufacturing managed by Jellyfish Print Solutions Ltd

CONTENTS

FOREWORDS

By Maev Kennedy, *Guardian* arts writer

The lost landscape of Syd Durston's paintings and chapters is as densely populated as a city street. The fields with their high hedges, the cottages and small shops, the narrow roads, all swarm with people at all seasons. As soon as the sun rises, they tumble out and set to work: hedgers and ditchers, shepherds and cider makers, butchers and boot menders, blacksmiths and mechanics. Even the children are freed from school only to take their own turn at weeding or stone picking.

Syd still lives in a stone-built house in the heart of the country, and superficially the view from his windows resembles the world he paints. In truth it has changed almost beyond recognition: disease took the tall sentinel elms, drainage did for the water meadows, changes in agricultural practice decimated the wildlife.

It was the silence of the new landscape that struck me. You could drive for two hours without seeing a living soul moving in the fields. The smart houses, their empty parking spaces betraying commuter homes, have telltale names like the Old School or the Old Post Office. Where he remembers conversations from field to field between neighbours invisible to one another but companionably at work on either side of the hedges, now there is only the sound of wind in the power lines and the distant hum of the motorway. This book, with Syd's typically pugnacious conclusion, is a vivid illustration of the price of progress.

We first met when I went to see a rather grand exhibition in a rather grand museum, the Holburne in Bath. As I came downstairs from the old master paintings, silver candelabra and Chippendale chairs, I heard a surprising sound: guffaws of laughter from a ground-floor room, where a dapper, bright-eyed, grey-haired man, with a cherishable Somerset accent — there is a touching account in the book of how his own father was sought out in the fields by posh ladies, just to listen to him speak — was holding court. I now know the snorts of laughter probably meant he had got as far as the arrival in his remote village of the buxom land girls, and the audacious small boys watching goggle-eyed through cracks in the door as they shed their dungarees to wash in tin baths.

The Holburne has just reopened with beautiful new spaces, but in those days Syd's show hung in an awkward long narrow gallery, with no natural light. I hadn't heard the talk, but at first glance thought the pictures were quite nice: very conventional, neatly drawn, the sort of appealing rural views that would make good greeting cards. I soon became fascinated. I watched people poring over every detail of the paintings, explaining them

to grandchildren for whom a pen of piglets was as exotic as a cage of tigers, pointing out the details of hand tools their own grandparents had used. I realised that beneath the superficial charm which fooled me initially, these were often depictions of a harsh world, of cold and hunger which even grindingly hard work couldn't always overcome, of death as well as life, where the ache of a child set to an adult job could be seen in the tired slump of a small back.

The crush was appalling. Visitors went in to glance quickly round the small pictures, and they never came out. It was like that every day, an attendant said helplessly.

I said then that his work deserved a book, not just a temporary exhibition. It is a joy to see this book at last.

This is not a soft book, not a *Lark Rise to Candleford* or a *Cider with Rosie*. Syd doesn't like wasting anything: a piece of timber that might come in useful some time, the box of paints his daughter gave him for Christmas which sparked his new life's work, or words. There are few adjectives, and no romance except that of bird song and wild flowers.

I knew some of his stories. I knew that although he has siblings and children of his own, after 700 years there are not likely to be any more Durstons in Catcott, gone from the village forever like the baker and the coffin maker. I know how carefully he has framed his account, choosing the wartime period, from 1939 to 1945, to leave out great hardship suffered later in his young adult years. I know things that, typically, he has not put in: he writes, 'when I was eight years old I made my first three-legged milking stool', but not that he makes country furniture of museum quality, as I discovered at his home. I knew that animals trust him instantly, as did my own son, then very young and so shy that he could hardly raise his head in strange company.

I did not know that this highly intelligent, thoughtful man is dyslexic, that in his own words he has been 'unable ever to read a book'. Unable to fall back on reference books, he has had to remember every detail: 'I was there', he writes, and no reader could doubt it. He recreates a small lost world in microscopic detail. If you want to know how unpleasant milking is when the cows have bad breath, how to treat leatherjackets in mangolds with Paris Green – after signing the chemist's poisons book – or the name of the stone-breaker passed by a three-year-old boy wearing a disastrously hand-knitted pink suit for his first day at school, this is the book for you. 'Ow Twerr,' as Syd says, indeed.

By Cleo Witt, Head of Education at Holburne Museum, Bath

One May morning in 2002, two people sat in a remote Somerset cottage, surrounded by delicate, luminous watercolours. Paintings covered every surface: table, chairs, window sills, an old oak stool and the whole of the floor. Laid out for inspection was one person's childhood, a unique record of country life in Britain during the Second World War, made many years later by the child as an adult, Syd Durston. The visitors were there to select images for an exhibition to be held at the Holburne Museum in Bath, entitled 'A Child in Wartime Somerset'. It would turn out to be a landmark for the Museum in its audience development, engaging a wide range of people from this local area with a powerful, Somerset-based story.

By the end of that afternoon, the chosen pictures had been grouped in themes such as Working the Land, Men and Machines, Make Do and Mend. All had all begun as sharp, bright images in Syd's imagination, then been translated into drawings and tinted with

watercolour. To set these images off, the Museum's basement was hung with russet linen and an alcove painted sky blue with hints of cloud to house objects complementing the images. Between them, artist and curators found farm tools, a wheatsheaf, teazels, a vintage pair of labourers' boots, a bundle of horse beans and the ever-present mangold wurzels. Ration books, flimsy wartime leaflets and Utility-marked objects gave further substance to the images.

People of every age came to the exhibition: adults remembering their own or their parents' childhoods, many bringing their children. They saw a long-forgotten way of life, before the large-scale mechanization of the post-war countryside. Images like 'rayballing eels' recorded seasonal activities (in this case, winter when the flooded levels turned into a different world with a distinctive ecology, to be changed permanently by wartime drainage schemes). Here also was an unusual perspective on the Second World War, describing how a highly structured rural society adapted to national demands from outside because of the war, losing most of its active men to the Armed Forces, for instance, and accepting outsiders such as evacuee children.

Looking back nearly ten years later, what is striking is the deep absorption with which people studied the pictures, and the warmth which it made them feel towards the Museum, a warmth which still endures. The same was true at the exhibition's other venues, Somerset County Museum in Taunton and the Somerset Museum of Rural Life in Glastonbury. While the schoolchildren who came for the Harvest, Home and Hitler workshop enjoyed working with Vera the munitions worker, it was the images which focused their attention: the evacuees in 'Is that our new home?'; the harvesting boys in 'Boys and the Dilley'. Today the world seems to have caught up with Syd, and the countryside is now an increasingly powerful focus for our critique of how we deal with the natural world. These paintings too have their role in that debate, but above all, they resonate with a central truth – the extraordinary power of the image.

By Christopher Woodward, Director of The Garden Museum, Lambeth, London

Each January, whilst doing my tax return, I wonder why there is a special category for 'farmers or creators of literary and artistic works'. Now I understand: Syd. My colleague at the Holburne Museum, Cleo Witt, describes the exhibition of watercolours she and Syd put on show ten years ago. It coincided with an exhibition in the domed exhibition gallery at the top of the stairs of paintings by artists such as Canaletto and van Dyck, all on loan from country houses such as Badminton and Berkeley. It was our first 'blockbuster'. 'Owe Twerr', Syd's exhibition, was in a smaller and lower gallery at the bottom of the stairs. What was striking was the difference in response: upstairs people admired, approved, and from time to time whispered an artist's name. In Owe Twerr they clustered, laughed, and looked closer and closer. Above all, they talked to each other.

The pictures, and this book, resurrect an agricultural landscape which has been lost to mechanization. But in the bookshop it won't slip easily into the shelf for local history or rural interest, or sepia-tinted nostalgia. In such books, the past is prelude to the present. But Syd's drawings and words make the past more real, more vivid, more colourful than the present. Read the passage on ditching: the language glints as sharply as the tools, and words

that have vanished (mumps, eaving, drang) jump up as bright and alive as the frogs. The Catcott he returns to after years working on The Quantocks is unreal in comparison. The ditches at the approach to the village are cleaned by 'massive mechanical diggers' which kill the wildlife in their path; as boys, Syd recalls, they had paused to let frogs and water voles escape, and to put back newts and sticklebacks into the water. The elms have gone, of course, and most of the willows which drooped by the roadside have been killed by chainsaws, and in the pub you can no longer drink cider out of a barrel. In the mornings, the High Street is blocked by mothers driving their children up to the school gates. The new and bigger Catcott seems unreal and insubstantial – as flimsy as the new houses in cul-de-sacs in comparison to the old village sunk up to it knees into the levels.

The south-west is busy with imaginative conservation projects. They're well-meaning, Syd agrees, but it's painting by numbers in comparison to a great tapestry. That is, you can apply numbered splodges of colour but you cannot reweave what has been unravelled. Badgers multiply. But when did you last see a dead hedgehog on the road? What will the cranes released by the RSPB feed upon? You can't put it back together again. Since the Second World War, we are told, 98 per cent of meadows have vanished, and millions of miles of hedgerows. But we have heard these statistics so many times that they have become meaningless. Until this book reminds you of the richness of each few steps: standing up in the ditch, for example, you would see 'the wild plants that no one bothered about, looking back as I see them today they were so beautiful. The lords and ladies, the young tight leaves of the wild carrot (cow parsley), primroses, violets, teasels and cowslips all joined together by my favourite, the dense celandine'. And, later, recalling the flowers in the meadows: 'These are just a few of the plants, there were many more'.

In *When the Grass Was Taller: Autobiography and the Experience of Childhood* (Yale University Press, 1984), Richard N. Coe explains that 'in the great libraries of the world, there are significantly fewer volumes of true autobiography than of memoirs'. Memoirs are the big shiny books piled up in the windows of Waterstone's. A politician tells us of his decisive influence upon world affairs; a sportsman puts the record straight; an actor writes down anecdotes of Larry, Liz, and Richard. An autobiography is much harder to write, as it requires the reader to be interested in a place he has never seen, and mothers and aunts and neighbours of whom he has never heard. Syd walks us through a small, swearing and soggy village in Somerset sixty years ago, and makes us feel that every person in that village matters. Their 'importance' is in their relationship to the landscape, and to each other.

His return is one of the saddest endings to a book that· I've read for a long time. In the last decade, oral history has been very fashionable. Millions of pounds has been spent, and voices recorded for millions of hours. Syd would be an ideal candidate, as he has a strong voice and has never read a book, owing to his dyslexia. But not only do more people read books than listen to oral history, but the challenge Syd has set himself gives a directness to his writing, as if he is weighing each word like a scythe or the long-handled ditching knife. (The description of how to castrate a piglet is so vivid that no man can read the paragraph sitting down.) At one point he tells us, 'Today there is more thrown away in a month than would have been thrown away in a hundred years.' There are more books published in a month than were published in the whole of the sixteenth-century, a period which seems closer to 1940s Catcott than the present. This is one worth the writing.

CHAPTER ONE

FIRST THOUGHTS

The Durston name goes back a long, long way: our records in the church at Catcott date back to the thirteenth century. However, this particular line is about to come to an end as my father's elder brother, Edmond, had a son, Edwin. Edwin had two daughters. Father's younger brother, Earne, had a daughter. My father had three sons, and a daughter: Hedley, Leslie, myself (Sydney), and my sister, Grace. Hedley had two daughters; Leslie had a son and daughter but the son, Ian, isn't married and has no children. I have two sons: the eldest, Mark, has a daughter; the youngest, Stephen, started with a family and there seems to be no chance of him having any of his own. Now me being the youngest of the three sons of William Henry and Gladys Olive Durston (deceased), and me myself now at the ripe old age of seventy-three, I don't think I can do much to rectify the situation!

Catcott is situated on the northern slopes of the Polden Hills in Somerset, flanked by Shapwick (Shabbick) on the eastern side, Moorlinch (Merlynch) to the south, Edington (Edeeton) to the west and Burtle (which kept the same name) on the northern side. Catcott had a population of about 400, a school, a Methodist Chapel, St Peter's church, three pubs (The King William, The Royal Hotel and The Crown Inn), and all the aforementioned were always very well attended by the people and all the many characters that lived in the village.

Catcott had two grocers' shops. The first was Miss Bawdens in Manor Road (who also had the Post Office and stocked all the sorts of groceries sold in a village shop at that time). Next door to her was a bicycle shop owned by her nephew, Les Bawden. Mrs Acreman had the other shop: this one was in Steel Lane, adjoining Cypress House. She sold sugar from Hessian bags, tea from a big square tea chest, sweets from jars and a few other essential groceries, as well as paraffin for burning in the lamps, mouse traps, rat gins and rat cage traps, rabbit wires, cockroach traps, string, mops, door mats, wire netting, candles, brushes and the odd kettle and saucepan.

There was also a bakery in Manor Road run by George and Libby Bryant and their daughter, Ethel. George was a wonderful old man and the bakehouse was the lifeblood of the village. There was Fred Arthur's carpenter's shop. Fred was as bald as a coot – not a hair on his head – and always standing straight as a flag pole. He was also the local funeral director, and his premises were at Langlands Lane.

Catcott also had a road man, Mack Hellier. He lived at the bottom of the village with the Gullifords at Dryclose. Mostly working on his own, he swept all the roads, cleared all the ditches, cut all the hedges and grass on the sides of the roads and kept the whole village spick and span.

At the bottom of the drang – a long alley joining the top with the bottom of the village – was the cobbler's shop. This was run by Sammy Elver. He always had a mouth full of

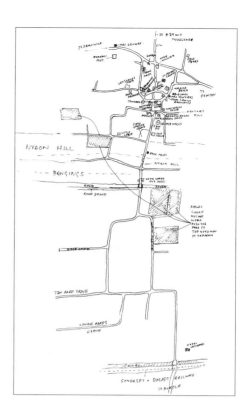

A sketched map of the area.

sprigs and his wife was forever cleaning the brass handle, knocker and knob on the door. There was another carpenter's shop at Brook Lane, next door to my grandparents', Hubert and Olive Bartlett at Northbrook Farm. It was owned by Tommy Acreman, who was also a wheelwright; at the bottom of his garden, along the roadside, he had a saw pit where they cut the trees into planks by hand.

There was a garage at Lippits Way run by Mrs Pam Coles. It had a petrol pump (I suppose this was normal for the time). It was worked by winding a handle with about a 12ins crank backwards and forwards, four times each way, to deliver a gallon. It was also the place where you got your accumulator charged, or a dry battery for a radio, and carbide for the gas lamps for bicycles. Her husband, Roland, was away in the army and Pam, on her own, as well as looking after a young son, looked out to everything, booking all the petrol and making out the monthly bills for the accounts.

There were twenty-three farmers in the village, most trying to eke a living from milking a few cows, keeping a few laying hens and table birds perhaps, a breeding sow and growing a few acres of corn, a few potatoes to sell, a few mangolds, odd jobbing around and helping one another.

Practically in every direction you tried to look, the view was blocked by enormous elm trees, some up to 80ft high and 4ft across. The only place you could look away with ease was at the top of the village at Cedar Farm, where my other grandparents, Henry and Rose Durston, lived. At this point you could see clearly all the way to Glastonbury Tor. If you could find a small gap to look north towards the Mendip hills, the trees looked like a large forest. Most of these trees were elms – and all of these elms were ravaged by the

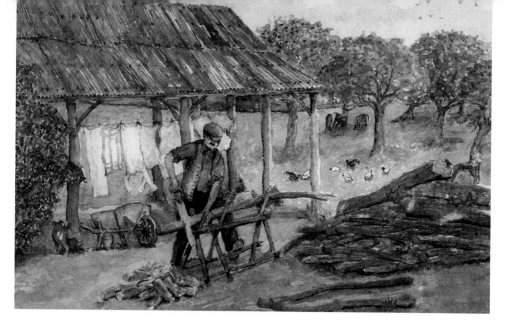

Cutting logs.

deadly Dutch Elm disease. Now all the elms have gone, and it's little wonder the crops are so much heavier today due to all the nutrients the trees were taking from the soil.

For many, many years now, people from all walks of life have been trying to persuade me to write a book about my memories of what life was like growing up in Catcott during the Second World War years. The odds against this happening must be about one hundred to one, as I am dyslexic: words seem to jumble up after a short period of concentration, and I found reading for any length of time very difficult at school. When I attended school, there was nothing known about this problem and so the most I have been able to do is read reasonably long articles about things, but there were kids far worse off than me who couldn't learn at all at school. They weren't stupid, however, because some started with nothing and finished up owning their own large businesses. Having been unable ever to read a book, I find it difficult to understand how I'm now writing one.

People say that I have missed out so much by not being able to read, but the way I think, to write something factual about anything, to get it right, you have to have been there: otherwise you can only write what you research from other people's writings, or by a third- or fourth-hand conversation that has been handed down, lost, and added to over the previous, say, sixty or more years, the person that first uttered it by now deceased. This book draws only on my memory. People, when researching, rarely seek out someone who really knows the truth, but someone instead who can tell a story that sounds good and makes good reading. A true story, it seems, is not important! For instance, three people can give three different versions, and all think they are true – so the researcher decides to use the one that could remember the most, no matter if it was true or not, just so as long as it would make good reading.

Being dyslexic has not been a burden to me, nor a disability: in fact, when I look back over my life I can see that it has had many compensations. Although I'm dyslexic, I have always been able to draw, and also work with my hands. I always taught myself very quickly the way to do things, so I have spent my time doing things, rather than reading what someone else had written about them.

When I was eight years old, I made my first three-legged milking stool. This set me on a journey which ended with me making oak, elm, yew and walnut furniture – refectory tables, dressers, chairs, joint stools etc – and building new houses with character from old materials, using the same methods that were used 400 years ago, dressing the stone and adzing the timbers. I was only able to do this, I think, because of early character-building that gave me the dedication needed, from having to get up early in the morning milking cows by hand, hoeing mangolds and kale, laying hedges, feeding animals, digging ditches, building dry-stone walls, hanging gates, lambing ewes, chopping logs, taking cuttings, making grafts and much, much more.

These things that I have mentioned are just a few of the things I can talk about without having ever read anything about any of them. Four things I learnt from a very early age were that you could never get something for nothing, nothing nice lasts long, the hardest part of doing any job is thinking about it, and there are a lot of laws and not much justice.

The mainstay of my character is that I never like to be beaten. This is why, when given a box of watercolour paints for Christmas 1993 by our daughter Rebecca, and having asked my wife Margaret, who is a very talented artist and sculptor, to teach me how to use them, she said: 'You've got a good hand, and eye, a good memory, and you would be much better off to develop a style of your own than to get me involved.' With this in mind, I drew and painted what I knew, all the time trying to develop a style with a limited pallet, mostly mixing the paint on the paper. This was all wrong, of course, but it worked for me. Having done this I narrowed my subject down to farm and village life in 1939-1945, the Second World War years, a subject on which there seems to be little on record.

After finishing about forty paintings, I picked up my folder one day and took it to the Brewhouse Theatre and Art Centre in Taunton, with the hope that I might be given the chance to hold an exhibition. I found the woman in charge of art, told her why I was there and asked her to have a look at my work. She very quickly ran through the folder, gave me a rather weak smile, and advised me to join a group and get some lessons.

I wasn't too downhearted because of the feelings and comments of other people, including my wife, Margaret, and Jan Sweeney. Then I had a breakthrough – the broadcaster the late Johnny Morris, after seeing samples of my work, said to me, 'Syd, I don't know much about art, but I know what I like, and I really like your work.' Having taken this comment on board I decided that there was no way I was going to change my style.

Having heard that the woman at the Brewhouse who turned me down had been replaced by a new head of art, I picked up the same folder some ten months later and went through the same procedure as before. This time things were very different. This time there was a look of joy and a smiling face slowly looking at my work and making all sorts of wonderful comments. Without hesitation, she offered me a four week, one-man exhibition some fourteen months later, which I accepted with joy.

I started to paint like mad, getting up at five in the morning, painting until seven, then working all day renovating old houses and coming home and painting until eleven at night, on a 4ft x 2ft table in the lounge with just a standard lamp for lighting. By the time the exhibition came around, I had painted 127 paintings and hung 120 of them. It turned out to be the Brewhouse's most successful exhibition ever.

Paintings were bought by people from all over the country. Two were bought by a lady from Bath, and in turn were seen by the Education Officer from the Holburne Museum of Art in Great Pulteney Street. She was so taken with them that she showed them to the museum curator. I received a letter from the education officer saying how much they liked

my work and asking me if I had a selection they could have a look at, as they would like to mount an exhibition of my work at the Holburne. I invited them to our home, where I had some fifty odd paintings strewn about the floor for them to view. They asked if I could paint the scenes that I had not, as yet, covered, what the exhibition would be called, and so on. Margaret and I were invited to the Holburne and shown where the exhibition would be hung. Within five weeks everything was sealed and settled and on the road: the exhibition was to be called 'A Child in Wartime Somerset: Owe Twerr (How it was)', and it would run for three months. I thought hard and painted the scenes that I didn't already have, some farming exteriors and some domestic interiors.

There are no records of people and children working and playing during this period, as there were very few cameras in country areas and, if anyone did have a camera, it was unlikely that they could get any film; if they were lucky enough to have film, the chance of getting it developed was almost nil. This must seem very hard for young people to understand, but it's true of the time.

Artists were out fighting, and if by chance there was one around, they weren't interested in painting someone working. Consequently, the only records of this period are a few photographs taken by the local newspaper. These were static scenes of horses and men standing still by their machines, or long lines of men, women and children, dressed in their Sunday best (the men in their bowler hats, black waistcoats and their silver watch chains very much on show, the women in their white bonnets and aprons), standing in front of an empty wagon with their pitchforks, rakes, cider jars, dogs and so on, after finishing haymaking, or harvesting, as no camera could take a moving picture. From my memory and imagination, I have conjured up some scenes that I remember from when I was a lad. These scenes are mostly of no specific place, or of no particular people, but just the atmosphere. Somehow, the people still around today that I grew up with see the characters working in my paintings and put names to them all.

The book is in text and picture form, with each picture being painted completely from memory and imagination, using no props or photographs – just my memories of that period. After my exhibition at the Brewhouse, so many older people, from so many different parts of the country, wrote or called to say that they thought, 'at last, someone has got it right'. I believe this is not because I'm a better artist, but just because I was there and have actually done all the jobs. I also know that each part of the painting has to relate to the other; the background, figures, dogs, horses, chickens or whatever have to relate to everything else.

While reading this, and looking at the illustrations, try to imagine, if you can, what I am trying to portray in the writing and the illustrating of this book: the memories of a child between the age of seven and thirteen. How life was in the home and in the school; the time and education that was given up by the children to go to work on the farms, doing all sorts of jobs. How they made the best of what little time they had to themselves for their own recreation. How they left school by the time they were fourteen and went, without a break, straight on to start work – and in many cases were expected to do the work of an adult.

For this they have never been thanked or received any public recognition. Many have now sadly passed on, but for those that haven't, and for others that are interested in the history of the period, I hope to tell the story of how farm and village life was for the men, women and children that were left to do the work in a farming community in a village on the Polden Hills and levels in Somerset during the Second World War years of 1939 to 1945.

CHAPTER TWO

SCHOOL

I started going to school at the age of three, walking about one quarter of a mile. I remember it as plain as if it was yesterday. My mother, for the first time I went to school, dressed me in a little pink knitted suit; I suppose she thought it was designer gear. I was made fun of and teased all day. On the way to school there was always an old man, Alf Norris, sitting on the side of the road cracking a large heap of stones with a hammer. These stones were used for repairing the road.

The teacher in charge of the class was Miss Selway, who came from the village of Moorlinch over the other side of the hill. Her family owned the village shop and garage.

The order of the day at school when I started was a hymn, a prayer, and then straight to work with trays of sand. With these you learnt to do your figures and letters, drawing with your index finger. This sand also left no room for indiscipline, and Miss Selway was very strict. Once you had drawn the figure or letter, it would be all shaken smooth and you would do the same again and again until it was perfect.

In the afternoon, we all laid on our backs for thirty minutes: this was supposed to ensure that our backs would form properly. We lay on what must have been coconut doormats, far larger than the ones perhaps available today.

We graduated to chalk and slate, before moving on to pencil and paper. I was just getting into the way of things with pen and ink when the war came and changed everything: all the lesson books were cut in half, and there were no more rough books. Sandbag walls were built about 5ft high, 4ft from all the doors, to stop any bomb blast. All the windows were covered over with a thick kind of cellophane to stop any glass from shattering and flying about. The windows were also fitted with heavy dark blinds to stop any light showing at night. This was because the school was the only place in the village used for social gatherings.

The sandbags were soon removed and replaced with thick brick walls. The classes soon became much larger, with the arrival of the evacuees. We were packed in like sardines in the classroom. A couple of the evacuees were unruly and foul-mouthed, but the teachers, between them, soon knocked them into shape and toned down their language. I seem to remember there was complete harmony between them and the village kids; I can't recall any animosity.

The library at the school ceased to have any new books. All new writing and arithmetic books, pencils, rulers, rubbers and even pen nibs became very scarce, and old scraps of paper were used for rough work. We learnt our tables 'parrot fashion' and had a mental arithmetic lesson every morning. You had to know your tables – there was no excuse!

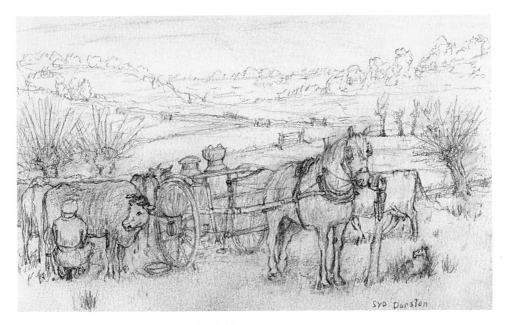

A sketch for a painting of milking in the fields.

With my dyslexia, I hated reading lessons as I couldn't follow the story in the book – it was all jumbled up. When I was called upon to read I wouldn't have a clue where they were, and as the teacher thought I wasn't paying attention I always got a rollicking. Spelling was even worse, as I would get the letters mixed up more than ever, but if the teacher wrote a word on the blackboard I could learn how it was spelt, like learning a piece of poetry, though it would not stay in my memory for more than a few days. The classrooms were usually very quiet, sometimes interrupted by the crack of a breaking ruler. A small lump of blotting paper would be dropped into the inkwell, fished out with the pen nib, placed on the end of the ruler and flicked onto the ceiling to join the many other little lumps. If a ruler was broken it was usually in this way. The lad who comes to mind – who flicked more than anyone else – was Lewis Norris, or at least he broke the most rulers.

While the war was raging, most of us had no radio. One lad, Trevor Jones, who was lucky enough to live in a household that had a radio, would take notes and then write his own news before he came to school. Then he would sit on the wall under the old oak tree at the top of the playground and say, 'Gather around,' which we did. He would then say, 'This is the news with Trevor Jones reading it.' He read out the headlines and then elaborated on each one. It seemed as if we were usually retreating according to plan after the initial push forward. All very frightening.

A 'Save Britain' fund was set up by the head teacher of our school, Mrs Humphries, and a large barometer was set up outside the school. The target was enough money to buy a spitfire: £6,000. This seemed an incredible amount of money, but the money rolled in from all angles, and the target was raised. It was raised by people buying war bonds, saving certificates and Post Office Savings. Thus the whole incentive was dedicated to winning the war. The Blue Card System also started. This allowed all school children over the age of ten to have forty half-days a year off from school to go out and help on the land. You went to school from 9.00 a.m. until midday, and then spent the rest of the day at work –

sometimes until 9.00 p.m. at hay-making and harvest time. You would then get up and go milking in the morning before going to school again.

When I reached Mrs Humphries' class, I found her to be a very different sort of teacher. Everything she taught she made exciting, usually mixing subjects one with another (like geography and maths, or maths with gardening, history or art etc). Even though I was dyslexic, I found she was a brilliant teacher: she explained things in a way that I could understand. She was very giving of her own time, and during the evenings, weekends and holiday time she did a double frieze of lined and wash drawings of the history of the world that reached all the way around the classroom. She was exceptionally good at art. She wouldn't bother about how many afternoons we had off if we were needed on the farm – she thought that if the war was lost, our education would be useless anyway – but mornings and maths was a must. Most boys went to school with patched trousers – everyone except Trevor Jones. Everyone else wore grey flannel, grey and red or grey caps, but Trevor wore a navy blazer with a badge, and a light blue and navy cap with a gold badge.

Later on in the war army surplus clothes became available, and quite a few of us bigger lads wore this to school, rather than keep patching the grey flannel. Lots of working men wore battle dress, and practically everyone wore army surplus in some way or another.

The school was also a collection place for rose hips and haws. The rose hips were used to make rosehip syrup, a vitamin C substitute to help with the poor diet of rationing. What was done with the haws, I don't know. We were all taught gardening, when and how to dig, fertilizing with compost, sowing, weeding and tending to the crops, helping out with the dig for victory campaign.

Once a fortnight we would have gas-mask drill. We all had our own places to go to in the large corridors, putting on our gas masks and lying face down on the floor.

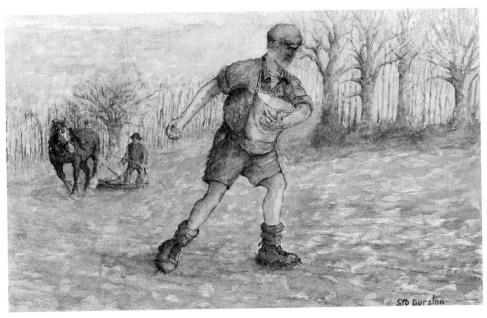

Sowing in the afternoon, after school, with boots clogged up with mud.

Water for the school was from a pump in the playground when I first started school, but very soon there was mains water and a cloakroom with wash basins. The toilets were earth closets packed with peat brock and peat dust, and were situated at the top of the playground. They were still in use when I left school at the age of fourteen. These were tended to by the school cleaner. She was Mrs Lotty Alford and she lived at the top of Hectors Hill, opposite the Methodist Chapel. She also cleaned the church from top to bottom every week, and never ever missed a service on Sunday or in the week, always wearing the same black clothes for best. She was very dedicated, lighting the school fires very early in the morning when the weather was cold. Some years later her daughter-in-law, Eirwen, took over the job. She did it with such care, vigour and dedication that she was awarded an MBE for her outstanding work. I think probably one of the worst things about the situation was that three kids shared a desk that was only designed for two, but we got by. We walked to school in the morning, walked home to dinner, walked back to school after dinner, if we weren't working, and then back home after school. There was a bicycle shed but no bikes, as tyres became unobtainable.

We were all examined by a doctor at the school once a year, and a dentist came and set up his business at a private house a couple of doors away from the school at Mrs Towsers, opposite the war memorial. We all went in turn for an inspection and treatment, and were greeted by the Towser parrot. He answered to 'Pretty Polly' and a few swear words and was a big favourite with all the children.

During the play time, the emphasis was all on activity: the girls skipping or doing handstands against the toilet walls, the boys playing tag, or getting in a line and the one at the end being pulled around, skating in his hobnail boots. The playground was very smooth but just like fine sandpaper. A pair of boots just nailed, if you did this, would only last about a fortnight – and money was a very scarce commodity. Needless to say, I never got on the end skating, as I had been threatened with the leather strap if I did, and my father only threatened once. The next time there was no reprieve: it was the full works. Looking back, I'm glad he was like that because I knew where I stood – knew what I could do and what I couldn't, and the consequences if I stepped out of line. Whatever my father did, he always showed me how much he loved me, sat me on his knee and gave me a hug and a kiss, and said, 'That wasn't to hurt you, but just to teach you. So don't do it again'. He always stressed, 'Don't be afraid to admit you might be wrong, and that it's one thing to talk about how to handle a certain situation and another to be faced with it.'

I have written quite a lot about my school days, but for some reason I have not mentioned anything about the class between Miss Selway and Mrs Humphries. The teacher in this class was Mrs Young. She was a farmer's wife with two children and they all cycled to school and back each day again. Like Miss Selway, they lived at Moorlinch.

It is hard to imagine now that she taught us what she did, and, if she was still alive today, I wonder how she would feel about it. She taught us that man would never get to the moon as it would take two lifetimes to get there; if, by chance, a vehicle could be made to take him there, she said, he still wouldn't be able to go because there would be no air for him to breath in the atmosphere. On top of all that, she finished, we would never know whether they did or didn't get there as there would be no way of getting back. How things have changed, in oh so many ways! Sex was a thing that often happened on the way to school, and sometimes on the way home. Dogs were knotted up everywhere and no one took any notice, though today you seldom see a dog without a lead or unless it has someone with it. I remember an evacuee girl running in to tell the farmer's wife that the

cockerel was killing the hens. I also remember another evacuee girl asking Mrs Young, 'If a female horse is called a mare, what is a male horse called?' She said that a male horse is called a gelding. I was only nine but I thought this was wrong and promptly said, 'I think a male horse is called a stallion'. Her reply to me was, 'That's a word you may need later on in your life.' I wonder what she would have thought about the sex education and the space rockets of today!

It's a wonder we learnt anything. The broad Somerset dialect that my parents used was such that the words were spoken nothing like they were spelt. For instance, there was no 'f' in the dialect: they were all changed to 'v'. Thus Friday became Vriday; fog became vog; no one ever said 'give me', but only 'gee I'; you can't became 'theese cassun'; you wouldn't became 'theese ood'nt'; you are not became 'theese art'n'; going became gwain; sow, zow; saw became zaw; 's' was always changed to 'z'. Practically every sentence of an answer started with theese, and the word 'nearly' was never used – the word used then was vernigh. Counting, however, was nearly the same: won, do, dree, vower, vive, zix, zebun, ate, nine, den, lebum, dwelve. This is just a fraction of how it was, and towards Glastonbury over the moors, it was much worse even than this.

Jonathan Swift, describing a large country house, once said:

Be all accounts tis very vine
But where dye zlape and where dye dine
I think are what yee been telling
That tis a house and not a dwelling.

This Somerset dialect is now sadly nearly gone, as it has been knocked out of the kids in the schools.

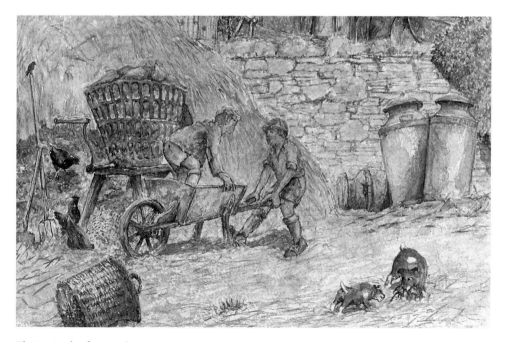

Playing in the farmyard.

When I was a lad, when the war finished, well-to-do women would go out into the fields to find my father working just to talk to him, to try to learn the dialect and hear him talk. Rita Brooking Clark of the Clark shoe family comes to mind as being one such lady: she spent hours and days doing just that, and they always had a good laugh between them.

Looking back, it's so sad that the old Somerset dialects that I grew up with will very soon have disappeared, as the young move away to different areas and lose them. When I hear plays on the radio or see films on the television that are supposed to be of old Somerset, I find there is no resemblance between the dialect that they try to speak and the one that I grew up with. When a few older people who spoke the Somerset dialect get together and start talking and get excited, then the old dialect comes out. These people are now very quickly dying out: their age is against them.

When I left school at the age of just fourteen, books were still cut in half. Pencils, pen nibs, rubbers and rulers were all very much in short supply. I was glad to be leaving school, glad to start a proper job and earn my own keep. From the very start I did a man's work and got a man's pay, but I was always very grateful for what Mrs Humphries had taught me in a very short time. Like there were 'horses for courses', that we would not all be equipped with the same kind of skills or all be the same size or have the same strength. The job we chose to do would be governed by this, and in all probability we would all do something because we had been somewhere at a certain time – the luck of the draw. She always stressed, 'just give of your best!' You can do no more; your country can do nothing for you, but you can all do a lot for your country. One more thing she always told us was this: there are not only three R's but five, the fourth being 'Responsibility' and the fifth 'Respect'.

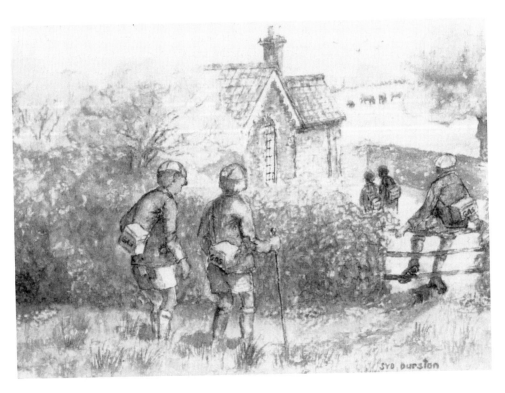

CHAPTER THREE

MILKING COWS AND WEANING CALVES

What I first remember about cows and milking is the sight of people taking their milk home in a couple of buckets using a pair of yokes. Yokes are a piece of wood shaped to fit on the shoulders, with chains to carry the weight instead of your arms having to do it. Jack Pole did it this way. He walked to the moor in the morning to milk his cows, and brought the milk home in buckets with a pair of yokes. He then had his breakfast, caught and harnessed his pony and drove the pony and cart to Shapwick moor, cutting peat all day, and bringing home a load of dry peat. Then he would stack the peat in a rick, have a cup of tea and walk to the moor again to milk his cows, carrying the milk home again with the yokes.

Archie Norris would go milking on his bicycle: he would milk his cows and then bring the milk home in a skillet balanced on his head (a skillet is like a large bucket, but is the same diameter all the way up so it would balance on his head). He used to cut a couple of thistle tops and throw them in the milk. You may think this strange, but in fact it stopped the milk slopping about. This method was used if you had to carry any liquid very far in a bucket.

Milking cows was probably the biggest tie a man could have, as it had to be done twice a day, no matter how you felt. You could have the biggest hangover, the worst cold, a dreadful headache, be bilious or be anything else and you still had to get up in the morning and do that milking. There was seldom anyone else to take your place, as the cows were frightened of strangers when they were in the fields in the summer (in the winter, when the cows were in the stall tied up, it was different).

When you were young and saw someone squirt milk from a cow's teat like water from a water squirter, it instantly made you want to try it. Naturally, the way to do this was to learn to milk a cow. Once you could do this, you felt a bit grown up and wanted to become good at it – but as soon as you could, you were expected to, and even had to. Most kids who could milk cows did so before school in the morning, and again in the evening when other kids would be out playing.

Some cows were temperamental animals, but the temperament stemmed from their genes. A heifer calf taken straight from its mother at birth would have the same mannerisms as its mother, and when it had calves of its own they would all have the same traits. So if a cow had some very funny ways you wouldn't rear any of its calves.

The heifer, as the cow was known when she had had her first calf, had to be broken in. Cattle then were very different from the cattle of today, as they saw very few people and were never handled until they had calved. They were all mixed breeds and all the animals

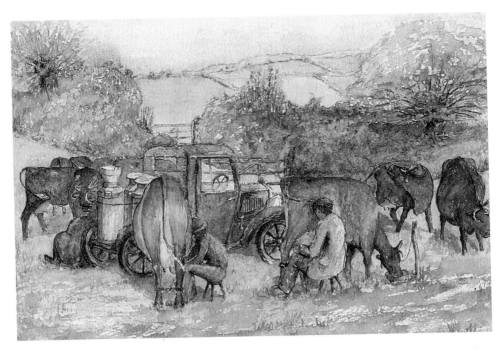

Milking in the fields.

that weren't dominantly Long Horn – the crossed Ayrshires, Shorthorn, Red Polls, and Galloways – were all interbred, and were very high spirited. 'Breaking in' was the way you got the animal to be quiet and let it know that you were the boss. To do this it would be spanned. A span was a plaited rope of horse hair about 30ins long and about 1in thick with a loop at one end and a wooden toggle at the other. This was put around the heifer's rear legs – around the far rear leg above the hock – and then twisted tight around the other rear leg, fixing the toggle through the loop. Once this was on and the heifer started to move, she would start to kick – only to find that she was kicking against her own leg. She would carry on with this for a while, but usually she would soon calm down so that she could be milked. If, however, she did not calm down and carried on kicking, she would have another span put on her, one side on top of the hock and the other side underneath. This would usually stop them very quickly, and in most cases the ones that were hardest to break finished up the quietest cows.

Milking by hand in the morning, in the fields or on the moor in the spring and summertime, was idyllic, as you heard the constant calls and songs of the birds. The most dominant were those of the lapwing, snipe and skylarks, but the additional calls of the crow, moorhens, ducks, pheasant, partridge, curlew, and the warblers and buntings seemed to be like a backing group.

One of the worst things about milking was when it was raining, cold and blowing – there were no waterproofs then. We tried to keep ourselves dry with sack bags, one around the front, one over the shoulders and one over the head and back, like a pixie hood. The dog always had the best place underneath the cart. Sometimes you had only milked three of the ten cows that you each had to milk, and the water would be running out of the seat of your pants. As you got up to empty your milk into the churn it was like you had walked through a river, but it was something to talk about for a few days.

The problem when it was raining really heavily was that the cows would become very restless and always put their rear end to face the storm: you had to go along with this and move yourself to suit the cow. The whole herd would want to go to the far end of the field. This is where the dog would come in, as it was his job to stop them from moving away.

Another thing about milking by hand is that you need to keep your hands in good condition, but, with all the jobs on the farm – pulling mangolds, stitching corn, hedging and the odd squat finger – this was nearly impossible. The chaps from pulling mangold, the thistles in your hands from stitching corn, the thorns in your hands from hedging: all were very painful, but you took a deep breath and just got on with it.

When the milking in the field was finished in the evening, the milk had to be taken home and cooled. In Granfer Bartlett's case, he stood the churn in the running water of the brook to cool the milk down. He left it there for a couple of hours, which seemed to give it a good keeping quality. In the morning, it was measured up and put on the 'stand ready' for the lorry to take it to The Wilts United Dairies at Bason Bridge, but there were times when the lorry was late. In the summer, if it was hot and thundery, the milk would be returned because the keeping quality was then poor; in fact, by the time it was returned the next morning it was a thick curd and would be fed to the pigs.

When the cows were tied up in the stalls in the winter – lots of them in shacks made of elm rails and galvanised iron, with cobbled floors – all the water that they drank was carried to them in bucket; this was often pumped from the well. If a cow was giving five gallons of milk a day she would drink at least fifteen gallons of water twice a day. This was very hard work, as often the water had to be carried a long way.

Another thing that was noticeable when the cows were tied up in the stalls was how their diet changed the smell of their breath. When they were being fed marrow stem kale or turnips their breath would smell terrible, and you could even taste it in their milk.

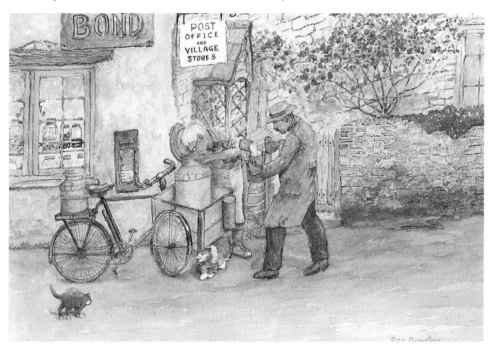

The milkman and his bike in Catcott.

Sometimes they would be fed bean meal from ground-up horse beans at the same time as the kale or turnips; this would make the cows perspire and the stall would become like a pea-soup fog with a terrible smell.

Hay made from grass with a lot of buttercups present would also give their breath a very strong aroma. Whenever you were feeding bean meal to the cows in the stalls, the rats would straight away start running along the side walls, and quite often a big old rat would jump into the bowl of the cow you were milking and frighten it. You always had to be ready for this, as it was very easy to spill all of your milk. It really was amazing how many rats there were around at this time.

When the war came, and the people who had cars found they could not get petrol, the farmers bought cars very cheaply, cut the back ends off them, fixed a platform to the chassis and used them like a pick-up truck, for milking and other jobs. I remember one car that was 'cut down' (as it was called) was a two-year-old Rolls Royce! Sid Gardener, an agricultural contractor, used it as his pick-up. An allowance of petrol would be made (petrol coupons were issued by the Ministry of Agriculture) for any vehicle to do with agriculture. It seemed great at first to be able to go milking in the dry and warm, but you soon realized that all of nature's weather signs – ones you had been aware of while going with the horse and cart – were now lost, as the only thing you could hear while in the car was the noise of the engine. By this time the BBC were giving a weather forecast, but the old signs of the birds, animals and the skies that we were used to were much more reliable.

I remember one farmer, Harold Venn, who was educated at Cambridge; one day, as he was filling out the forms for his petrol allowance for the car and stationary engines, he replied to the question 'name any other form of transport' by carefully writing 'bay gelding' – and got more coupons for the bay gelding than all the rest put together. How many times did we hear this story, and how many laughs!

It was always a good thing to be able know, just by looking, when a cow was about to calve. A couple of hours before a cow would start to give birth, a bone each side of the cow's tail and at the top of the leg bone would unlock and fall apart as much as 2ins either side. This was called 'pitching in' in our neck of the woods. When this happened, you kept a lookout at about two-hourly intervals. In most cases the cows calved themselves, but they sometimes needed a bit of help. The cow would usually go to the furthest end of the field to calve and if there was a pond or ditches about it was a good idea to be there when the calf was born, as the cow would go to drink and the calf would often finish up in the water; if no one was there, it would drown. This happened a lot on the moors when people weren't good at animal husbandry. Sometimes cows couldn't calve on their own or with a lot of help. If this was the case then the vet was called. More often than not, the calf would have to be cut up inside the cow with a special knife, and taken out bit by bit. This was later replaced by doing the same thing with special cutting wires, and finally this was all done very humanely by Caesarean section.

Rearing the calves was usually a boy's job, taking a bucket with about five pints of warm milk in and letting the calf suck your fingers whilst holding your hand down in the milk. After a few days of this, the calf would start to drink the milk on its own. This was carried out twice a day, morning and night. When there was more than one calf being reared at the same time it could become a problem, as one would finish drinking more quickly than the others, and would upset all their milk – so you kept a stick handy to make sure you were in control. A boy could only safely feed two calves at a time: three and it would often be trouble.

Calves that were weaned from September to Christmas were kept indoors until the spring. These calves, by then, would be called 'house blind'. This meant that when they were fit to go out in the spring it was nearly impossible to get them out of the building that they had been reared in – and when you did get them out, they would just run into everything from a stone wall to a thick hedge, and smash poultry pens all to pieces. This running around would last for about ten or twenty minutes – all good fun for us boys, seeing them run into things, tipping upside down and sometimes knocking themselves out. The calves by this time would be called yearlings, and at twelve months would be called stirks. Sometimes they would knock their horns badly, which would result in the horns growing into a horrible shape. Two to six calves would usually be weaned each year to replenish the old cows in the herd, and probably a couple would be sold.

Ringworm was a problem. Some years, when the calves had these, you had to be very careful as it was easy to catch them yourself. The cure for these at that time was to paint them with creosote. Very painful on the face!

On the moors, and on the hill in some fields, the cows became very prone to a thing called 'red water'. This meant that the cow's urine was the colour of blood. When I was a lad, cows were drenched for this, but in many cases they finished up in the knacker's yard. Some people thought it was caused by the cows eating horses' tails, but in fact it was caused by tick infestation. These would get in the crevices between the udder and the back and the front legs and the chest where you couldn't see them. Today, a small injection would soon put them right.

When cows were kept on the moors, they were usually checked last thing at night to make sure that none were in the ditches. If they were, and it was a cold night, they would be dead by the morning unless they were rescued. If there was a cow in the ditch, the farmer whose cow it was would go around the village and collect up a half dozen chaps. They would all walk to the place where the cow was with a spade and wagon line (a strong rope): one would double the rope up and throw it over the cow's head, twisting the rope tight and leaving a bit loose over the cow's windpipe. The men would then dig a place in the bank, pull the cow over on her side and usually pull her out like this. Sometimes, however, a rope would have to be put beneath the cow's tail and then four men would pull on the neck and one each side. However much trouble it was, the cow would always be got out. All this was done with just a hurricane lantern for light – and that had to have a shade on it so it couldn't be seen from the air. The payment for this was a big 'thank you, chaps' and – if you were lucky – a pint of cider at The Crown on the way home.

Warble fly was another hazard. You could be sitting quietly milking when a warble fly would buzz by – and the cows would all take off in a stampede. This was usually how they came to be in the ditches, as they would just gallop anywhere. These flies stung the cattle on the legs, laying their eggs at the same time. The grubs would hatch out and burrow beneath the skin on the cow's back, where they would stay until they turned into mature pupae about 1¼ins long, and twice as big around as a pencil.

Looer (foul in the foot) was another problem. The cow's feet would become full of pus and burst open. The only cure for this was constant painting with petrol.

Wooden tongue was something else that was difficult to get on top of, the mouth, throat and tongue becoming very inflamed, sore and hard. This was sometimes mistaken for foot and mouth disease. There was no cure for this at this time.

Milk fever was often a case where a cow was lost. Cows usually got this when they had recently calved and were milking very heavily. They were unable to stand up. Sometimes, when a cow was like this in a field, a temporary shed would be built over it. Sticks were woven around the outside and a tarpaulin was put over the top. Village people offered to take it in turns to stay up with the sick cow all night, as she had to be turned over every two hours. I remember at one time a cow was like this for two weeks. Then the weather turned very cold, and it was decided to move the cow into the farmyard. This was done by lashing a gate on two elm rails, and rolling the cow over onto the gate, pulling it back to the yard with a couple of horses. In this case, however, when the cow was rolled off the gate she immediately stood up and started eating! This was just a one-off, and no one could understand it. Today, this ailment is cured immediately with a large dose of calcium.

It was possible at this time for someone who worked on a farm, if they were so inclined, to start farming themselves. This was done by cutting the grass on the wide verges on the side of the lanes with a mowing scythe and making it into hay. Grass in orchards was often given away if it was going to be cut by hand (so as not to damage the trees) and this could also be made into hay. A quarter acre of allotment could be rented from Lotty Durston to grow swedes, corn and mangolds. Elm rails could be cut from the hedge to build a structure for a shed, faggoting up the brush wood to make the shape of the roof (not too high, using a bit of common sense). Shaulders cut from a ditch on the moor could be used to finish roofing and thatching it, with the help of a few spars made from willow gads. Once the shed was sorted out, you could negotiate a couple of gallons of milk a day in the summer, when the price was low, with the farmer you worked for. Then buy a couple of calves, keeping them in the shed and using the milk, hay, swedes, mangolds and corn to rear them; you would put a couple of dozen or so ears of corn through a mincer each day, and sprinkle it on the finely chopped-up swedes or mangold. This only required the money for the nails for the shed, rent for the allotment and the bit of money for the seeds. Your time was your hobby. This would be a hard struggle for about five years, but you would then be, with a bit of the right kind of luck, what was called 'on your way', and if you were able to buy some grass you could expand. Several people started this way, by doing a full-time job and rearing a few calves to start off with. One couple who did it also had eleven children, and they eventually finished up owning a 300-acre farm outright. With all the rules and regulations there are today, this would be absolutely impossible.

The farms in Catcott and most of the other Polden villages were made up of fields scattered all over the villages. When the grass was eaten in one field, the cows were moved to another field along the road, sometimes up to a mile away. This was often a problem, as the newcomers to the village would leave their gates open and someone would have to run on in the front to make sure they were closed. This was usually done by two or three boys, who also stood on the corners to send the cows the right way. The dog would bring them on from the rear. There were usually ten to fifteen cows in a herd: thirty, at that time, was a big herd, as in most cases the milking was done by the farmer, his wife and children.

It was always good to know that no one else was moving cows at the same time, as when strange cows got together they fought like dogs and were very difficult to part.

During the late spring, while we were milking on the moors, we would watch where the lapwing and moorhens were working. As soon as we had finished milking we would go to where we had seen these birds, knowing their nests would not be very far away (though sometimes they were very hard to find). When we had found them we would memorise two objects in a straight line with the nest, and if there was more than one egg,

and less than four in the nest, we would take one every day for a fortnight and the birds would keep on laying. You could see people all over the moor collecting eggs in their caps and trilby hats. These eggs were plentiful and free and tasted much richer than hen's eggs, and helped with the rationing.

After the war was over, sulphate of ammonia to most small farmers was a new thing on the market; it was a form of straight nitrogen. This made green crops grow very quickly. I remember my uncle asking me, when I was fifteen, if I thought I could sow some of this sugar-like substance by hand at a rate of 1cwt per acre. I thought about it, tried and successfully managed to do it using a two-gallon bucket to carry it in. I sowed it on a nine-acre field on the hangings just above the moor in mid-March 1947. The grass soon became what was known as 'black green': it grew like we had never seen grass grow before.

The milking herd was turned out onto this field straight from the stalls in the spring. We thought that they would love this luscious grass: how surprised we were when the cows rushed into the field and began biting off the grass and throwing it over their backs, all walking to the end of the field and back, and bawling the whole time and not eating a bit of it! Their milk yield, instead of flushing up as we thought it would, practically halved. It took the cows three days before they even started to eat it – and when they did it just went through them like they had been given a dose of salts.

Today more than three times the amount is sown and the cows happily eat it. They have been used to nitrogen ever since they were calves, and when they were born their mother's milk would have been full of it. The hay they ate would have been heavily fertilised, and with modern-day farming practices everything else is just the same, so they now know no different. Could it be that the amount of nitrogen sown on most green crops is the reason for so many stomach problems (IBS, celiac disease)? I have asked this question many times but have never found anyone with enough knowledge to give me a measured answer: perhaps someone that reads this may make a few enquiries? At least I hope so!

CHAPTER FOUR

GEORGE BRYANT

The bakehouse where George lived, with his wife, Libby, and daughter, Ethel, was such an asset to the village. Without it, half the villagers would have starved, as you could go and pick up bread without any money as long as you noted what you had taken in the book. I know you had to pay for it sometime, but George would give you a long time, and he wouldn't see you starve if you were really having a hard time of it.

The day's work for George was as follows: up at 4.30 a.m. to light the stick fire to start the ovens; then he would start cutting up and weighing the dough on an old pair of scales with a brass pan and weights. After all the dough was weighed up, he and Libby would knead it, taking two pieces of dough, turning them round and round under the back of the palm of the hand, one in each hand, until it was in a round ball. Then they would pull it out in a long length, holding it in either hand, and bang it like a piece of rubber on top of the dough bins. Then they would turn the two ends in and start all over again. They would do this three or four times to make the bread light. When all the dough had had this treatment, it was ready to be put into the tins, where it was pressed down hard to make sure all the corners of the tin were full. When all the tins were full they were covered with a cloth and left to rise again.

When the heat was up in the oven George would load it up, one hundred and eighty loaves in nine rows of twenty. While this was cooking George would have a snack, after which he would unload the oven, stack the bread and reload the oven with the second batch. While this load was cooking, George would be cleaning the large electric mixer and packing the basket of his bicycle ready to start delivering, and Libby would be packing her van. George would unload the second batch all by himself, if there were no kids around, and then he would start delivering.

When he and Libby had delivered all the bread, George would start all over again, getting two sacks of flour from the store and taking them in to the bake-house, looking at all his rat gins (and they were everywhere), mixing up the next day's dough and putting it in the bins to rise – ready to start the whole process again when he started the next morning.

At Christmas, George would have a special Sunday when he would cook Christmas cakes for anyone who wanted a large cake – and that was most people. He would also cook large joints, turkeys and geese to be picked up at noon on Christmas morning. How many people would do that today?

George lived about 50 yards up the road from where we lived; the smell was fantastic. George was a real character. You didn't need a newspaper or a radio if he was delivering the bread; he had all the news and all the answers. He loved kids and would spend no end

of time talking to us, telling us stories and giving advice about life. He would say, 'Make sure you learn your tables and do your sums. If you do this you can always get help to do anything else you need'. He was usually political, but with no obvious leaning; he would debate everything and anything. No one could understand where he obtained all his knowledge.

He used to say to us, 'Save your money, and as soon as you have saved a bit, buy some land, preferably somewhere you can build a house on. Or buy an old cottage, because there's going to be no more land made and if you got a house, you'm right for life.'

Once he had mixed the dough and laid it in the bins to rise, he would gather us around the bins and tell us about his life's experiences and the adjustments he would make given the chance again. 'When you get married, always let your wife think that she's the boss,' he said; 'but the biggest problem that you boys will face in your lifetime is going to be inflation.' He picked a large loaf of bread from the rack and said, 'You see this 2lb loaf? Well, today it costs 4d, but in your lifetime, my sonnies, this same loaf will cost a shilling.' Little did he know that the 4d loaf would be fifty times more expensive sixty years later; 240 pence to the pound in those days. He was certainly right about the problem, but if only us kids had known the extent of it and could do our sums.

When George told you something he always finished up saying, 'You remember that, my sonny,' and then his chuckling laugh would break out. He was full of fun and would get us kids to play a game with him. This game he called 'In Irishman's trousers'. We had to think of a proverb. This wasn't hard to do as, in those days, everything was run around proverbs. When you had thought of one, you said it out loud and George would then say, 'In Irishman's trousers', and have a good laugh: for example, 'A stitch in time saves nine', 'Waste not want not', 'A rolling stone gathers no moss', 'Smooth runs the water where the brook is deep', 'The early bird catches the worm', 'Hell hath no fury like a woman scorned', and so on. Some of them were very funny, and we would have a good laugh. I think all these things helped us to become more social and taught us to get on together.

We would grease the bread tins for the dough, stack the tins in piles, and put the bread on the racks while George was unloading the oven, and Libby wasn't around. He used to take out two loaves at a time on the wooden spade and throw them on the bins in such a way that the bread would leave the tins. It was all very hot, but we used cut-off small yeast bags, wearing them on our hands like mittens. This stopped the hands from burning and also kept the bread clean. George made little loaves for us kids, about the size of a small orange: they were very crusty and were eaten just as they were, hot and dry.

During the war years, when things were going badly across the Channel, and also at election time, George would take forever to deliver the bread as he would stop and have a discussion with everyone. Anyone who wanted bread in a hurry would go to the bake house and help themselves to what they wanted, leaving a note in the day book to say what they had taken, as Libby would be out delivering as well.

While George was out on his round delivering he would sometimes go into the pub for a pint; we knew he would be a while then, as he always had to have a discussion about something. Then one of us kids would take his bike and ride it around in the road. This was difficult, as you had to get your leg under the nameplate that was underneath the bar and this made it very difficult to pedal; consequently the front wheel would turn too sharply and the bike would tip up, hurling the bread all over the road. We would all scrabble around very quickly, pick up the bread and dust it off and pack it back in the front basket, and put the bike back where George had left it, and he would be none the wiser.

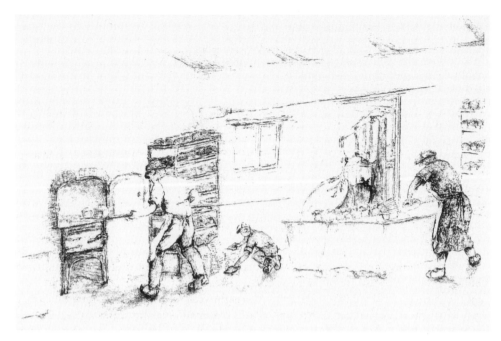

George busy in the bakehouse.

When I first remember George, he delivered the bread with a horse and proper old bread cart; he left this on the side of the road with the reins tied to the shaft. We would climb up on to the seat and be waiting for George when he came back. He used to say, 'Mind you don't hurt yourselves climbing up here,' or, 'Mind you don't get under those wheels.' Sometimes when the horse started to trot it would break wind, and George would have a little chuckle and say, 'The wind's up the channel again, lads.' George was a wonderful old chap, full of humour and pessi-optimism. He kept a lot of Christmas cockerels, and about a dozen laying hens in the large orchard adjoining the house and bakehouse. The cockerels and hens were kept in a wire pen. When the apples in the orchard were ready to pick, or were ready to shake and beat in for the cider that George made just a couple of weeks before Christmas, the fat cockerels were killed and George would catch all the blood from them and add it to the cider with some molasses and yeast; all this would work out during the fermenting and the cider would be beautiful and was thought to be some of the best around.

CHAPTER FIVE

CHAIN HARROWING, ROLLING, HAYMAKING AND THATCHING

The start of the haymaking, I think, was really when you decided in the spring which fields you would let up for mowing. These fields were then chain harrowed. My very first experience of harrowing was when I was eight years old. Grandfer Bartlett cut three large white thorn bushes out of the hedge then trimmed them flat on one side. He then cut an elm rail from the hedge and tied the three thorns side by side to the rail with short ropes. He then fixed a bodkin to the rail with a couple of trace chains, hitched in the lively breedy twelve-year-old, half-way horse Peggy, and dragged these around the field. These thorns did nearly the same job as chain harrows.

Chain harrows were like large square links of chain made of half-inch metal rods, about 6ins across, all joined together to make a square about 8ft each way. There was a spreader at the front that the chain was hitched to by crooks, and that in turn was hitched to the horse by way of trace chains and a bodkin. At the rear there were weights about 6lbs in weight and about 1ft long, at about 2ft intervals. The weights were to stop the chain from rolling up, and another spreader at the rear would keep the chain at its full width.

All the stones that had shown up on the surface when the chain harrowing was being done, or when the soil was being worked about to make a seed bed in the plough fields, were picked up and put into a heap in the farmyard. These were a very valuable commodity, being the only stone available for making up holes in gateways, Rick Barton or any other place that needed stone. Once the field had had this treatment it would be rolled, with a flat or ring roller, again pulled by a horse or horses. These two treatments were carried out to get rid of any old dead grass, small ant hills, mole hills, old cow pats and stones ready for the haymaking machinery, as rough ground played havoc with the machines, and if the weather was good once you had started haymaking the last thing you wanted was something breaking down when you wanted to be going full-steam ahead.

When the weather looked settled in early June, the first grass was cut with a mowing machine and a pair of horses. The principle of a mowing machine was a knife with triangular blade sections reciprocating backwards and forwards, through pointed round fingers. This action cut the grass. Usually the farmer had one horse of his own and would borrow one from someone else, or hire one. Some people kept a horse to hire out at times like these. Usually they were mares that were kept for breeding, as at this time of year they would not be far on in foal and would be doing nothing else anyway; if the mare proved to work well it was a good advert for selling the foal.

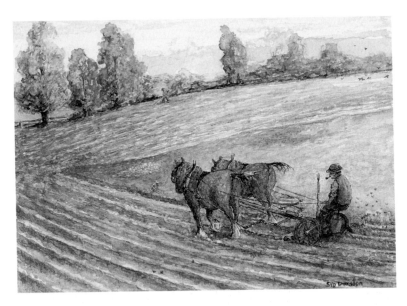

Mowing.

I remember vividly going mowing with my father in the field opposite The Crown in Catcott. My job was to hold the horses while my father put the bed of the machine down and gave it a drop more oil. This was a hard job for a boy, as the horses never stopped flicking their heads because of the flies, or trying to eat the grass, and as your arms were above your head anyway you soon lost any strength you had in them. Once everything was ready and I was out of the way he put the machine into gear and, in his usual way, said, 'God send us good luck'. He then set the horses going with the command: 'Hold fast'. He had only gone about 12ft when there was an almighty bang and everything came to an abrupt halt. The reason for this was that someone had thought it would be a bit of a prank to drive a piece of half-inch rod into the ground to see if God sent him the good luck he always asked for. The iron rod had broken two sections out of the knife and twisted a finger. Once again I had to hold the horses while my father did a repair job on the finger using the tools that were always carried in a bucket hanging underneath the seat. He changed the knife and was ready to go again – and by this time, my arms were nearly falling off. Once he was ready, he again uttered the words, 'God send us good luck.' His patience seemed never-ending, and off he went again.

After he had cut about four rounds with the machine, I had now got some life back in my arms and started to rake back. This was raking the edge of the cut grass from the uncut grass after the horses had walked around the outside of the field the first two times. It was done using a wooden rake called a mead rake. This might seem a laborious task, but actually it was quite peaceful: thousands of grasshoppers, large and small, hopping everywhere, butterflies of all kinds feeding on the red clovers that were now in flower; the smell of the honeysuckle and the dog roses in the hedges, and all the rest of the wildlife. Keeping your eyes open for a good run to set a snare in to catch a rabbit, and making a mental note of where a pigeon was building on a low branch (thinking of a pigeon pie in August!). My mind was always occupied by nature, and so whatever job I was doing was always rewarding and interesting. Some other kids hated it. This outside grass would be cut going the opposite way as soon as the rest of the field had been cut. Raking the grass back was to stop the grass catching up on the bed of the machine, as it was very hard work

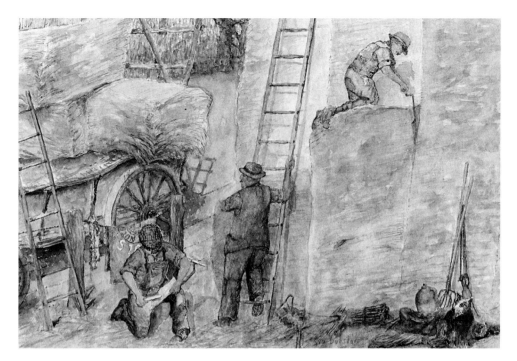

Cutting hay.

to get a horse-drawn mowing machine to move backwards. The only way this could be done was by dragging the driving wheel on the bed side of the machine backwards, while at the same time keeping the horses' heads up. The machine had to be pulled back at least 18ins to see what the problem was, and for the knife to be free before it reached the grass again. If the machine was going downhill, it was doubly difficult – as you can imagine, this was not a job for a boy, but for a good strong man. Pulling the machine back by the wheel had to be done when the horses and machine turned on every corner and when anything caught up on the bed or fingers.

As the summer got further on, mowing became more difficult, as by now the ants would have pushed little heaps of soil up into the grass where they kept their lava. The mice would have made their nests to have their young, and everything would catch up all the time. It was at times like this that I learned a few choice words from my older cousin, to widen my vocabulary.

The seed would now be ripe in this grass, and this is what kept the small birds alive during the hard frost and snow during the cold winter months when the animals were being fed with it in the fields and in the farmyard, where these small birds would flock.

The grass having been cut, and any left in the corners or in odd bits around the outside cut with a mowing scythe, the pile was then left to dry well on the top (hoping for plenty of sunshine, of course). When it was dry on the top it would be turned over, either with a swath turner or by hand. Most of the small fields were turned by hand as, around all the fields, the hedges were like forests of elm trees. Sometimes when you bought land you would have to pay a quarter as much again for the timber on the land; under these trees it was a terrible job to dry hay and it always had to be shaken out by hand.

When we were kids out in the haymaking field, where the men were working, at about ten or fifteen minutes to one, mother would arrive with a full cooked dinner, meat and three veg, and would lay it all out on a cloth on the ground in tureens with plates, knives and forks. She would have cooked this and then pushed it in the pram, with my little sister as well (who was eight years younger than me), to whatever field the work was being done in. The men stopped work and sat around the cloth and ate their meal and then got straight back to work. Mother would then pack up and make her way with the dirty crocks back home to Townsend.

When it was tea time she would arrive again with the same pram and my sister, this time loaded up with the tea. As soon as she arrived, father would stop whatever he was doing and get a tripod ready to hang the kettle on. For this he would cut three green willow sticks, and tie them together like a tripod about 4ft high, then hang the kettle on with a piece of wire and a crook. I would have already found the dry sticks necessary to make the fire, having done it many times before. Father would then light the fire and the kettle would soon be boiling, By this time, mother would have laid out a cloth and put plates around; she would cut the bread (George's, of course) when or how it was wanted. She always made fresh butter to take out to the field. Fresh butter has a really special taste and smell, and this always went down well with homemade jam, or soft boiled eggs with pepper and salt.

Father always took water to the field in a milk churn with the horse and cart, and kept it underneath the cart in the shade, so there would always be water to drink. We would all sit chatting and eating once the tea had been brewed, taking in the smell of the smoke of the fire, the sweet smell of the hay and the smell of all the herbage, and the really strong smell of the wild mint, and, if it was on the moor, the wonderful smell of the ditches.

When the tea was all over, the menfolk would get back to their work, and mother would pack everything back in the pram with my sister and set off for home. If it was on the moor, she would have to push the pram and my sister up over Nydon, a very steep hill, on past The Crown Inn, and then up over the steep Hector's Hill before arriving at Townsend. By this time she must have been absolutely shattered, but she never grumbled. She must have been as strong as an ox: when my sister was born the previous February, she was in bed for five weeks with a clot on the lung. The cure for this, at the time, was mustard poultices twice a day. Mustard was in big demand at the time as it was used for many things.

The trees around the fields often proved very useful, as the lower boughs or branches were cut down to make a staddle. The larger timber was put around the outside first, after a discussion as to how big the rick would be and however many paces each way. Some large timbers in the middle, then the smaller branches would be carefully put together so that the hay would be kept up off the damp ground to stop it from going fausty. This method was used whether the rick was built in the field, or in the farm yard, and it was also used for the corn mows. It was also a sure source of dry firewood in the late winter.

While you were waiting for hay to dry, it was just as well to recognize the signs that it was going to rain. The black slugs still around late in the morning; the call of the green woodpecker while in flight; your hat constantly blowing off with very little wind; hay winding around the machinery; swifts and swallows skimming the ground; ordinary house flies biting like mad; also, on the levels, a snipe standing on one leg on a gate post with its beak pointing to the ground (you could safely put all your money on this one). If the mist went up over the hill and did not return, this was another sure sign of rain. Rooks and crows sitting on pooks or cocks of hay, or feeding in a field of dry hay, is another sure sign

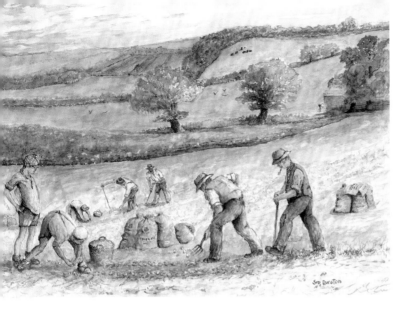

Harvesting potatoes on small farms was mostly done by hand, digging them out with a fork. The women and children then picked them up.

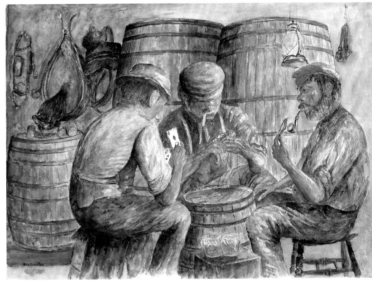

The cider house was where the farm workers could relax with plenty to drink and a few games of cards.

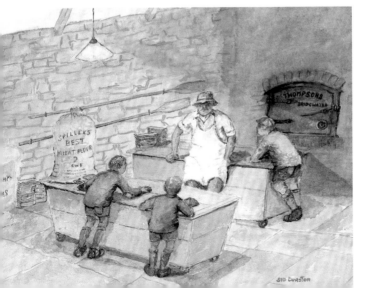

This is the bakehouse where George told us how to live our lives and the things to do – he always gave us positive advice.

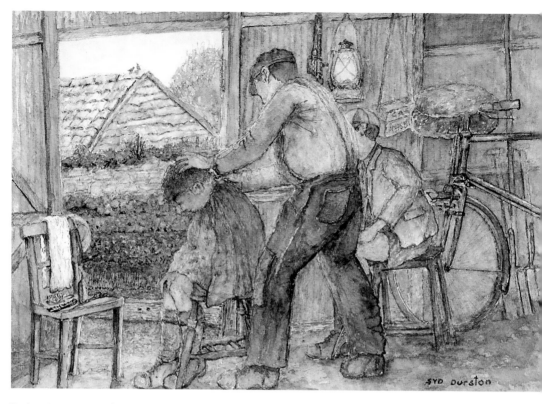

Barber George at work. His day job was working on the railway, keeping the rails secure.

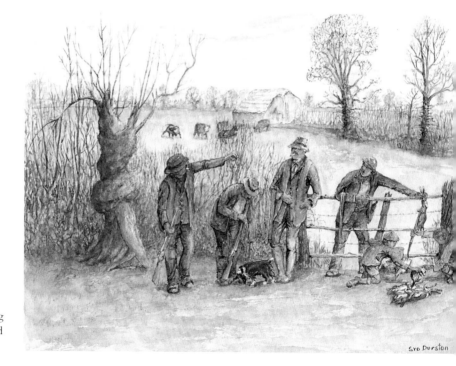

Boxing Day was the biggest day of the year for shooting, hunting and ferreting, and us kids loved it!

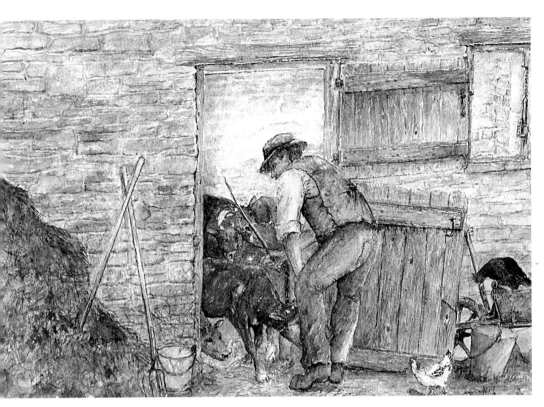

Calves were weaned indoors. They were usually put in to be weaned before Christmas and in May. It was an awful job to get them out of the house afterwards.

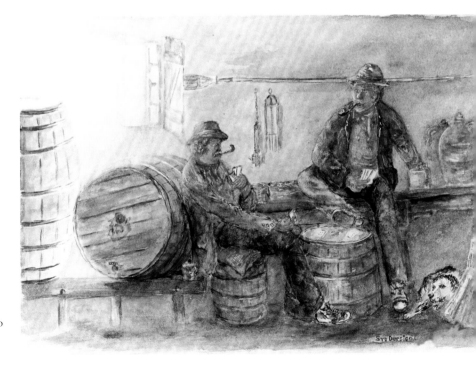

Putting the world to rights: another card game in action.

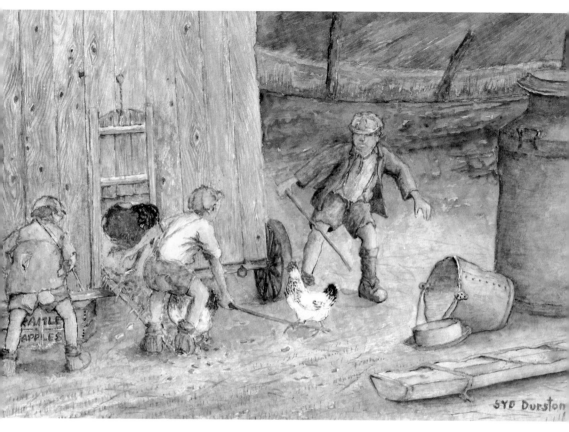

Penning up early was quite a job if the hens decided they didn't want to go into their hen house. (The boy is urinating beside the hen house to keep the foxes away.)

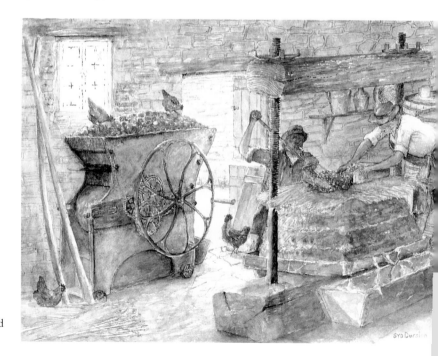

Apple pomace being put onto the cheese, and pressed down hard onto the former.

Boys cleaning the stall with dung forks and an old-type wheelbarrow, much harder to push than one with pneumatic tyres.

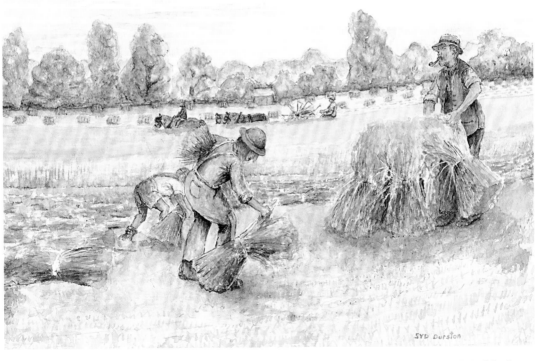

Stitching corn was hard work for all us lads, and it was also hard on the hands: some of the corn was full of thistles.

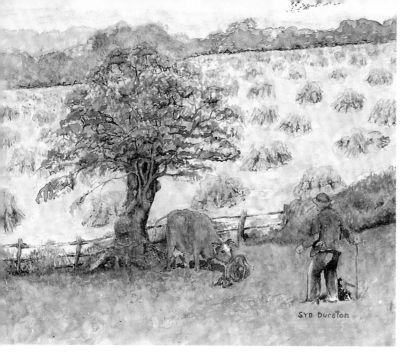

This man has just given a cow a bit of help to get the calf away. As soon as the calf has suckled it will be alright, as long as it doesn't come into contact with any deep water.

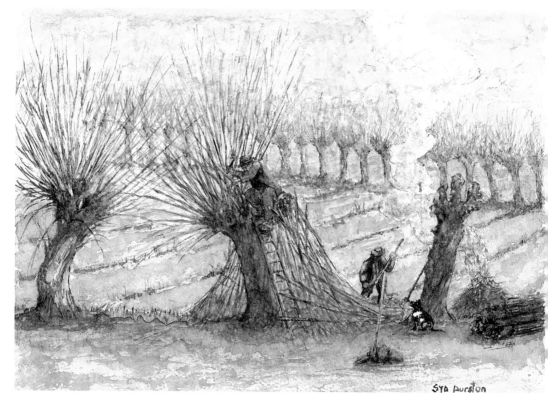

Cutting withy branches, trimming them out and turning them into gads ready for making spars. These were cut every three to five years.

An uneasy peace: a cat, dog and chicken in the farmyard.

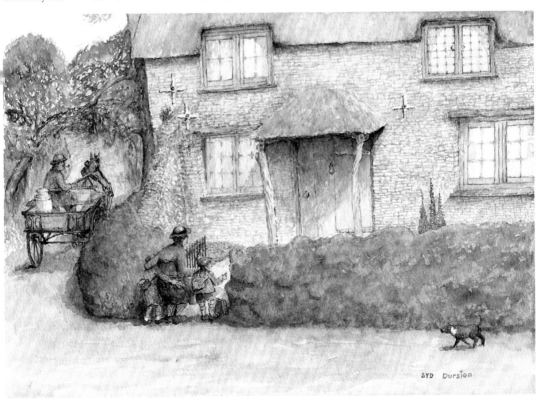

These evacuee children have just arrived from Romford and are being shown their new home – and they are not happy with what they see, or who they are with!

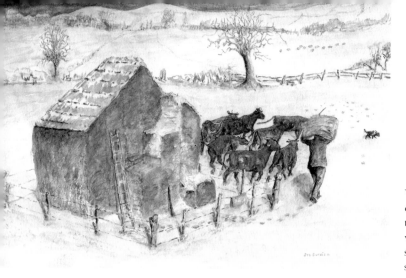

When cattle were wintered out-of-doors in the fields, the hay that was taken out to feed the cows when there was snow was full of seed. These seeds are what kept the small birds alive.

This tub was used to hold water for the cattle to drink from in the dry summer. It was scary but fun to be pushed around in it.

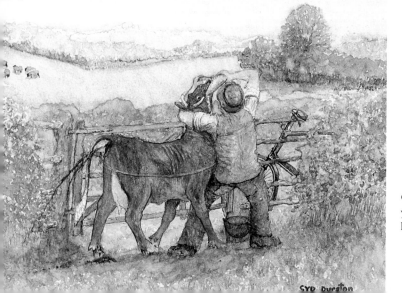

Cows were drenched like this on your own, as you seldom had any help if you were a small farmer.

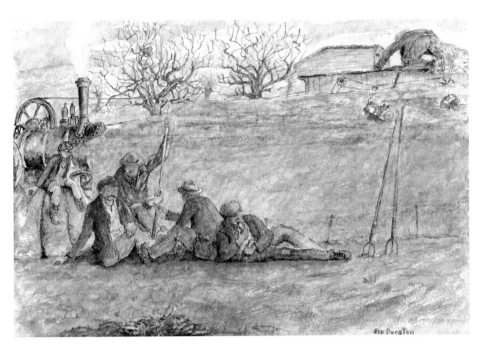

A healthy debate. Tolerance (and its consequences) was argued about more than anything else (other than rats).

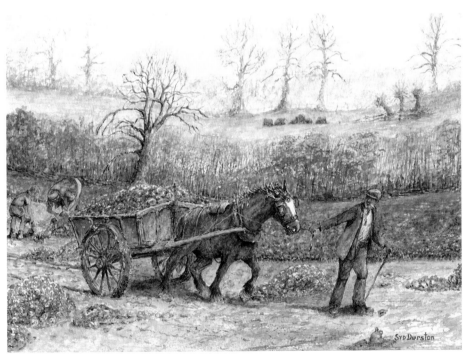

Hauling mangolds was hard work again for us kids as these were quite heavy things – up to 12–14lbs in weight.

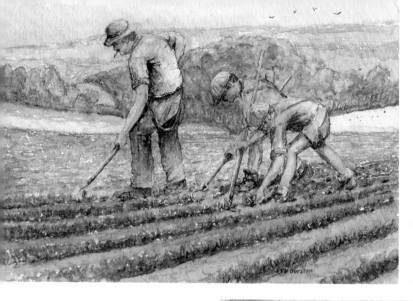

Thinning mangolds. An experienced hoer would seldom put his hand to a weed or a plant whilst thinning, doing everything with the hoe. This was very skilful work.

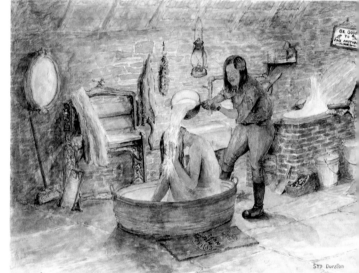

Few country farmhouses had bathrooms, and to have a bath you had to go to the old washhouse (with a bit of help from a friend).

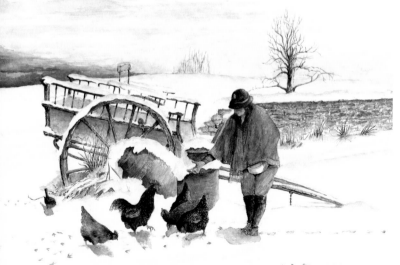

Land girl and hen. This painting was for the cover of the *Western Daily Press* Christmas magazine.

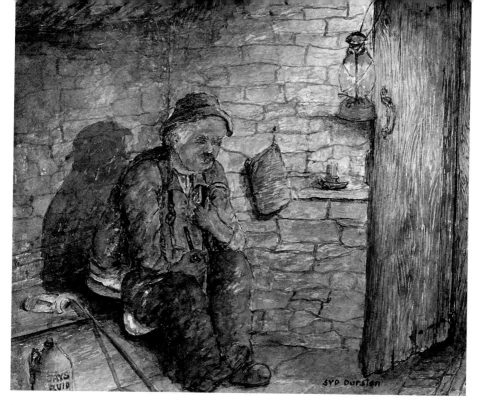

The 'thunderbox' at the bottom of the garden comprised of an elm plank with different size holes cut into it.

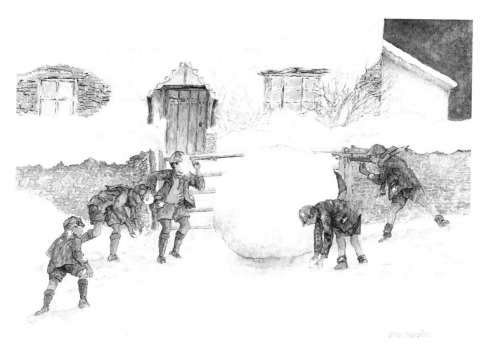

Kids rolled up snowballs like this and left them outside of gateways or doors; if they froze it was a job to move them.

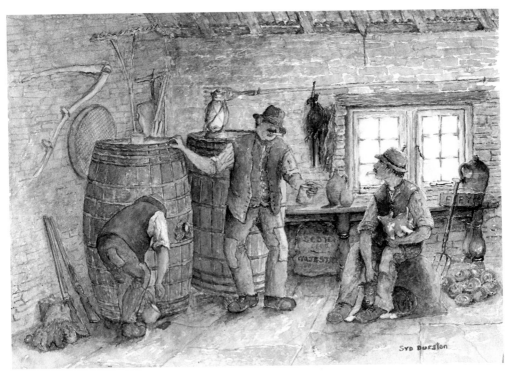

'Mark my words' was a phrase you would often hear, as the forecasters of the future were many. Some were seldom wrong.

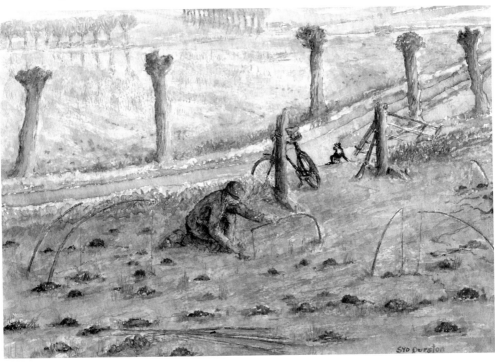

Mole catchers were in big demand as the higher land on the moor was black with molehills and mole skins were quite expensive.

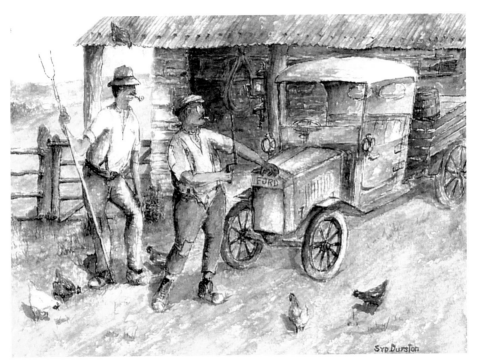

Frank and Walter Norris used this old Model T Ford for hauling peat turves from Westhay Road to The Crown at Catcott.

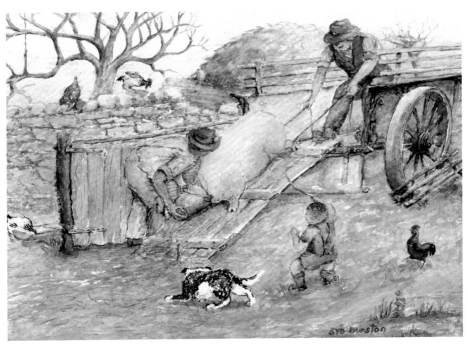

Pigs were loaded like this. First you would lay a door up to the putt, corner the pig and then put a bucket over its head. You then tied a rope around each back leg and guided the pig up to the door backwards into the putt; then you would pen it in.

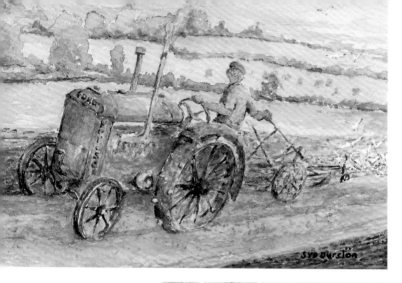

The old Fordson tractor was the most prominent tractor at the beginning of the war, at least before 1942.

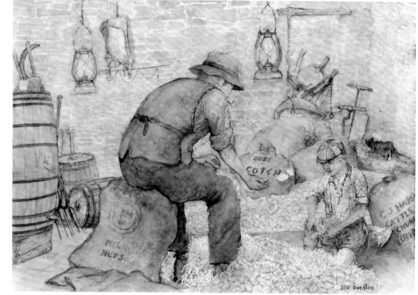

Chessoming the potatoes was a laborious job, and usually done during the evening time; it had to be done at least twice a year.

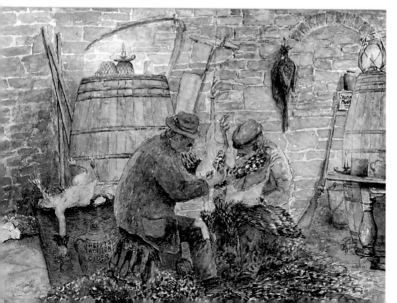

Turkeys, as far as I remember, were only bred to be killed at Christmas at that time, so all hands to picking before the end of the year.

Chasing the sewage. This was a thing we did going home from school, if we weren't working and it had been raining hard enough to ensure a good flow of water.

Pigs were kept like this in an old shed nailed up of old galvinise and elm rails cut from the hedge; if a boy got really interested at that time it was a sure way to forge ahead.

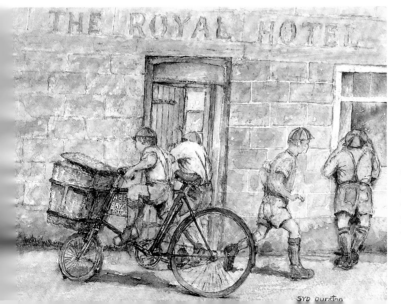

The kids all fancied their chances at being able to ride George's bike around the square in front of the Royal, but most tipped it up.

Saddlebacks: a sow and litter of piglets.

Chicks and mother hen. You could watch these for long spells and it would not become boring, as there was always something going on.

Spars were made mostly in the evenings, with a barrel of cider handy. This was all piece work (so much per 100 spars).

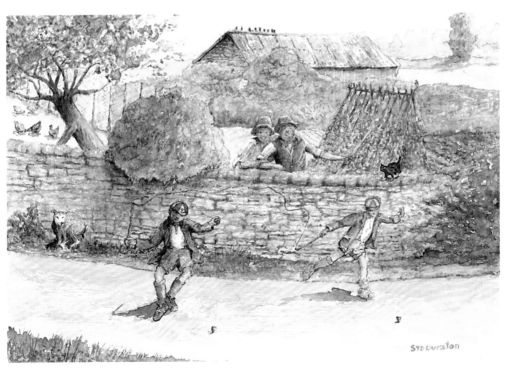

Whip and top was a game or race we played if we had time to get involved. We made the tops from old cotton reels and a hob nail.

Jackdaws kept laying if you kept taking the eggs, and would always end up rearing a large clutch of young.

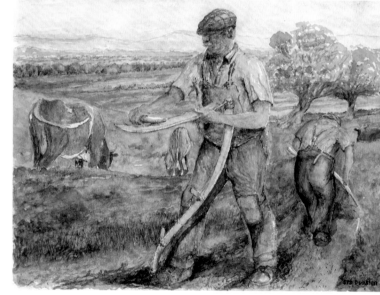

The scythe had to be sharpened often, as it had to be very sharp for a person to be able to use it.

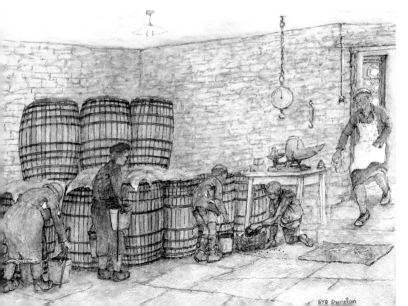

Blackberries were taken or collected at Fred and Emily Bartlett's, opposite the war memorial, Catcott. They were stored in barrels, as many as three and a half tons a week.

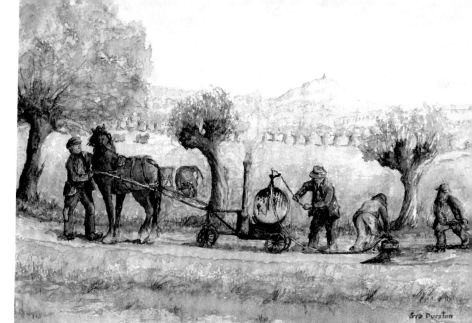

The roads were tarred with a tar pot like this one, pulled by a horse. This horse and tar pot was used every day, six days a week, and the surface covering was spread by hand.

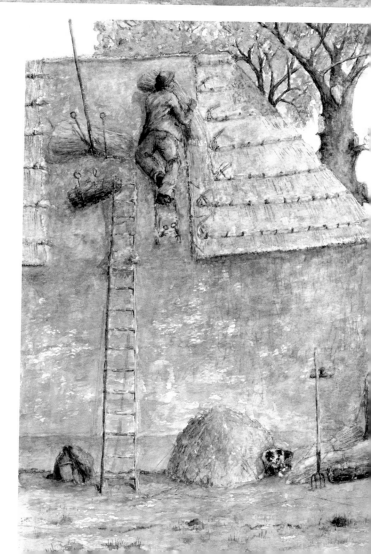

Ricks were thatched in much the same way as this is being done, using either combed wheat straw or shoulders cut from ditches on the moors.

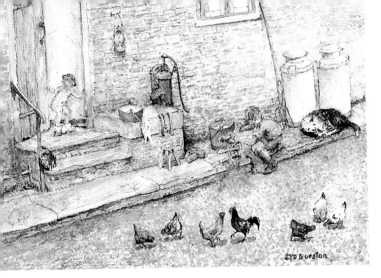

Townsend was my family home. This scene shows a boy scrubbing milking stools clean. This was an important job, as dirty stools could contaminate the milk.

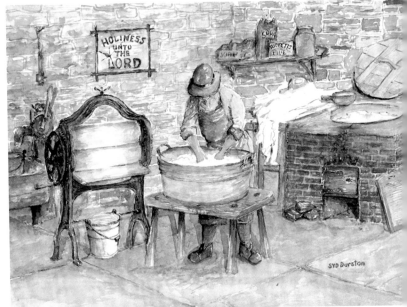

The washing was done in an old washhouse by hand. All the water was heated by the old copper on the furnace.

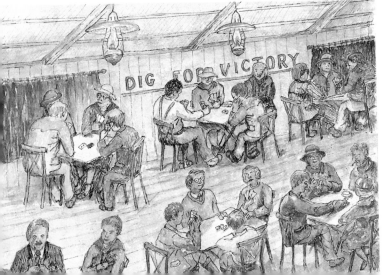

Entertainment during the war years: a whist drive in action. The prizes were usually vegetables or cider.

Hens like this could have all their chicks in the beginning of the week, but the rats and magpies could take one a day if the hen wasn't careful.

So much steam was let off in the playground, but absolute discipline was demanded inside the school doors.

The Home Guard was a bunch of 'ragtag and bobtails', or that's how it seemed to us kids. We used to get on the high wall at the Royal to watch what was going on.

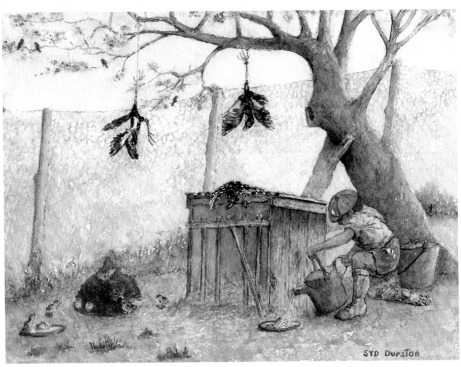

Chickens were often kept in runs with dead birds that had been shot and hung to deter other crows and magpies from coming near.

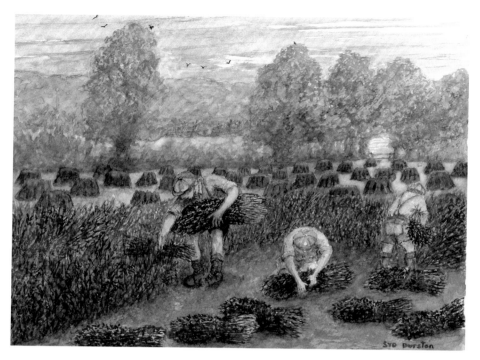

Beans had to be pulled by hand, and often this was a job that would be done by boys alone, pulling, tying and stooking.

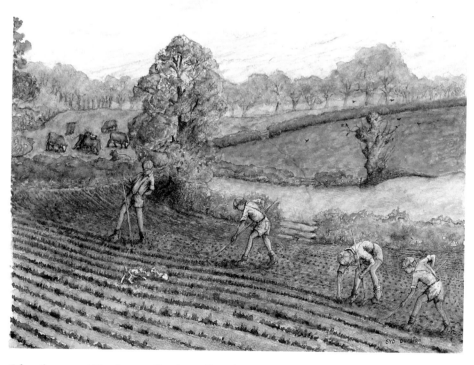

Often there would be three or four boys all working together, hoeing or thinning mangolds for a five-hour stretch.

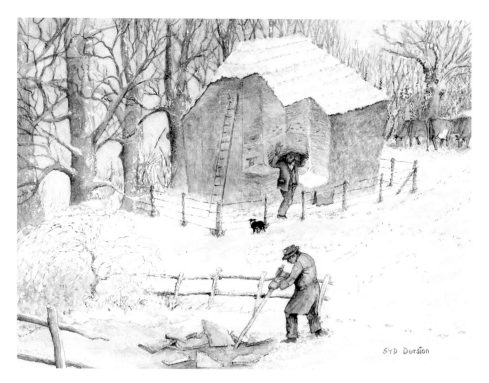

The seed in this hay kept the small birds alive, and when the ice was broken on the pond this was also where the small birds could drink.

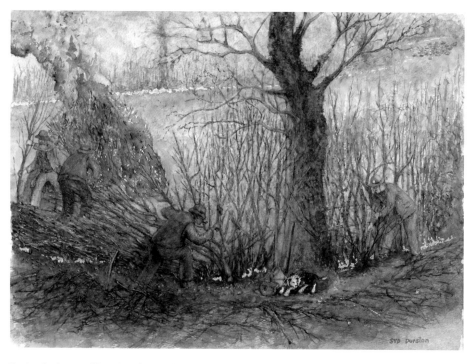

Laying hedges and burning the spoils was again hard work, and also very skilful – if a fire was going really well you could burn anything on it.

of rain; also if the handles of the tools seem very dry, and you have to spit on your hands to use them. Or if the curlews were calling when flying up over the hill in the direction of Moorlinch and the swifts and swallows were flying high, nearly up out of sight, you could expect a month's fine weather. During this spell of fine weather, the mist would always go back to the moor. The first day it didn't you knew it would rain. Nearly all these signs have gone. No snipe, no curlews, very few green woodpeckers (as nearly all their nesting sites and the old orchards have gone). Swifts are seldom seen, as most of their nesting places have gone; they nested on the old flat elm wall plates of the old tiled roofs, and most of these have now gone. Most of the swallows' nesting places have likewise vanished, with all the old barns being converted, so how long will the swallows last? I haven't heard a cuckoo now for two years. What's going on? What a debate those old chaps would have had while shaking out the hay.

When the hay was dry it would be raked up with a horse rake, and in the large fields swept with a horse and sweep to the centre of the field, where it would be made into a rick. All of this by hand using pitch forks. The rick was put in the middle of the field, as the field is where the cattle would be wintered, and to feed the cattle in the winter the hay was cut into flops with a hay knife. The flop had a spar put in the top to stop it blowing away, and was carried to every part of the field in turn, on your head, to spread the manure about the field. The small fields were carted either to the farmyard or to one of the ricks in the larger fields.

If, when the hay was being made, it was a bit green, not quite dry, this would cause it to heat when it was made into a rick. If there happened to be a strong breeze this would drive all the heat to one side and cause the whole rick to tip over if it wasn't propped up: this was another time when the young elms came in handy.

There were only six wagons in Catcott: Harold Venn had one, Tommy Gardiner one, Uncle Edmond Durston one, Walter Parker two, and Arthur Vowles had one. Then my father bought a wagon from Clifford Hurford of Hill Farm, Edington. The only problem with this wagon was it only had three wheels; one back wheel was completely rotten apart from the nut, and it had no lades. Everyone was laughing and making jokes about my father's three-wheeled wagon. I felt very embarrassed for him and myself, but my father said, 'Where has all your faith in me gone? You leave it to me, my son.'

He borrowed a wheel from Arthur Vowles, loaded it onto the put, threw up an iron bar, a spade and a wagon jack, and we set off to a place called Swill Stall at Sheephays, Edington, where this old broken-down wagon was. He then set to with the iron bar and spade, and found all the missing cleat bonds that used to hold the wheel together, also most of the dug nails they were nailed on with. The wagon was jacked up on an old milk churn but it wasn't high enough to put the other wheel on. He took off the nut (the old wheel hub) then put the axle jack underneath the axle, jacked it up and found that the wheel fitted a treat. He put the pin in to hold the wheel on, put the spade, iron bar and jack in the put and set off home. When we got home dinner was ready, and over dinner father told mother very excitedly about the wagon and assured her he could make a wheel. I remember her being very doubtful. After dinner he set off on his own with the horse to get the wagon. He arrived home with it and parked it at the top of the orchard, next to the farm Barton. He took the horse out of the wagon and put it in the put, jacked up the back axle of the wagon, took off the wheel and loaded it onto the put and returned it to Arthur Vowles and thanked him very much.

The next day, he started on the job of making another wheel, finding some good stout ash for the spokes and elm for the fellers. Once he had found the elm he set it out and

marked it out, then cut the fellers out roughly with a handsaw. When he had done this, he shaped them with a hatchet and a couple of chisels. When he had the wheel near enough round, he fixed a flat rope around the outside of the wheel, and got it nearly round by making hundreds of saw cuts between the joints of the fellers, pulling the rope tight all the time by twisting the ends of the rope with an iron bar. Then he shaped the spokes and fixed them to the hub, taking out the rotten spokes from the hub, cutting the tenons and fixing them in the hub. He then laid the hub and spokes on to the fellers and marked where the tenons on the end of the spokes would go. After he had cut the tenons on the spokes, he again laid the whole lot onto the fellers again, and then marked the mortices on the fellers. Once he had done this, he took all the fellers apart, putting them in an old blacksmiths vice one at a time, and cut out the mortices. When these were cut, all the fellers were hammered back on the spokes with an enormous mallet like a sledge hammer. Then the flat rope was put back on and twisted tight, square dowels were put in to hold the fellers together, the rope was taken off and the cleats were nailed onto the fellers to hold the wheel together. The wheel was put on and my father had a smile from ear to ear. He then made a pair of lades and the wagon was ready for use.

The first job it was used for was to carry corn from the Nydon to Dryclose Rick Barton. The wheel was fine and the wagon was kept in use until father bought a tractor, a BR John Deere, and a redundant pneumatic tyred brewer's dray. The blacksmith made a draw bar for it, but father much preferred the horse and his old wagon.

If the hay wasn't going to be swept in, it was made into cocks, or pooks. This is when the hay is put into flat piles and then piled one on top of the other using a short-handled fork. If this was done in the right way, the hay wouldn't get wet. It would be left in the field until the weather was right, turning them upside down to air out the bottom, before being hauled back to the farmyard with a horse, or horses, and wagon, the hay being pitched up on to the wagon again with pitchforks. When the wagon was fully loaded, the man on top would either get down over the front loader onto the horse's back, or someone would throw a rope over the load and he would come down that way, hand-over-hand on the rope.

When all the hay was in the ricks, they would be left to pitch or settle for a couple of weeks or so. Then each rick would be pulled into shape and have the bottom cut around with a hay knife. This hay would then be pitched up onto the rick to make the roof ready for thatching, allowed to settle for about a fortnight, and then thatched with reed, combed by hand from wheat straw straight from the straw trusses behind the threshing machine, or shoulder cut from a ditch on the moor. The willow spars used were the ones made during the winter evenings. Thatching the rick was done by laying a short ladder on the roof of the rick, which was stopped from slipping using iron rods made by the blacksmith especially for the job. Some more of these iron rods, about 4ft long, were stuck into the hay to hold the materials that were being used. Another ladder was placed on the ground to get to the short ladders. A layer of straw, reed or shoulder about 2ins thick was placed at the bottom of the roof of the rick, with the butts downwards, keeping it in place with lots of spars until the bond was put on them. Whatever material was being used was placed in overlapping layers the opposite way up, butts up. The bonds to finally keep it all together were usually made of the same material, being twisted up like a rope. The spars that kept it all in place had to be put in at a level or upward angle so the water would not run down the spar into the hay.

The skill in thatching was more to keep the wet out than to make the job look pretty, but when the wet was kept out and the thatch looked good, that was skilful. Thatching was

always a talking point between the men and many of the women, as some thatchers could make the job look very pretty, but could not keep out the wet.

After the thatching had been completed the rick was fenced in with elm posts and barbed wire. When the holes were being dug for the posts in most places in Catcott you had to have a small saucepan or tin to dip the water out of the holes; today you could scarcely find water anywhere in the village, as the water table has been destroyed with all the mechanical digging that has been carried out with buildings, sewers, mains water and piping the water along the sides of the roads. All the agricultural land has been drained. All the land has been made level, and consequently there is no water table any more.

When it was hot and dry, and the horses were working hard, it was idyllic. There was always that special sound of the creaking harness, the crunching of the chains and all the commands for the horses. The sweat and breath of the horses could be smelt from a 100 yards – and the men that worked them were nearly as bad. It wasn't always like that. Sometimes the hay would have to be dried two or three times, shaking it out by hand to get it dry. Sometimes it would rain again, ricks quickly having to be sheeted down. Loads and part-loads also had to be sheeted. Hay that was raked up with the horse rake, now very wet and heavy, had to be spread all over the field again. When the soil was wet, the sun would draw the dampness up into the hay. The more work you had to put into making hay because of wet weather, the worse the quality of the hay would be. If the hay had been dry several times and then got wet again, there was a temptation to put it into a rick: however, if you did before it was dry, it would either go fusty or the whole rick would catch on fire. There were special long iron rods that were used to test how hot the rick was. A rod would be pushed into the centre of the rick about 4ft high. It would be left there overnight, then pulled out and spat on. If the spittle stayed on the rod it was ok, but if it shot straight off it was close to catching on fire and a hole had to be cut in the centre down from the top. This was a very difficult, hot job and no one volunteered

The old chaps had a saying, 'Make hay while the sun shines, make love when it's wet.' You would often hear this on the rainy days, with a lot of other jokes as well, but I suppose being light-hearted is what kept them going – along with the cider, most of the men could drink plenty of that. But seldom were they in a state where they couldn't work. However, sometimes they would tap a barrel of really potent stuff, and this would cause a problem. Men would go home very inebriated and their wives would be upset, but it would all soon sort itself out.

As soon as the cars were bought cheaply by the farmers and were cut down, some were used for cutting grass, the car having all the bodywork taken off, leaving the engine, chassis and front wheels. The back wheels were taken off and replaced with cogs to drive large cogs driven by flat chains that were fitted to the mowing-machine's wheels. The mowing machine was slung beneath the middle of the chassis and bolted firmly together. This contraption was known as the motor mower, and was revolutionary. There was no more hard work pulling the machine backwards when the grass caught up, or when turning on the corners as there was a reverse gear. In most cases it would be an old type gate-change gear box. A chap that had one of these motor mowers was Denis Bartlett. He did a lot of contract grass cutting, taking the strain out for the old men using horses for grass cutting. He also had a pack of playing cards that he was very proud of. At that moment in time these playing cards were illegal, because on the back of them were pictures of scantily-dressed girls. These pictures of the girls were no more than looking at today's women's underwear section of, say, a Littlewoods catalogue.

Cider in the hay after a hard day's work.

In 1942 tractors really started to come on the scene, and things quickly started to change. No more having to catch and harness the horse and prepare a nose bag: just fill the fuel tank on the tractor with TVO, and petrol in a small tank to start it, check the oil and water and you were away. However, this had a big downfall, as not only did you have to buy a tractor but all the machines to go with it. The bed of the horse machine was shorter than the tractor machine. For instance, you couldn't cut the grass with a horse machine and turn it with a tractor machine, or vice versa, as either way only half of the swathe would get turned over. This very soon made all the horse-drawn machines obsolete, and even the magic motor mower with its narrow bed was now obsolete as there were mounted tractor machines as well as the trailer type, both with wide cuts.

The wagons that had been drawn by horses were now drawn by tractors with the aid of a new invention: the iron horse or donkey. This was an iron contraption to chain into the shafts of the wagon the same way as the shafts were chained to the horse. The first iron horse or donkey, as they were called, were difficult to chain into the wagon shafts as there was practically no adjustment and all the shafts were different. The first time I saw one of these contraptions was at Harold Venn's. Harold was trying desperately to get the chains adjusted right. Several of us were looking on as Harold was trying to tighten a nut with a pair of stilsons as spanners (tools were hard to come by then). The stilsons slipped off the nut, Harold flew into a rage and shouted, 'Bl—— F—— donkeys!', and threw the stilsons as hard as he could across the yard. Uncle Edmond, as if nothing had happened, his hands on his knees, looked at Harold and said, 'What's the matter, governor, have you got a little job to do over there?' This caused roars of laughter to all except Harold. After a few more choice words and expletives, Harold calmed down and between us we got the donkey fixed. Some things stick in your mind forever, and this memory is one of them.

CHAPTER SIX

CUTTING PIGLETS

Cutting piglets was actually castrating them. Now this was a job that had to be done properly as, if it wasn't, the piglets would often die of infection, especially if the weather was hot.

The pigs were usually kept in some old shack, nailed up out of a few elm rails cut out of the hedge and some old pieces of galvanized iron, or in some old stone and tiled open shed, both with plenty of straw to lie on and under. Pigs may like lying in the mire, and love mud, but are actually very clean animals, never ever making a mess in their bed.

You had to hold the piglet, holding its back legs apart, with its back towards you, holding its head tightly between your knees. Holding the piglet was often done by a land girl, but some couldn't do this job as it used to upset them in many different ways.

Where the big, strong land girl Barbara couldn't do the job at all, the cracking little girl Sally would always jump at the chance and actually finished up cutting the piglets herself – but then she didn't mind what she did, she would have a go at anything, usually very successfully.

The piglets were cut when they were between two to three weeks old. During the lunch or dinner break before the piglets were to be cut, the pocket knife would be honed to perfection. It would shave the hairs off of your arms or even shave off your beard. Honing the knife was one job that Sally couldn't do, no matter how she tried: she could never get the edge needed for the job. With her being small, she had to stand on a bag of pig nuts so the man with the knife could see what he was doing. Once she got hold of the piglet, it was like it was in a vice.

The testicles – or stones, as they were called – were squeezed down as low as possible, then a small incision was made and the stone would pop through the hole, all the slack on the cord would be taken up by gently pulling and then the stone was cut off. You had to make two incisions, as it could not be done with one. The incisions were made as low as possible so any pus could drain out. This was all done with no anaesthetic. The knife was sterilized by drawing it through spittle on the lips and it was so sharp the piglets at the time seemed to take very little notice of it. It was only later, when the piglets were a bit hunched up with tails out straight, that you knew they were feeling it, but if the job was done properly, in a couple of days you would never know that anything had been done to them.

Probably a couple of litters would be cut at the same time. Sometimes it would be nearly all boar pigs, and sometimes nearly all sows: sometimes half and half. I think this was nature's way of keeping the population right as it seemed to be general, everyone being the same.

Some years saddle-back gilts were very difficult to get hold of. The pigs I grew up with were usually saddle-back sows covered by a large white boar, finishing up mostly with white piglets with blue spots on them. These piglets were very hardy and seemed to be less affected by worms.

The piglets were fed twice a day, making sure that they ate all the food they were given quickly. This was for two reasons: not to feed the rats, and to stop the piglets from overeating, because if they overate they often got inflamed stomachs and died. This is known today as guttadema. Piglets either have to grow up with food available all the time or they have to be fed a set amount, just enough for the stomach to handle.

The animal always on the winning side when the little piglets were being cut was the dog, looking on with pricked up ears waiting for the little hot morsels. The piglets were cut for a reason: to stop the ham and bacon from being strong in taste when cured. Very often today, with piglets not being cut, the bacon and ham is very strong in taste and smells like urine; it will only keep for a short time.

CHAPTER SEVEN

PICKING UP APPLES AND MAKING CIDER

Picking up apples was a job where, if you wanted to, you could learn an awful lot about wild birds. It was out in the quiet, with sometimes the odd cock pheasant strutting around looking for the apple pips. Pheasants are very partial to these. You could hear a cock pheasant when it started its day, and again when it went to roost in the evening, but it wouldn't be around very long, as someone would have it for the pot. There were blackbirds, thrushes, starlings, rooks, crows, jackdaws, magpies, pigeons, sparrow and kestrel hawks, partridges, finches, woodpeckers (green and lesser spotted), tits of all kinds, robins, wrens and jays. All these birds were common, and all had their own distinct ways and habits, and nearly all the birds ate different varieties of foods. You learnt about how all the different species of birds fought with one another over food and territory. You could see all of these things going on around you, as all these birds were very common, but to hear, or see, a buzzard on the Poldens was then very rare.

The first lot of apples to be shaken down and picked up for cider were the Morgan Sweets. These were used on their own, as the cider made from them would not keep for very long, and was very pale in colour. It was often used in the jars, mixed half and half to sweeten up the old cider. While picking up the Morgan Sweets many people got their fingers stung, as the wasps would burrow holes in the apples. There could be four or five wasps inside each – all a bit stupid after consuming so much apple juice. They wouldn't fly out: they just stuck their stinger through the hole.

My uncle, who had lost his wife in childbirth, lived at home with my grandfather and grandmother. Even though they made between three and five butts of cider every year – and drank most of it, because neither of them went to pubs – all thought that they were teetotal, and if they were asked if they drank, they would say, 'Well, I might have a light ale if I go to market.'

The second cheese (the pomace and straw ready for pressing) would be made from an apple called Crimson Kings, a fairly large apple. These made excellent cider, very dark in colour. During the war, they sold the best of these to a man in Bristol who had a shop and sold them as dessert apples. Remember, there were no foreign apples in those days. They also sold him Morgan Sweets, but the slightest bruise on these would turn a dark brown almost immediately.

The apples for cider were picked up either in buckets or in a woolly basket, then put into bags or tipped into a heap. Sometimes for the late apples a high-sided wagon would

be left in the middle of the orchard and the apples would be tipped straight into it. Most of the best cider apples were good keepers: Soldiers, Kingston Blacks, Hermans, Hangdowns, Sugar Sweets and a few other varieties would keep until well after Christmas and would not be made into cider until then.

Shaking the apples off the trees was an art that had to be learnt. You couldn't just get up into a strong tree and shake the apples down if they were what was known as 'hanging on'. There was usually one person who was better than the rest at shaking the tree, so whoever this happened to be was given the job. Sometimes all the apples in the orchard were shaken down at the same time. The few that wouldn't shake off were beaten off with a long thin pole. When they were all down, they would be picked up by women and children. Payment for picking up the apples was not made in these instances until after the apples had been emptied out of the bags again, as there was a rule that the apples had to be free from any grass. There could be chicken, sheep or cow droppings, but definitely no grass. All the equipment for making the cider had to be clean and dry, with nothing other than cider on it.

Before you actually thought about starting to make the cider cheese, you had to be sure you had enough long, clean, sweet-smelling wheat or oat straw, absolutely no foust.

The cider was made at either Shapwick or Chilton Polden, as there was no cider-making equipment in our village until farmer Arthur Vowles, who also had the village shop in part of his house, bought three cottages for £130. Two were derelict and one was occupied by an old man living on his own, who the kids knew as 'Grampy Tratt'. The two derelict ones were knocked about a bit and a mill and press were put in one. The other was used to keep the cider, absolutely chock-a-block with barrels, from about eighteen gallons upwards. These two cottages were situated right in the centre of the village, and from this time on most of the people in the village made their cider here. However, this only lasted a couple of years, as Arthur decided to sell Buckfurlong Farm, where he lived with his family, and bought a much larger farm, Throop Farm, Wilkinthroop, Horsington, Templecomb. Before they moved he renovated the two cottages, turning one into living accommodation, and the other into the village shop and store, and it's still the same today. He sold the farm house and split up the land and sold that off, as well as the shop. By this time Grampy Tratt had had a stroke and died, and his cottage was sold as well.

Always after this, the cider was made at Shapwick at Cliff Jenning's farm, part of the Lord Vesty estate. This became a real education, as there were so many dry characters whose lives revolved around drinking cider. Every day was like a pantomime as they told jokes and stories about the past. Banger Williams, the postman, came in for a drink a couple of times during delivering his round in the morning. Once he'd finished he would stay for a couple of hours. Wapsy Bill Durston (no relation), built like a barrel, was the butcher; he couldn't pass without coming in. Farmers Frank Lockyer and Joe Tully came to put the world to rights. Farm manager Allen Duke called in two or three times a day, always looking for someone or something. I think they were all looking for company as much as cider. Cliff must have made four butts of cider every year for people just calling in for a few glasses – well, actually mugs – during the day time, but he was a man with a very happy disposition and whatever happened would always think of a way to laugh about it.

To make the cider, the apples were put into the large hopper on the mill, a machine with two large and heavy stone rollers that turned inwards towards one another, squashing the apples without squeezing out any juice, and leaving them so that they would hold together when the cheese was being pressed. It was turned by hand and geared down so

that the rollers turned very slowly. It had a large heavy wheel with a handle, which acted like a flywheel when the machine was being turned by either one or two men. The apples were let out of the hoppers onto the rollers, at whatever pace, by way of a wooden slide in the shute. Then, when they were rolled into pomace, they fell into a large, oblong, elm wooden box. When there was enough pomace in the box – after some of the long straw had been placed in a layer about 1ins thick in alternate ways across the bed of the press, leaving at least 2ft out over the edge of the bed – the pomace was transferred to the press once a former – a square 3ft each way, 6ins high – had been placed on the corner of the bed. The pomace was pressed firmly into this by a man using his hands. The same was done on all four corners, leaving the pomace firm and square. Then the straw hanging out over the side was pulled up and over towards the middle, acting like a bandage and holding the cheese together, leaving about 8ins all around the outside of the cheese for the cider to run away when the cheese was being pressed. Then another layer of straw was laid in alternate ways the same as before. The former was then put into place again and the pomace was pressed firmly into it as before. Then the straw was pulled to the centre again as before. The same treatment was carried out eight or nine times, each layer being made about 6ins smaller each way across than the previous one. When the cheese had finished being made, a layer of straw was then put on the top before the pressing board was lifted into place. Then the screws of the press would be turned down by hand until the pressing board was firmly in place.

The press consisted of a very large piece of wood, usually elm 2ft square and about 10ft long, with two large vertical bolts, each about 4ins thick, and 7ft 6ins long, with a very heavy thread through it, about 7ft 6ins apart. The bed of the press was laid between the bolts. It was 7ft square and 2ft thick, with 6ft high upstanding sides, with a spout to let the cider run out into a large oblong elm tub 7ft by 2ft by 18ins high. A heavy pressing board, 3ft thick, with heavy cleats, was put on the top of the cheese. Another piece of wood 18ft x 14ins x 10ft long, with the vertical bolts running through this coupling up to a nut fitted to a wheel 2ft across, with metal upstands at quarter intervals, was fixed to the large piece of elm, taking it up or down whichever way you turned the wheel. To really press the cheese, a strong wooden pole, usually of ash or hazel and about 10ft long was placed between the upstands on the wheel and turned clockwise by one, two or three men using all their force. Doing this on alternate sides would put the cheese (pomace) under immense pressure.

When the cheese was pressed it would run about ninety gallons, give or take a few. Then the nuts would be slackened off and taken up to the top of the bolts. The pressing board would be taken off and the cheese would then be what was called sheared. This was shearing 6ins off the four outside sides, sloping it gently outwards towards the bottom. This was done with a hay knife. The shearings were broken up and made into three or four layers using the straw and the former as before. Some more straw was placed on the top, the pressing board was lifted back on again, and was then pressed once again; it would probably run another twenty-five gallons. This process would be carried out one more time, taking off about 4ins, and would run something like ten gallons. By this time the cheese would be under such pressure that the apple pips would shoot 2ft to 3ft from the cheese, and the pomace now was very dry. By this time the cider would all have been put into barrels in the putt, and taken home with the horse. Once home, the cider was transferred to a butt barrel by way of wooden buckets and a wooden funnel called a tunditch. A butt barrel holds 120 gallons, and when the barrel was full and running over, the cider was left to ferment. It had to be kept full all the time as the cider would evaporate

very quickly while fermenting. The barrel would be kept running over using some of the same cider kept in a small barrel. This is the stage when the kids loved the cider, as it was sweet with a bite and just like it was carbonated, and was an excellent laxative. When the cider had finished working (fermenting), it would be corked down and left to mature. This could take anything from one month to one year.

When the cider was being pressed it ran out through the straw as clear as crystal, and we all got around the trough with straws drinking it. To stop us doing this, Archie Norris would fill a bottle with the new cider, put it inside his trousers, then undo his flies and make it look as if he was urinating in the cider. At first we thought it was real until, after a while, someone saw the bottle he used with a small rubber tube on it. Then we were all back drinking again, but if you drank too much you would have terrible stomach ache – and more!

Different people added different things to their cider to give it body and flavour. Archie Norris added a couple of pounds of yeast to his. George Bryant, the baker, always made his cider at Christmas time and added molasses, yeast and all the blood out of about thirty cockerels when he killed them at Christmas.

Some added the juice of crushed sloes, but before the war many people added two to three pounds of raisins. Much of it was drunk around the fire at night, with the old people telling tales and stories of how life was when they were young, drinking it hot with ginger or added wines like elderflower, elderberry, dandelion and so on.

To all the people new to this beverage it was very potent stuff, but most old people could drink it like drinking milk. Occasionally, someone would get the worse for wear.

One day, a woman who was having some building work carried out asked one of the workman, Jim Brewer, if he would like a cup of tea. He replied, 'No thank you, marm, I drink nothing else but cider.' 'Even first thing in the morning?' she said, surprised. 'Never anything but cider,' he gravely informed her. She thought about this. 'If you never drink anything but cider, whatever must your insides be like?' He replied, 'I don't know, marm, but I'll bet you it's a lot cleaner than the inside of your teapot.'

Another time an old workman said to his boss, 'The cider idn't very good, in fact tidn't worth drinking, and remember, this is part of my wages'. So, in the end, he negotiated long and hard to make the deal better for himself. The deal was that he would be given twice the normal rations.

Lots of time was spent in the cider house, where all the tales of the past were told (not forgetting a few jokes). All and sundry visited, and helped themselves to a mug of cider, drinking out of mugs that were never washed out, just the thumb and finger run around the rim. The mugs were kept turned upside down on top of the barrel. All around the top would be a swarm of little fruit flies, a lot of which got into the cider as it was being drawn.

I remember going to my Uncle Bill and Aunty Florie Coombs', and going into the cider house. Edgar Elson was sitting on a bag of apples; he was an old chap that always made the cheeses. He said, 'Going to try one, Syd? I'll get 'ee a clean mug.' He drew a drop of cider in a mug, swilled it around with his index and middle finger, swooshed it around again then threw it away; then he proceeded to wipe the mug out with the bottom of his old and dirty milking smock. 'Now 'ee be nice and clean,' he said, and drew some more cider and handed it to me. It was full of those little fruit flies, and I started to get them out with my finger. He said, 'They wont hurt 'ee, they will do 'ee good, they be what birds and spiders live off o. Gid on drink it down, that will make yer air curl.'

CHAPTER EIGHT

FRANK AND DORRET NORRIS AT THE CROWN INN

Frank and Dorret lived at The Crown Inn, at Moor Lane, Catcott. It was a cider house, but a cider house with a difference. It was a place where many intellectuals frequented (unusual because the place was so old-fashioned, even in those days). An old box settle was a room divider. None of the settles or wooden chairs had cushions, just hard wooden seats. The floors were flagstones running into an open, flat hearth inglenook fireplace. This was always kept burning with peat (or 'turves', as they were known). Hanging over the fire on an enormous brand iron was a large, cast-iron crock. This was for the customers who looked after it, replenishing it with swedes, turnips, carrots, onions, and dressed pigeons, starlings, rabbits and cider. This crock was never washed out, just boiled every day. The customers brought their own hunk of bread and helped themselves from the crock. Food poisoning – never!

Frank was practically blind with cataracts. He knew what money he had been given by the feel of it, and the change just the same. He never looked at it. He decided when the mug was full by putting his thumb on the rim, and feeling when the cider reached it.

There was no skittle alley or darts, just a shove-halfpenny board, and some brilliant players. The old squeeze box and harmonica were very often played, with most joining in to sing the old ditties. There was another brother, Walter. He lived with his wife at Little Leese small holding about 300 yards from the pub. During the daytime Frank and Walter cut peat (turves) at a two-acre turf pit that Frank owned at Westhay Road, Burtle. Cutting or digging the peat, bearing back, splitting, hyling and ruckling, doing everything, all on their own, to cut and dry the peat blocks. Frank usually drove his old Model T Ford to work, at about ten miles an hour. Or if the lorry wouldn't start, they drove Walter's pony and cart at about the same speed. All the peat was brought back to the pub either by lorry or pony and cart, and stacked in a large rick.

Frank had a very large gut, but Walter and their sister Dorret were like bean poles. Frank somehow always wore trousers that would nowhere near meet around his waist. The top three buttons were always undone, or gone, leaving a gap of about 6ins. The legs of his trousers never met his boots by about the same distance. His longjohn underpants were always showing around his waist. All this was kept up by a pair of old threadbare braces, and his boots were falling to pieces. Walter, on the other hand, stood quite upright, well over 6ft tall, and always seemed to dress more tidily, usually wearing brown in the summer and black in winter. It had to be very hot for either of them to be without a waistcoat.

Dorret dressed in very heavy clothes that dragged the ground, with shawls thrown around her shoulders. Her hair always stayed dark. She wore it strained back in a bun underneath a white bonnet.

Sometimes, when the old lorry wouldn't start, Frank would threaten it with the starting handle, and Walter would say, 'Let's catch the pony, Frank'. Walter had nothing to do with the pub other than sit and drink cider, trying to listen to an old radio that was more crackle than sound.

I don't ever remember seeing Dorret anywhere else in the village other than in, or beside, the pub: she spoke to everyone and didn't seem shy, but she never mixed in the village. She washed the mugs and dishes, scrubbed the floors and ran the pub during the daytime, and always looked after Frank.

Just before the end of the war, Walter's wife died. He then moved to The Crown to live with Frank and Dorret, and sold his little lease smallholding. They all lived in the pub for about eight years before Walter died. Not long after, Dorret died, leaving Frank on his own. He carried on running the pub for another three years or so with the help of some of his intellectual customers. Then, one day, he was found dead in bed. The place was then very quickly sold by auction, with all the settles, chairs, jars, jugs, mugs, all of the furniture that was in the living area of the pub. The Model T Ford, and the scrap one they kept for spares, went next, followed by all the tools and implements, and finally the pub.

The will said that the executors must burn all the old bills, cheque stubs and letters that had accumulated over the period that Frank had been at the pub. This they thought they had done, but when I walked to where the fire had been I found several cheque book stubs dated 1937-39. These showed that Frank was paying a Mr Keen £14 a fortnight for cider at 6d a gallon. This meant that he was buying 560 gallons for £14: these figures show that he sold roughly 280 gallons a week. I also found in the fire an old unopened envelope with the corner burnt off. This turned out to be 10 John Bradbury £1 notes with all the paperwork. It was the gratuity money Walter was paid for his services in the First World War. I just wonder how much, or what, was in the clearing-out process. All the mattresses were burnt, and Frank always said you couldn't trust the banks. So it gives a lot of room for thought...

This brought an end to a way of life that, unless you were there, it would be impossible to imagine: a time when farm workers, road men, peat diggers and the like, and all kinds of professional men, were on the same wavelength with their jokes, dancing, songs, tales and laughter, and drinking lots of cider, but as soon as they were outside of this environment it was all very different again. All but a few of the professionals feeling very superior, though none was superior to Frank: he could seem to argue any point any way, in his own way, which was always very humorous.

When Frank was present at the Parish Council meetings, when something important was being discussed, all Frank's supporters would be there, and it would often turn into a comedy.

Then usually there would be another meeting back at The Crown where anything and everything that had been discussed at the meeting was put to rights and kept well in hand for the next meeting.

CHAPTER NINE

CUTTING AND STITCHING CORN

When the corn was ripe and ready to be cut, about 5ft in width was cut by hand, using a mowing scythe, all around the outside of the field; large round corners were also cut. This was called 'cutting round'. When this corn was cut, it was then bundled up and tied with about ten or a dozen strands of the corn, taking them by the ears and passing them underneath the bundle (then taking them in the other hand, holding the straw end, and twisting it around the ears and folding this end underneath the straw band). After a short time you could do this like a machine. This was if the person that had used the scythe was a tidy worker. My father and my Uncle Edmund were both in this category, but my mother's brother, Uncle Ivor, was the complete opposite. It took him half as long to cut round as either father or Uncle Edmund, but it took twice as long to bundle and tie behind him, because he never let the scythe make the whole sweep; instead of cutting some of the corn he just bent it over, but then he never gave himself time to do anything. Uncle Edmond, on the other hand, always had time to stop for a laugh, chat and a joke. The corn was cut around so that the horses could walk around the field pulling the binder without trampling on any of the corn, and also so the horses couldn't eat any, as eating the corn while working gave the horses colic, and would often stop them from working for several days.

Moving the binder from one field to another with horses was quite a job, as it had to be packed up to be pulled along the road and through the gateways, fixing the pulling pole underneath the bed of the machine, and fixing an iron travelling wheel on either side. When it got to the next field it had to be unpacked, turned around the other way (with the pulling pole fixed in front of the large drive wheel) and pulled the opposite way as it was pulled on the road. Packing up and unpacking the machine each took a half to three quarters of an hour for three men, and someone had to hold the horses whilst this was going on. When everything was ready the horses were hitched in, and the string box filled with two balls of binder twine. It was then ready to start. The binder cut the corn with the same principal as the mowing machine with a reciprocating blade, with wooden sails that turned on a central shaft, pushing the corn back onto the 5ft wide canvas with wooden cleats across it. This turned and took the corn to the inside end of the bed, where a pair of 5ft wide canvases with wooden cleats across them turning inwards towards one another. These took the corn to the top of the machine, where it dropped down onto a series of packers. This made the bundles, and a pressure spring decided when the bundle was large enough to be tied; when this pressure spring was tripped, it set the tying process in motion. The curved needle

threaded with string went round the bundle and through the knotter that tied the knot and cut the string; then the needle went back to its resting place and the bundle was flicked out onto the ground. Everything was a mechanical process, all working like clockwork and driven by a series of flat chains and cogs spun by the large land-drive wheel.

Three horses pulled the binder. A man rode on a seat on the back, and drove the two horses on the pole with reins. A boy usually rode the horse in the traces in the front. The corn could be cut at whatever height by using a lever that put the bed up and down. Another lever was used to tie the bundles, however high or low. This was done by the knotter mechanism being moved back and forward along the machine, and another lever moved the sails up and down.

Unlike the mowing machine, the binder was kept going forward on the corners, leaving a long pointed bit on each corner; this was cut the next time round. A boy usually walked behind the binder to carefully pull any docks that had grown in the corn about the width of the cut the next time around (making sure not to shake out any of the seed and trying to keep the field dock free, a very hard thing to do). There were no sprays then, just good farming practise.

There was usually plenty of help in the cornfield, as this was a time when the rabbits would be shot as they ran out of the corn. Anyone who had a gun, cartridges and the time would be there, and after the corn was cut and the rabbits shot, they would help to make the sheaves into stitches, six, eight or ten sheaves in a stitch. This was always done the same day as the corn was cut, often still working by the light of the moon, and was called stitching. One person missing from the stitching would be the boy that had been riding the front horse, as it would take him a couple of hours to realise that he had legs again once he had got off the horse. After the stitching was done, the men would all go back to the farmhouse, have some supper, and plenty of cider, and tell a few yarns.

The horse-drawn binder for cutting the corn was the only horse-powered machine that had a life after the tractor appeared, as to cut off the pole and fix a linkage to hitch it to the tractor was all that was needed. These machines that were new at the end of the First World War were still in good working order, and still being used annually, at the end of the second. The new machines of 1945 were not very different from the old ones, other than the cut was much wider and the mechanism had changed from being driven by a land drive wheel to being driven by a power shaft from the back of the tractor. The principal was exactly the same, but the power shaft was very dangerous and caused some terrible accidents, as a loose hanging garment, belt or piece of string would catch and wrap around the power shaft – effectively a high speed winch pulling whatever with it. This is when guards became normal practice.

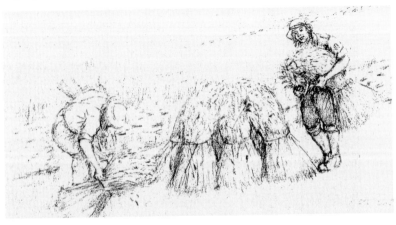

Land girls
stitching corn.

46

When a field of corn was cut and all stitched up in immaculate rows, and you looked at it the next day, it was obvious there had been artists at work, though not working with canvas or paper but with what they had at hand. I suppose they never had the chance, or time. They probably thought this way of doing this job would last forever. What a pity it hasn't! For today's artists, bales of straw left in the field after they have been combined just don't seem to look the same. Each stitch was different then, but now there's no bys or furrows and every bale looks the same, all the same distance apart.

Very often, when the corn was being stitched, you would find rabbits that had been hit hard but had not been killed, and who had got underneath some of the sheaves. They would get in there and it was impossible to find them without a dog until the corn was stitched up – and the last thing you wanted when you were shooting was dogs running after the rabbits. When they were found, they were held by the back legs and given a clump behind the ears with the side of the open hand. This would kill them instantly. A rabbit was killed this way, or by turning the head backwards and pushing whilst holding it by the back legs. This pulled its neck out. Both ways were very quick.

Barley, I think, was the worst of the corn to handle, as it had things on it like thin saw blades called hyles. They were hard on your hands and seemed to get everywhere: inside your shirt and trousers. It must have been very uncomfortable for the land girls, as they often had to get lost and sort themselves out.

Horse beans were unlike corn: they had to be harvested and threshed but, unlike the corn, the beans were usually pulled by hand as the pods on the beans then went right to the ground. Often this job was done by boys, pulling them into bundles and tying them with tacker weed, a long spreading weed that always grew in the bean crop. The beans were pulled and carted when it was damp (so the pods would stay closed and the beans would not fall out, and also because the bean stalks weren't so hard on your hands).

The bundles of beans were put into a mow like the corn, but were usually threshed very quickly as they were very high in protein and the rats would play havoc with them, and carry them off to store in some other place. At times, whilst ferreting and digging out rats from around the hen house, you could come across a large pile of beans that had been carried at least 50 yards by them. The waste from threshed beans was called hulum and was very good for bedding: it was much harder than straw and was long lasting. The beans themselves were ground into a meal, a coarse powder. When this was fed to cattle, even in very cold weather, the steam would rise off them just like fog; it was also very fattening.

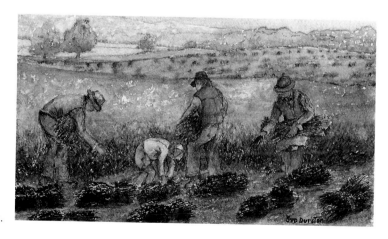

Pulling beans.

CHAPTER TEN

MANGOLDS AND KALE

After I left school I started work for my uncle, Percy Bartlett. I was just fourteen. The first time I was sent hoeing mangolds my uncle said that Bill Pole will be there hoeing – and not to go to where he is hoeing, as he is on piece work. Go to a different part of the field instead, he cautioned.

I hadn't been there very long when all of a sudden, out of the corner of my eye, I saw him stop hoeing, rest the handle of his hoe against his shoulder, drop his trousers and relieve himself, produce a piece of newspaper from his pocket, wipe himself, pull up his trousers and (nearly all in the same movement) with his hoe pull some dirt over what he had done and start hoeing again! When we were going milking that evening I told my uncle what had happened and he said, 'Well that's old Bill, he wouldn't take the time to walk to the hedge.'

Mangolds, when they are mature, are like very large, long or round orange (or light red) beetroot; they were grown for winter feed for cattle and sheep, or sometimes fed to sows in the spring as a filler substitute. It was a crop that needed a really good, fine, fertile seedbed, as they had to be hoed by hand from the start (or at least as soon as they could be seen showing in the row). Hoeing was very difficult if the soil wasn't fine. The seed looked just like beetroot seed and was sown with a drill early in April so that it would germinate quickly, and would be up and away, hoed and all thinned out before the haymaking started.

You had to keep a lookout all the time for leather jackets, the daddy-long-leg grubs. One sign that these were present would appear when you walked away from the field: the rooks, crows and jackdaws, and the odd magpie, would swarm in, and you would also see a mangold dying off here and there. Often when you were hoeing or thinning you would hear the constant call of the cuckoos, though sadly they are rarely heard now.

The plants, having all been hoed through by hand, were then singled out to about 9 to 12ins apart. They were then hoed through again, and given a light dressing of sulphate of ammonia. It was at this point you could see how much damage the leather jackets had done, as they would bite the plants off just underneath the soil

If there was a very bad infestation it could be treated very much like slugs are today. First, you obtained some Paris Green from the chemist (for which you had to sign the poisons book before you took possession, as it was pretty deadly stuff). It was a green powder and was mixed thoroughly with ordinary bran, to a ratio of 2lbs of Paris Green to 1cwt of bran. It was then broadcast by hand very thinly over the affected crop: this was enough to treat about three acres. The problem with this was that the dead grubs would fall to the ground and were then eaten by the birds, rooks, crows and jackdaws, and in time many of these birds died too.

The plants were hoed through with a horse hoe. Then, after the haymaking was finished, they would be given a top dressing of 1½ cwt per acre of sulphate of ammonia and then horse-hoed through again. They were then left until November, when they would be mature and fit to harvest. If harvested before November, however, the mangolds would shrivel up and get very soft.

Harvesting the mangolds was done by pulling the mangolds by hand and wringing the leaves off, putting the mangolds in a tidy heap, covering them up with the leaves to protect them from the night frost. Sometimes you couldn't start pulling until noon as the frost was still around, and if you pulled them with frost still on them the mangolds would rot. Pulling the mangolds was very hard on the hands: the lime from the soil, the sandpaper roughness of the crown of the mangold, the biting winds and frost, and the chaps that these things cause were very painful. Chaps are when the hands get very dry and the creases on the hands split, especially between the thumb and forefinger and where the fingers join the palms of the hands. Sometimes these splits would be 1ins long and an eighth of an inch deep. They were treated with a mixture of olive oil and sugar.

If you went to the mangold field just as the light was fading in the evening, and sat down quietly beside the gate when the mangolds were mature, you would see the owls, probably two or three, flying very slowly and silently up and down the field. Then one would seem as if it had dropped out of the sky, and after a few seconds it would fly off to its favourite perch. At this time you knew the owl had got itself a meal (usually a short-tailed vole, as these were the main diet of the owls at this time of the year. The owls ate these little creatures whole).

Very often, when you were opening a gate or getting over a stile, you would see the owl pellets, the skin and bones of the kill regurgitated in tidy little bundles, on the top of the posts.

The mangolds in the small heaps were soon invaded by these short-tailed voles. They were only small, about 4 or 5ins long, but so destructive: they had teeth like beavers, and gnawed the mangolds to pulp. Sometimes there would be three or four in a heap.

After the mangolds were pulled, they were then loaded by hand on to a put (a heavy tipping cart) that was pulled by a horse back to the farmyard where they would be tipped in a large clamp. When all the mangolds were in the clamp and packed tidily, they were covered up with straw, old hay, shaulders and hedge trimmings to protect them from the winter frosts. This was a new home for the rats and they soon moved in; shelter and food all in one.

Before the mangolds were fed to the cattle during the winter time, they were scraped clean of dirt, and then pulped into small pieces like large chips with a machine called a root pulper. This consisted of a large, cone-like hopper that held the mangolds, a large circular disc with cutting blades running from the outside to the centre. This disc was fixed to a shaft running through its centre with a cranked handle that was turned by hand. It all stood on four legs and the pulped mangold came out at the bottom.

Once the mangolds were pulped they were put in front of the cows in the stall in the crib. They were carried in a woolly basket, a large round basket with two handles all made out of willow.

In later years they were fed to the cattle whole, leaving the cows to do the scraping and pulping with their own teeth.

When farmers stopped growing mangolds, preferring silage instead because silage was so much less labour intensive, and when the corn mows disappeared with the arrival of

49

the 'combine harvester', the owls noticeably started to disappear. There were several things that happened at about the same time, and any one or all of these could be the reason for the owls' decline. When the mangolds disappeared, so to the constant supply of food the voles provided for the young owls.

At the same time, hydraulics and chain saws appeared in abundance and many of the old hollow pollard trees were cut down (for no other reason than that they now easily could be). These old trees were the nesting places of the barn and tawny owls.

With the hydraulics, many of the banks were pushed level, scrub land was cleared and everywhere was made tidy. This destroyed yet more habitats, many of which had once harboured the wild life that was in turn food for the owls. At this time there was a population explosion amongst the grey squirrels, and as they took the eggs and fledglings of small birds so did they also take the eggs and the young of the owls – just as they thought nothing of raiding the hen houses and taking the eggs there. An acquaintance of mine once caught thirty-seven grey squirrels in a single trap in just eleven days. This will give you some idea of the numbers of grey squirrels at that time.

Marrow stem kale was sown at the same time as the mangolds and also needed a fine seedbed. It was often difficult to get the crop away because if the weather was hot and thundery just as the seedlings were breaking through (or at any time until they were in rough leaf), the flea beetles (so called because they looked and jumped like fleas) would sting the plants so badly that the whole crop would die. These flea beetles were always in the soil but stayed dormant if the weather was cool.

When it was hot and thundery, and if the seedlings were breaking through, to try to save them four heavy hessian sacks were nailed to a 9ft long piece of batten with a rope at either end. The sacks were soaked with T.V.O. and dragged from the outside of the field around and around until you came to the centre. This was repeated over and over again, sometimes for a couple of days, and even after this the flea beetle would win and the crop would have to be sown again, hoping the weather would be kinder the next time the seedlings broke through. Today the seed is treated with a powder that stops the flea beetles stinging the seedlings. Once the seedlings were in the rough-leaf stage they would very quickly get away.

This marrow stem kale was a very heavy cropping crop and from the end of October was fed to the milking cows in the fields (as by this time the grass was becoming short). The kale was cut by hand with a hook, put into tidy heaps and loaded onto a put and carted to wherever the cows were to make the grass last longer. Before silage, kale was the only green crop other than grass that could withstand a hard frost. The cow cabbage, an enormous cabbage 12 to 24ins across, would rot with hard frosts. When the cows came into the stalls for the winter, the kale was fed to them in the cribs. All the woody ends left had to be cleaned out. When you grew kale you always knew when there was going to be a falling of snow as, for at least twenty-four hours before it fell, the wood pigeons would flock in their hundreds to feed from the young shoots at the head of the plants. When the kale was finished then it was time to start feeding the mangolds.

CHAPTER ELEVEN

RECREATION

Recreation, with no money, and little time, had to be made the best of. When away from home there was seldom anyone to oversee what we were doing, and with very little time to play we had to get on with one another. For us kids, things, other than clothes and shoes, came in and went out of fashion, just like they do today. The only difference was that the only way you could be in fashion – should you wish to be – was if you made whatever you wanted. There was nothing in the shops, and we had no money anyway.

When bows and arrows came into fashion we spent what little time we had searching the hedges for a dog-rose thorn, one that was the same diameter the whole length of it. We would always cut a few that looked good when they were growing, but looked very different once they were cut. Our aim was to have a better bow than anyone else. Once we had found and cut the right thorn, we would take it home, get some dry sticks, make and light a fire with a bucket of water and a rag beside it. Then we would hold the end of the green thorn in the flame, let it heat up a bit but not burn, then take the stick out of the fire and make it wet with the wet rag. We'd repeat the same again probably a dozen times or more. This was nearly the same as steaming and would make the thorn very pliable. We would then make the thorn whatever shape we needed, by driving pegs into the ground, holding and bending the thorn at the same time. Once in shape, we would leave the bent thorn to dry for three or four days: by then it would be set firmly into shape. We would then give it the same treatment the other end. The next thing was to find some strong thin string. This was nearly impossible, and we usually had to make do with binder twine. To make the twine stronger, we pulled it backwards and forwards on lumps of paraffin wax, or rubbed it with a warm candle before fixing it to the bent thorn to make the bow. The next thing was to find some straight thin privet for arrows, cut it to length and tie it in a straight bundle to dry. Once these were dry, we fitted short fine elder tips to the small ends, to make the arrows fly straight. These bows and arrows were very successful, and we had a lot of fun using them. We grew up knowing the damage they could do. Kids today would never be allowed to play around with the fire, or go out on their own to cut a thorn for a bow, and would never be allowed to play with bows and arrows as we did. What a pity this is! This is how we learnt first hand how to do things and the things not to do. We were all Robin Hoods.

When it was conker time, the bows and arrows were set aside and conkers became all the rage. We'd get to school early to have a few games in the playground before the lessons started. Even conkers is thought to be too dangerous to play in school today. How will these kids ever learn? Playing conkers didn't last very long as the conkers soon ran out.

Then it would probably be a whip and top, or climbing trees, with a bit of leapfrog in between, anything to try to outdo one another, making everything a race, a better standard or a competition. This is how we learnt our pecking order – though everyone was on top at some time or another. We never had a village idiot in our village – or at least not among the kids – so we all had to take it in turns.

When all the games had been tried and tired of, we would be back to the ropes in the trees around the old quarry, swinging from tree to tree. I can't remember anyone getting seriously hurt: one broken arm and a few bumps and bruises, a few scrapes on the rusty barbed wire. This was thought to be the most dangerous of all, as there was no cure for tetanus, and no preventative injections either. One studious lad, who kept himself to himself and spent most of his time studying, made a boomerang that came back and hit him on the head after ricocheting off the clothes lines. He contracted tetanus and died at thirteen years of age.

When the spring came and the days got longer, at every opportunity we were down on the moors looking for the nests of peewits, moorhens, curlew and snipe, learning how to jump the not-too-wide ditches on the way. The moorhens would usually lay seven to nine eggs, but all the ground-nesting birds on the moor only laid four eggs. If there were two or three eggs in the peewits' (lapwings') nest, we would take one. You could take one egg every day for about ten days, and the hen would keep on laying until there were four eggs. The moorhens were just the same. If there were only four or five eggs in the nest, you could keep on taking one each day for a fortnight and she would keep on laying. The day she laid two eggs you took no more. Practically everyone that milked cows on the moor ate lapwing and moorhen eggs. They were very rich.

When we were kids during the war, if we were hungry we would make a hole in the top and bottom of an egg, blow the inside out into your hand to make sure it was okay and then eat it, sucking it out of your cupped hand. We would also do the same with milk. Find an old quiet cow that would let you touch its udder, squirt some milk in your cupped hand and drink it. One thing we were warned never to eat was watercress, unless it had been thoroughly washed, as this was where the liver fluke lived: this was a tiny snail that if eaten would make its way to the liver and lay its eggs. When hatched, they were like thousands of little flat fish lying side by side. At this period in time there was no cure for this.

In the very hard, cold winter of 1941-2, the frosts were very severe. This vast area of flooded land, feeding hundreds and thousands of water birds, became an enormous ice rink. I was just ten years old, and in our hobnail boots we could skate as if we could go on forever. We always knew where we were by taking our bearings from Glastonbury Tor. When the water drained away from beneath the ice, it started to crack, and a crack could last on and off, sounding like thunder, for as long as half an hour, starting at Huntspill and finishing the other side of Glastonbury. It was a wonderful place to live, as the scene was always changing. When the ice went, the old half barrels that were used to hold water for the cows to drink in the dry hot summer were now used for fun, with a couple of us lads using them like coracles, pushing them about with a couple of willow stakes. This all sounds very dangerous, but as long as we kept away from where the ditches were, it was ok. We never told our parents what we had been up to, but we had been taught to treat the moors with respect.

Catching rabbits and eels was another thing we thought of as recreation. Imagine us, if you can. I remember one day when Diddy Gulliford and I took Archie Norris's eel spear from where he kept it in the bushes. Between us we carried it to Edington Drove

Rhyne, and between us managed to get into synchronization, both holding the spear at the same time for more strength. We pecked around and caught eleven good size eels but we couldn't put the spear back in the bushes where we got it from. From then on, Archie put it up out of our reach, and that was the end of our eel pecking; the last eels I could take to my Granfer and Nan Durston. They lived at Cedar Farm, looking directly at Glastonbury Tor: even when all the massive elms were about, the Tor was still plainly visible from here.

Right from an early age, Granfer Bartlett taught us how to catch pheasants by threading horse hair through dried peas and raisins. You had to thread the horse hair through the peas and raisins about half a dozen different ways, cut the ends off (leaving them about one sixteenth of an inch long), then throw them down near where you knew a pheasant had gone to roost, hoping they would not be taken by mice. You got up early in the morning and waited. The pheasant would smell the peas and raisins, if they were still there, and come straight down and try to eat them – but they would instantly get stuck in its gullet, and it would keel over, fluttering its wings. You could walk in and pick it up. You caught pheasants this way because it was a very silent way of doing it, and no one else but you knew you had done it.

Granfer Bartlett also told us about his life. When he was a young man when he went to Birmingham to earn his fortune, but unluckily found himself in a fight and lost his left eye; because of this he came back to Catcott and started all over again. This time he worked with his brother Fred, cutting grass with a mowing scythe as there were no machines then. They cut grass the whole summer, going anywhere where the money was good. Their diet was dry bread, cheese and cider, starting early in the morning to miss the midday heat. When the grass cutting was finished they cut corn, again with the mowing scythe, until they were no longer needed. They then cut shaulders from the ditches for thatching ricks, and after that they cut hay from the loose ricks with a hay knife and made it into trusses. This hay was the fodder for the many pit ponies used for moving coal about and out of the mines.

Grandfather and his brother Fred worked as far away as Shepton Mallet and walked everywhere they went, always carrying their tools and sucking a bone button. The bone button was to keep saliva in their mouths so as not to feel thirsty.

Another thing he taught us to do was to make what he called a callyvan (a kind of cage). Having four sticks about 3ft long, you had to place two sticks on the ground about 2ft 6ins apart, then placing the other two sticks the opposite way the same distance apart. Then you needed four pieces of string about 4ft long, tying each corner together, each with a separate piece of string. Then slightly shorter sticks were placed on alternate sides until the top had come together on all sides, and all four strings were then pulled to the top forming a loop in each piece. A stick was then threaded through the loops and twisted until the whole thing was tight. Then the stick was tied to the cage. A strong, straight bramble was then bent around the bottom of the cage, fixing it at the two back corners. A small stick was put beneath the cage and on top of the bent thorn and on top of a peg about 9ins out of the ground. This was the trapping mechanism and was set very lightly. One slight touch on the thorn would drop the cage to the ground, catching whatever was beneath it.

While Granfer was showing me how to make this ingenious thing he referred to as a callyvan, an old gypsy woman arrived on the scene selling wild lucky white heather. I have never seen any white heather growing wild but she had a large basket of little bundles.

She tried very hard to sell Granfer some but he was very tight with his money and she couldn't get him to budge, but she told him that during this child's lifetime – referring

Hunting for rabbits. This one has got away, and even the dog hasn't seen it go.

to me – the grass would be green the whole year through. That rooks would build so low in the trees it would be possible to push the nests out with an apple pole. This would be because all the elm trees would have died. That moon daisies and cowslips would be practically extinct. That Bridgwater would stretch from North Petherton to the Silver Fish (so named because a restaurant of that name was demolished at this point to make way for the Sedgemoor Drain, running under the A39 at Bawdrip at the M5 turn off). How my grandfather laughed at her and argued on every point – though now he would have to eat his words if they met today, as practically all of what she said has happened. The grass is mostly green the whole year through. All the large elm trees have gone and some rooks' nests can be seen built so low as 10ft high in ash hedges. Moon daisies and cowslips are hard to find, and Bridgwater is making its way to where she said it would stretch to, and from where.

She said she could not read or write, however, so how did she know all of this?

Diddy and I always rendezvoused in our den. This was in a gigantic thorn bush in the corner of the old quarry. Sticks of all sizes were woven around and up and down to make it more stable.

We had devised an ingenious way to catch rabbits, as all around us were hedges and trough ditches, and all the gateways had 4ins land-drain pipes underneath them to join the ditches. We would find long, straight dog-rose thorns and thread them through the pipes underneath the gateways, one thorn with the hooks of the thorn facing one way and the other the opposite way. These were left there all the time. Then, when we knew where Farmer Ern Acreman was, and he wasn't anywhere around, we would go out with the dog and hunt the hedges. The rabbits would usually run to the nearest pipe underneath a gate. We always knew which end it had gone into the pipe as that is where the dog would

be. One of us would then go to the other end and pull the thorn with the thorn hooks looking towards you: these would stick into the rabbit and it would come to the end of the pipe. You then pulled the thorn a bit more and grabbed it, though sometimes the rabbit would turn around in the pipe and run the other way. We never had any of the ones that did this.

I saw Nan and Granfer a lot as I often had little jobs to do for them. Nan used to make potato and apple scones, first making the flour from the potatoes, then mixing it with a bit of lard and grated apple, then placing the scones directly on the top of the old black lead range. Once they were cooked, she would smother them with molasses. I thought they were wonderful and I expect they were one of the reasons I spent so much time with them. Grandfather was very crippled up and walked with two sticks. He loved me to go to talk to him. Granfer told me the story about one of my ancestors, Captain Robert Durston, who fought for the King's men in the Battle of Sedgemoor. He was offered a knighthood, but because of the punishments that were being handed out by Judge Jeffries he turned it down. For this insult he was arrested, taken to London and locked in the Tower for four days – after which he still wouldn't accept it. He was then made to march back to Moorlinch under guard, being fed only bread and water. Recently I have tried to find out the rights of this, but the only lead I have found is the pistol used by Captain Robert Durston in the battle, which is now in the county museum at Taunton. I was told by the Tower Records that, even though they have no record of this, the story could very well be true. Captain Robert's family, true to their politics, set up a charity (The Durston Charity) that stated that anyone who fell on hard times and could trace their line back to him could benefit from it. The Durston Charity is still running today, and is now run by a firm at Bridgwater, Tamlyn & Sons of 56 High Street.

I have also been informed by several historians that (because of who he was and his actions) Capt Durston's records would most probably have been removed from Moorlinch and Catcott Church to Exeter Cathedral for safe keeping. Unfortunately, therefore, they would have been destroyed when the wing of the Cathedral that housed them was destroyed by German bombs during the Second World War, along with all the other records that were kept there.

Nan always wanted me to thread at least half a dozen needles so that she could mend something or another. They were two dear old souls, but, in today's standards, lived in utter poverty: earth closet at the top of the garden, bare floors, decaying damp flagstones downstairs, and worm-eaten elm boards upstairs. There were loads of mice everywhere and the rats ran in and out of the walls of the house. We would spend time trying to ferret them out of the walls, and killing them with sticks, catching sometimes as many as a dozen big rats. I remember once, after we had been ferreting out the rats from the walls, and gone back into the house for a cup of tea and a slice of cake, nan told us when she used to go on holiday to her cousins in the next village at Burtle: the rats, she said, were much worse there.

During the winter nights, when we weren't burning soda onto our chilblains with a hot poker, we would be playing cards, or draughts, sharpening up our wits, or making things with meccano. The trouble with meccano was that the nuts and bolts were so small, and the light we had was so bad, that they often got lost, and without them you couldn't do a thing. Fretwork was another thing we did, though the only blades we had were the ones that came with the saw and you were expected to make these last forever. You had to devise anything else you needed yourself. After the war finished there were catalogues to

show you what was obtainable and where to get it. This made life much easier, and we got new blades for the saw.

Ryne drove was the beginning of the moor, so called because a large ryne came between the drove and the Nydon Hill. Over the ryne was a brick Norman-style bridge. It was guarded at night by the Home Guard from two dug-outs, one either side of the road, at the bottom of the Nydon Hill. Immediately beyond the bridge, on the left-hand side of the road, was a ditch. This ditch was the place to find the best sticklebacks in the moor. You could also find newts of every kind and they always seemed to be there. The water in this ditch was always crystal clear. If we had the time we would hide a 2lb jam pot beneath our coats and nip off down the moor to this ditch with our worms and try to catch some of these enormous sticklebacks, using a worm tied onto a piece of fine string. We hid the pots beneath our coats because, at that time, these pots were a very scarce, valuable commodity, as they were used for pickling onions, beetroot, cabbage, cauliflower and many other kinds of pickles and chutney. No pickles or chutney could be bought in the village shops, and all had to be produced and made at home. For catching the sticklebacks we found worms of a special size, ones the sticklebacks were able to get down their throats right up to where they were tied on to the string. When the worm was in this position, the one with the worm pulled the stickleback out of the water; the other was waiting with a net beneath. The net was made from some old lace curtain and some soft wire. Keeping an eye on the fish, we held on to one another so as not to slip into the ditch. When the sticklebacks were in the water in the pot, they looked even bigger than ever and their colours were wonderful. The newts were easy to catch, but the lizard saw-back kind seemed to be lazy and would not often take a worm.

I once went back to help out at my old school in Catcott. After telling the children all about how we did things when we were kids, looking around at the ten-year-olds and trying to think what jobs they could have done on the farms, I then went down to the moor. The stickleback ditch was all grown over with weed and the rynes had all been dredged; very little signs of wildlife of any kind remained. I felt very depressed and wondered what on earth was happening.

When I was a child, the whole place was so full of wildlife. Going to school you saw all the kinds of birds you could think of. The thrushes were always cracking snails on the side of the road. There were toads hopping about, slow worms, hedgehogs and grass snakes, rats and mice, locusts, like massive grass hoppers about 3½ins long, stoats and weasels – and occasionally a lone fox. What a difference sixty-five years has made. I haven't seen a snake for about fifteen years. Everything today is moved with a mechanical shovel, which kills off the toads and slow worms, and also the kind of snails the thrushes live on. This is the price of progress. The problem, of course, is that we are getting no change – everything is just disappearing.

In an old, dead pollard elm tree at the bottom of the field across the lane, at the bottom of the orchard at Townsend Farm, Diddy Gulliford and I kept tabs on the amount of jackdaws that nested. You could shovel the eggs out of the tree and they would still keep laying. It was impossible to reach them with your hand, so we tied a tablespoon onto a stick and got them out this way. One day we counted fifty-three jackdaw's eggs and three barn-owl eggs all in the same nest. The owl's eggs were on the outside of the bunch of eggs, and beside a hole at the edge of the twig nest. All those eggs hatched out and were reared, but what a stinking place it was! The jackdaws had all left the nest long before the owls were ready to move out. Every year the jackdaws used this tree in the same way, seven or eight pairs using the same nest.

Some years, in the spring, the rooks would start to build their nests, high up in the tree tops. Then, suddenly, they would change their minds, and take the twigs from the nests they had built to make new nests about 18ins to 2ft lower down the trees. When this happened, you knew, later on in the spring, before the eggs were hatched, there would be very rough winds that would blow away any nests that were left high in the trees. This was a sign for anyone who had anything to secure to go ahead and do it before the winds came.

It is not because every lad in the village had a very comprehensive collection of birds' eggs that the birds have gone, but because of the changes that have come about by many different means. New people that came to the villages wanted everything tidy, and all the ivy taken from all the walls. This was where the small birds roosted in the winter. All the holes in the old lime walls were stopped in, and the walls pointed, leaving the small birds with no nesting holes. All the roofs were felted, and the starlings and sparrows kept out of their old nesting places. All the old dead pollard trees have been cut or bulldozed down. Most of the ponds have been filled in as mains water has been laid on. Hollows and banks around the fields have been filled in and levelled to make cultivation easy. Hedges are all kept cut low, leaving no cover for the small birds to escape from the magpies and sparrow hawks. On top of all this, the birds of prey are now a protected species, and new ones are even being introduced. Who does all this benefit? As the farmer, having cultivated every possible bit of land available with the help of government grants, has now to comply with Brussels in a set-aside scheme that demands that the good land is left to get covered with thistles, docks, ragwort and about every other weed. All this draws wildlife from a large area, but then, once it's established, the farmer has to spray it all with a strong herbicide. This not only kills the weeds, but also all of the wildlife as well. All this makes me despair. On top of all this, the modern machines are so violent they kill everything they pass over, other than the plant roots. Every insect, small mammal, butterfly, hare, pheasant, partridge, duck — even young deer go the same way. The people who design these machines must stand back and take a look at what they are doing.

Frolicking lambs.

CHAPTER TWELVE

THRESHING

Threshing was usually done in the winter time, when there were not as many important jobs on the farm that had to be done, after the cattle had been tended, cows milked and fed, pigs, hens, sheep had had an eye cast over them and been fed. In our village the threshing started somewhere between 8.30 a.m. and 9 a.m. as the helpers were usually farmers, smallholders and jobbers themselves with all the aforementioned jobs to do. They then had to have a bit of breakfast, and usually walk to the farm where the threshing was to be done. The day's thresh would finish at about 4 p.m. to give people time to go home and do their milking, feeding and other jobs, and feed the rest of the animals, and the mow and the thresher could be sheeted down, in case of rain. There was very little threshing done the week before Christmas as all the hands were on the poultry, killing, picking, plucking and getting ready for the table.

The steam engine pulling the threshing machine and all the tackle would arrive usually early in the morning or late in the day. As soon as it arrived it would be put in place, jacked and blocked-up level, and the sieve, for whatever kind of corn was to be threshed, was put in place. Then wire netting was put around the mow to stop any rats escaping. This was mandatory, and if not done carried a very heavy fine. It was the responsibility of the contractor, the owner of the thresher. This was so that everyone did not have to buy wire netting. The wire stood upright on slender wooden stakes 3ft high and was pegged down at the bottom with hazel pegs. The next job was to take the thatch off of the mow. This was usually done by someone who could start early so that everything was ready to go when the rest of the workers arrived. Once the thatch was taken off and the threshing machine had started, one man would stand on the top of the mow and toss the sheaves down to the person cutting bonds and feeding the machine. When there was room for two men to work, another man would join him, and these two would carry on until most of the roof had gone. Then they would be joined by another man or strapper, a strong woman who worked on the land. These three would usually carry on until the job was done. It was very rare for anyone else to take over the job of either throwing on, or pitching on to the thresher. These people would usually be thought of as the best workers, and the hardest workers were given this job to make sure that all the rest kept going. You all had a job to do, and if the sheaves went in fast then all the rest came out fast.

There were three on the mow, two on the sacks, one pitching straw, two on the straw mow, one on dust and cafeing (chaffing), one feeding the thresher and the last man, the contractor, making sure that everything was working, keeping the belts running well, and making sure the wire netting was in place and had not been bent over. Us ten-year-old

kids and the dogs killed the rats. At break time the men showed off their strength with the weights from the weighing machine, throwing sacks of corn around and lifting dead-weight wooden-pole ladders by putting their feet on the end of the poles and pulling on the first or second rung to lift it up straight. All these things were used like men showing off today in the modern gym.

When the corn was being threshed, the sheaves of corn, beans, peas or whatever were pitched onto the threshing machine, where a man stood: he cut the string bands on the sheaves, then fed the loose corn intact onto the canvas conveyor that took it to a rotating drum with rough ridges along it. This drum turned at an enormous speed and beat all the seed out of the straw. The corn or seed then went through a series of sieves and blowers that separated the grain from the 'cafin' (chaff husk) and husks that had previously protected the grain or seed. It was then graded into three grades: first, second and tailings, before it finished up in the sacks. The straw was then taken to the back of the thresher on a series of what are known as shakers to the next machine, the trusser. This machine tied the threshed straw with two string bands. The tied straw was called a truss, was about 5ft 6ins in length and was tied at about 18ins from either end by the same mechanism as the binder when the corn was first cut. The cafin that had been separated from the grain and straw came out beneath the thresher. Keeping this clean was an awful, dusty job, though some farmers valued this for winter feed (especially if the crop being threshed was oats). It was stored in the mangers of a cowshed and carried there in a woolly basket. This job was not reckoned to be a heavy job, and was usually done by a land girl or a boy. The worst time to do this job was when barley was being threshed as the whiskers or hyals had tiny hooks on them and seemed to get inside your clothes no matter how you tried to stop them.

Archie Norris was a very strong man and usually the first on the mow. He was a real character and always up for anything. He could do all the tricks with weights and the ladders, and when he was working on the mow and came across a nest of mice one or two days old, he would pick them up in his hands, blow the cafeing (the corn husks) away from the young mice, and swallow them whole, washing them down with a drop of cider. He would do this all day long. Bill Pole would bring bread and cheese with an onion for dinner, eat dry bread and the onion and take the cheese home again to bring again the next day, washing the bread and onion down with a drop of cider. Sometimes they would light a fire away from the mows and bake potatoes on the hot embers for their dinner and eat these with a bit of lard and salt. There was an awful lot of camaraderie, laughter, leg-pulling and jokes between the men. Sometimes there would be a conscientious objector with the thresher, and he would be given a hard time if it was thought that he was only objecting to get out of serving his country, as most of the men had sons or daughters away in the war or daughters in the munitions factory at Puriton – or they had fought in the First World War themselves.

Sometimes an objector would deliberately let a rat run away. This was when things really got out of hand, and it was like another war was about to start. Sometimes there would be more than a hundred large rats killed in a day, and probably half as many again young ones. I have seen so many rats running around that you didn't know which one to hit at with your stick. All the dead rats were put in a heap and counted at the end of the day. It became a thing that was remembered for the following years – where were the most rats killed?

As the war went on, the land girls came on the scene; by this time the steam engines had gone and tractors had taken their place. But it was a very different feel as the steam engines somehow had a grace and majesty, lost with the tractor. They seemed to have so

much power. When the boiler was really hot just a few shovels of coal would be enough to drive the threshing machine. The problem was that the fire box had to be lit up very early in the morning to get the heat up to start. This job was usually done by a local man, Bob Sugg, who also lit the fire boxes on the steam rollers for the council when they were working in the vicinity. He was another character; he shot anything that moved! I remember he once shot a brace of partridge, took them home and put them on his coat on the furnace copper boiler; he then went inside, had his dinner and came out to take them to sell. Only one was there. He said, 'Bloody cats', picked up his gun, and shot the first cat he saw; another ran across the yard and he shot that. This cooled him down a bit, and when he came back in the house he found the partridge he thought the cats had taken had rolled into the copper!

There were just two threshing machines around our area. These were owned by two brothers, Sid and Archie Gardiner, who were as much alike as chalk and cheese. Sid rode an old Douglas motorbike and side car, and drove a cut-down Rolls Royce. Archie rode a nearly new BSA 350 and drove a Morris 8 saloon. They both had the same tackle, Oliver 80 tractors and Ransomes' threshing machines. Archie was always well dressed and clean shaven. Sid wore anything, shaved once a week and was stripped to the waist all summer, looking very much like Paul Hogan. I remember a time Sid, while cutting corn with a binder, stopped to have his dinner. The land girl who was riding the binder was sitting down beside the tractor, eating her's. Sid went around the other side of the tractor to relieve himself — and urinated over the tractor, all over her! He thought this was very funny, but she didn't feel the same way.

There was always a 12-bore shotgun and .22 rifle thrown in the back of the cut-down Rolls and loads of ammunition. No one got shot in those days — in fact, there were guns everywhere. Fourteen-year-old kids carried them shooting, and no one would dream of shooting someone else. Nowadays all the guns have been called in, yet it seems that people are getting shot very often.

Sid always did my father's threshing, and would come around one evening in the spring bringing his bill, and stop over for a bit of supper. Father would write out his cheque after a little haggle. This is how it was done. The talk over the supper would be about new varieties of corn and how they had yielded; who had had the heaviest crops and how the straw stood up; which varieties would make good thatching reed, and, most of all, where the most rats had been killed and what it would have been like if they hadn't been. The thing I remember most was how much work was done even though everyone was so laid back and had so much fun in their work.

The weights of the sacks of corn varied by the kind of corn: the lightest sacks were the oats at 1½ cwt, wheat and dredge 2¼ cwt., barley and rye 2 cwt., beans and peas 2½ cwt. The beans and peas were always put in the loft or tullet, carried on the back up the slippery stone steps with no hand rail, and the corn was always put in hired West of England heavy hessian sacks. The sacks themselves each weighed 5lbs. Sometimes the people working on the back end of the thresher would grumble because they had to work so hard: this would make the ones on the mow work even faster, and even this would cause a bit of laughter. The old chaps seemed to be able to drink cider all day long and it would have no effect on them, but at Langlands Farm, the home of Harold Venn, they had to make do with tea all day. There was never any cider there, unless you carried your own. Needless to say, there was usually a different work force there, but the time was never dull, as Harold, even though he was educated at Cambridge and had a very wide vocabulary, and was a church

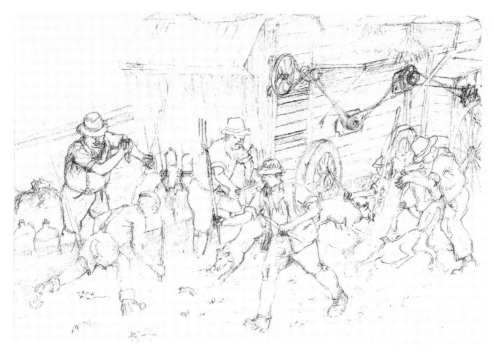

Sketch for 'Moving the Stadle'.

warden, could string more bl— f— together than even my cousin Edwin and he had no problem getting a bl— between two bl—s!

I remember vividly one occasion when I was twelve years old and helping threshing at Buckfurlong farm. The thresher had stopped for dinner. I saw a mouse run underneath the sacks, and I caught it and slipped it down a land girl's back, inside her shirt, and ran home to dinner laughing. When I came back after dinner everything seemed to be normal, and I was leaning against the sacks of corn when another of the land girls grabbed me from behind – and before I could get away, there were three holding me down. They got my trousers down and gave me a good oiling. I shouted to the old chaps for help, but all they did was have a good laugh and say to the land girls, 'Treat us all the same'. This really taught me a lesson – not to mess about with the land girls.

What I remember most about threshing time was the argumentative discussions about how the world could be put to rights. The word 'tolerance' in particular had a real going over: to some it was just a word, and everyone had different ideas about it. People only tolerated what they wanted to, what suited them. The outcome of the argument was always the same: that in the end everyone who was law abiding would do as they were told, and the rest would do as they liked. Looking back on these discussions, and seeing where we are today, it's a pity that some of these old chaps aren't still around, as even though they couldn't read or write they could think and reason. Even Harold, with all his education, could not get the better of them – unless he used words they didn't know the meaning of. This was always his defence, but once he'd told them the meaning they would use them on him, though sometimes with not quite the right pronunciation. He knew what they meant, though, and then everyone was happy – even Harold, as he thought he had taught them something.

CHAPTER THIRTEEN

DITCHING

Ditching, whatever kind, was always hard work but, in turn, it was a joy, as everything was quiet and you were alone with nature, with all the bird songs and calls, and the calls of the animals. You would probably learn more about nature in a week while ditching than in all the time you spent at school.

Digging trough ditches along the side of a hedge, with a very sharp spade, gave you an insight into so many things. You were half camouflaged as you were standing in the ditch. The wild animals – stoats, weasels, foxes, hares, rabbits and mice – were often seen in their natural environment first-hand during the winter, and at the back end of the war, the grey squirrels came about in our area. You learnt all their habits.

In the spring the wild plants that no one bothered about appeared. Looking back, as I see them today, they were so beautiful. The lords and ladies, the young tight leaves of the wild carrot (cow parsley), primroses, violets, teasels and cowslips all joined together by my favourite, the dense celandines. All these are weeds that you would never want in your garden, but along the ditch, bank and lane they make a wonderful border. None of these plants could be left in the ditch, however: they were all dug out and thrown up into the hedge. They would usually flower and seed to start the cycle all over again.

Ditching on the moor was completely different, as these ditches were usually full of water. The plant life in some of the main ones, called rhynes, was amazingly beautiful. You could stand on the bank and look in the water and see all the wild life there, frogs, newts of many different kinds, minnows, caddice fly lava, and much, much more. Then there was the plant life; so many species of plants and rushes, water mint, water violets, frog bit, broad- and curled-leaf pond weed, yellow iris and marsh marigold. These are just a few of the plants, but there were many more.

Sometimes, during July and August, the ditches were nothing but flowers. You would walk along the banks looking to see if there were any ducks about, as they would often paddle the water-vole routes, but you finished up being carried away with all the wonderful array of flowers. Then you came across a place where the flowers were all pulled up and the water was all churned up. This was a sign there were ducks using the ditch. Water voles were so common at this time you could see as many as three at a time, and if they saw you they would dive underneath the water and probably wouldn't surface for 20ft.

All of these ditches, if left un-cleared, would cover over with shaulder (a very large soft sedge).

Back to ditching. I think it was mainly done to drain the land in the spring when the water receded from the moor, but secondly to keep fence, to keep the animals in their own field.

To clean the ditch, first of all you had to shear the bank on one side of the ditch. This was done with a long-handled knife, an old hay knife on which the blacksmith had lengthened the handle. You held the knife leaning back towards you. Using this knife to sheer the bank was a very skilful job, as you had to cut a straight line. To do this you made an imaginary line in your mind, remembering a line between a number of points. Once you had conquered this you could cut a straight line.

This being done, the next thing to do was to cut the sheered bank into mumps (pieces about a foot long). This was done with a jagging scythe, an old scythe cut in half with the end forged and straightened, then fixed into a straight handle by the blacksmith, with the end of the scythe falling away. It was actually a very good tool and kept a very good edge. When the banks were sheared and mumped up, they were then pulled out of the ditch by a man with a ditch crook. This tool was also made by the blacksmith and would crook out anything from any angle, and it was all put on the bank. The same would then be done to the other side.

While all this was going on, the sounds of the birds on the moor was really something else. Imagine it; snipe drumming, lapwing and skylarks singing, curlews, ducks, buntings and reed warblers warbling, the odd pheasant and many partridges calling.

Ditching in this way caused no problems with the wildlife, frogs, minnows, newts and all the other amphibians, as they would just jump or swim away out of the muddy water. Today, with mechanical ditching equipment, sadly most of them don't survive.

I talked to my cousin Edwin last week about the moor and what has happened with the farming changes over the past thirty years. During the conversation, he said, 'My dog is four years old and you know how many frogs there were on the moor years ago. Well I go to the moor night and morning and the dog comes as well and I don't expect he's ever seen a frog. You hardly ever see a snake now and there used to be thousands.' Remember, while walking a ten-acre drove on a hot sunny day you would see hundreds of snakes sliding down from sunning themselves on the gorse bushes – now you never see one.

All the trough ditches along the sides of the roads were immaculately cleaned out by hand, and the spoil thrown up into the hedge. The pipes joining the ditches were cleaned out with rods; this job was always done when it was raining heavily, using the water to the best advantage helping to do the job and washing all the rubbish away.

Water in some of the ditches was separated in a very simple, scientific way: by inserting a pipe in the side of the ditch upstream running to another ditch downstream. The downstream water acted like a pump or siphon, pulling the water instead of just letting it run. This changed the course of much of the water.

On all the round corners of the ditches, large flat stones on end were put, with the leading edge of the stone behind the one in front. It was done like this so the rushing torrent of water wouldn't wash away the bank. All these simple scientific things have now been wiped out with the help of diggers. The open ditches have now mostly been piped, with gratings to let the surface water into the drain, but as the gratings are always half-blocked it needs very little to block them, leaving the water running all over the roads and flooding everywhere. Places that were never flooded when I was a lad, before the ditches were piped, are now a constant problem, resulting in many houses being flooded.

CHAPTER FOURTEEN

HYGIENE

Hygiene was something that was practically unheard of before the war. Cleanliness was the name of the game then. People relied on the old information handed down to them over the years as to what to do and what not to do.

The flagstone floors were an example. All the rest of the year, when there was no frost (or even when it was frosty), these flagstones would be perfectly dry, but as soon as the frost started to thaw after a long spell of frosty weather, even though the stones were indoors and there was a fire, these stones would become wet, with large beads of water on them. It could stay like this for two or three days. Bare stone walls were just the same. It was known as eaving, and while they were like this they were scrubbed every day. Other than this they were scrubbed once a week.

The kitchen table was scrubbed at the same time, whether it was elm or pine, but they never seemed to scrub the oak ones. Bath times were usually Saturday nights or Sunday mornings, in a tin bath, taking it in turns, one at a time, youngest last, either in front of the black lead range in the kitchen, or in the old wash house beside the copper (or furnace, as it was called by most people). I remember an old chap talking about when he was young. He came from a long family, and when it came to having a bath in the kitchen on a Sunday morning he was the last one in. He told his mother that the water was too cold, so she said, 'I'll soon heat that up', and strained the boiling cabbage water into the bath! I suppose the word used to describe this today would be 'cool'. Meat and water were never allowed to come together until the meat was about to be cooked (and preferably not even then, as meat that had been washed before it was cooked never kept as long as meat that hadn't been washed).

When a pig was killed, the bristles were then scalded and scraped off it, but the carcass was always left for a day or two before it was jointed up. This was to make sure there was no water present to affect the keeping quality of the bacon and ham as, if there was any water present, the meat would go rancid – smelling and tasting strange – and the fat would turn a brownish yellow. Today, all meat is washed: the whole carcas is hosed down with water then dried with blown air and is of a very poor keeping quality. Little wonder there is a problem with E. coli. Most things handed down over the years are now discarded or thought to be stupid because of the refrigerator.

The only disinfectant that I can remember before the war was Jeyes Fluid. This was used for almost everything. The old earth closet at the top of the garden always had a jar there. It was sprayed all around the rooms, the curtains and the sheets if there was anyone with an infectious disease (scarlet fever, whooping cough, diphtheria) in the house. When it was

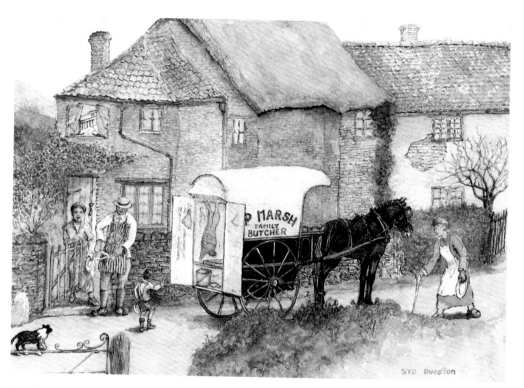

Butcher Marsh was 'Mr Marsh' to everyone.

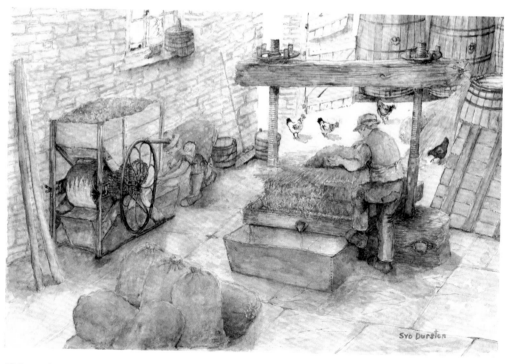

Cider makers were good at their job, never having a 'cheese' split or break. This picture was painted with a deliberate mistake, but at a guessing competition at the Holburne no one spotted it.

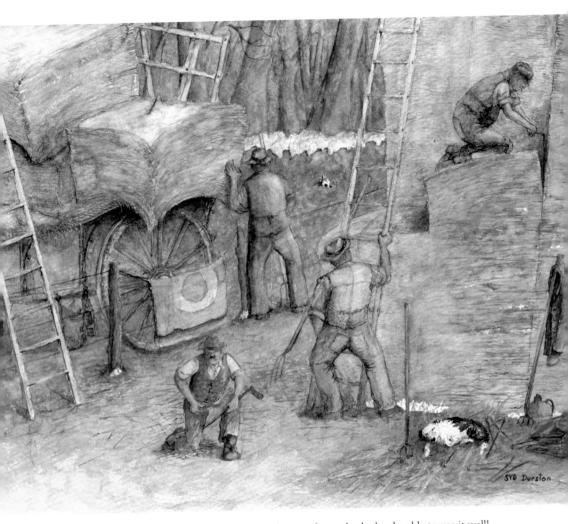

To cut loose hay you had to have your hay knife very sharp, and you also had to be able to use it well!

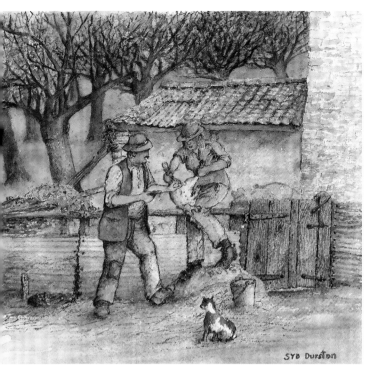

Cutting piglets. This was a job that had to be done well, as there was no aftercare at that time, and vets were very scarce.

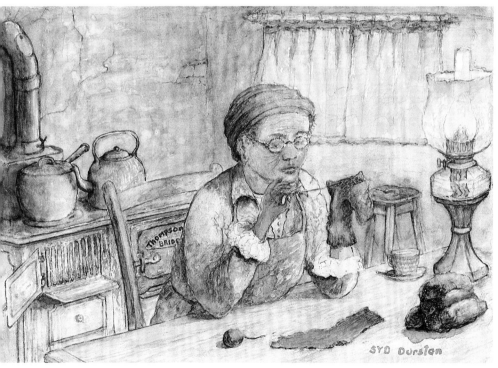

Darning was something that was done, in the main, by the woman of the house, but even the boys learnt to darn at school.

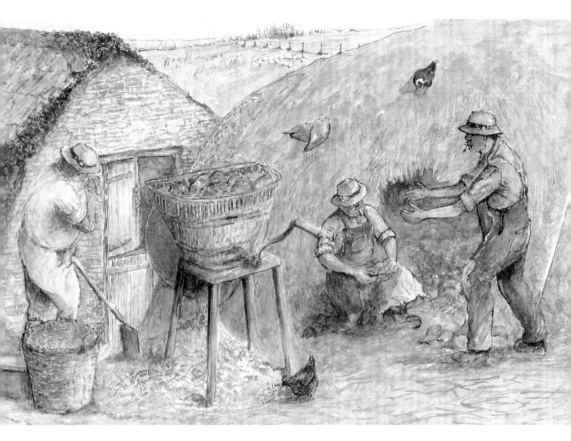

Mangolds were pulped when I was a boy, but as the herds got bigger the mangolds were fed to the cattle whole.

Sketch of a heavy horse.

Ironing was usually done on a kitchen table. The flat iron was heated, as a rule, on a primus stove after it had been heated on the old range fire.

Boys could be playing or girls could be playing, but dogs didn't go looking for a quiet spot – they just performed, and no one took any notice.

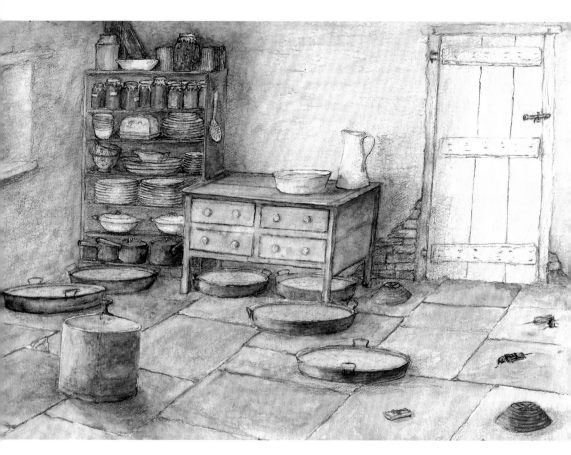

Mice were a real dread, as they got into the food, the drawers of clothes, and the diary – and there into the creamers, the large shallow bowls.

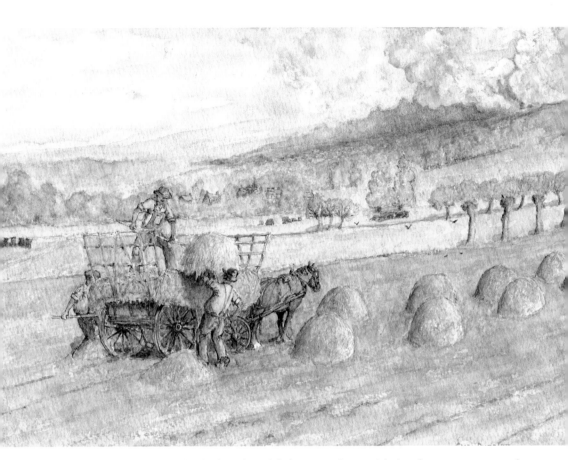

Hauling hay, pitching it by hand, was a hard job with pitchforks. It was always a job that, for some reason or other, needed to be done quickly.

Right: Community policing: the constable helping himself to a swig of cider, taking no notice of the guns lying around.

Opposite: Shaking and beating apples from the trees.

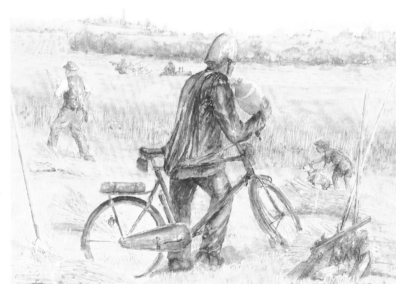

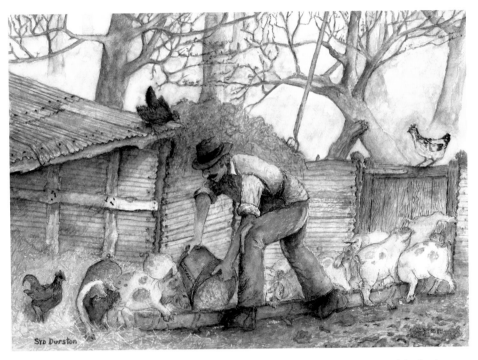

Feeding pigs with meal mixed with water to a slop could only be done if the top of the bucket was always facing you.

The rick was usually fenced with elm posts, cut from the hedge, and barbed wire. The holes for the posts were dug about 2ft 6ins deep and usually water had to be dipped from the holes in order to be able to ram the posts firmly home.

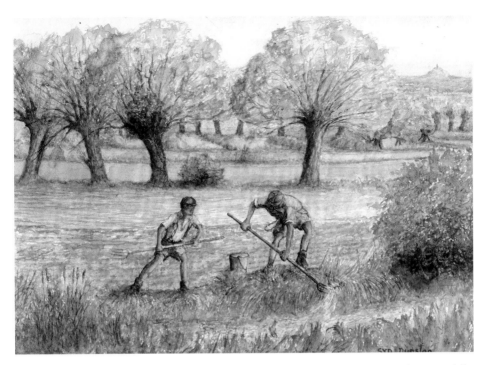

When the water dried up in the ditches in the summer, some bits of the ditch were deeper, and the fish would go to these places; we used to flick them out with dung forks.

Tools were very hard to come by as soon as the war started, and at a farm sale people would be queuing up to get a look at them. Good tools made work easy.

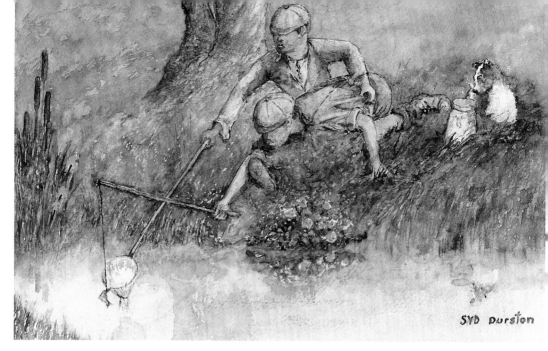

What a difference! Jam pots were then a rare commodity, but now there are plenty of jam pots and no minnows.

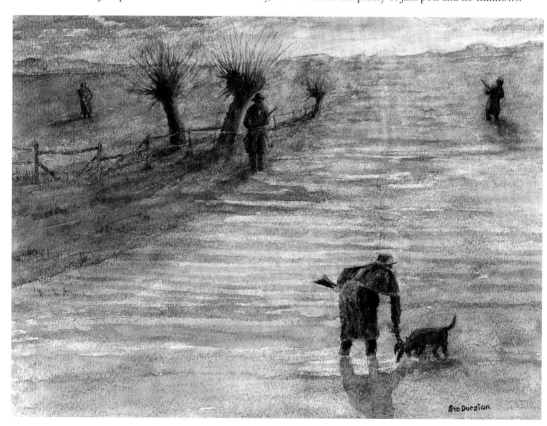

Night shooting. Getting extra meat for the table was a luxury that was taken with both hands, and one that some people didn't have.

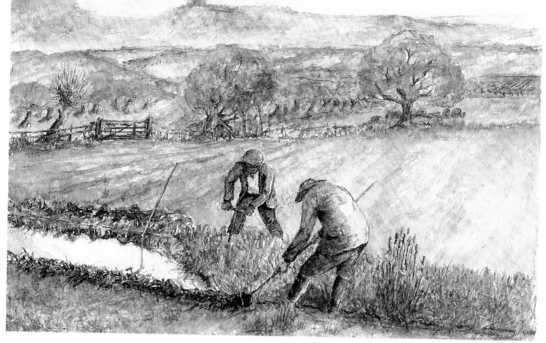

Ditching in November. At this time of year you needed to keep your coat on as it was very bleak on the moor.

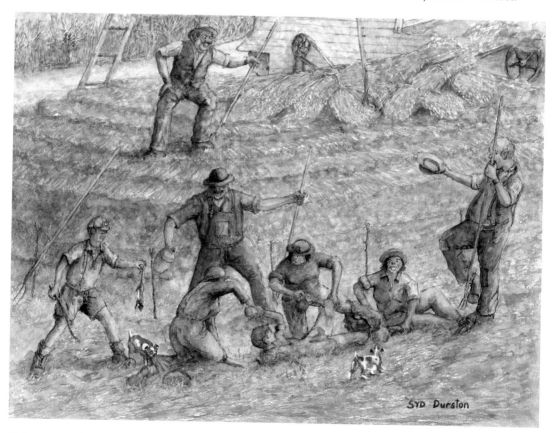

SYD Durston

This was a learning curve: don't mess with the land girls, as they would collectively get the better of you!

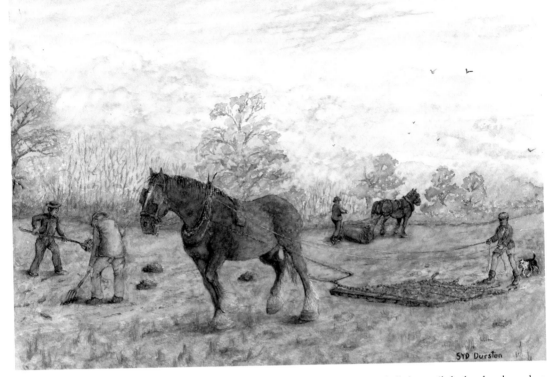

Chain harrowing had to be done like scarifying a lawn, only on a larger scale, and all the spoils had to be cleaned up and carted away to rot down.

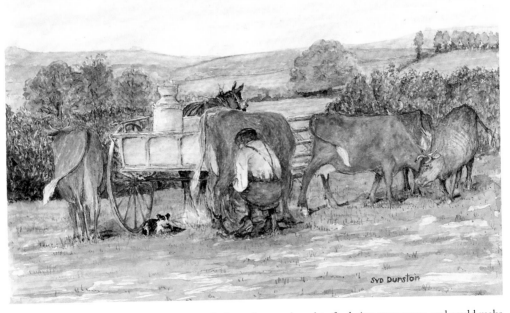

If a farmer had ten cows, a couple of sows and a horse he was thought of as being prosperous, and could make a good living.

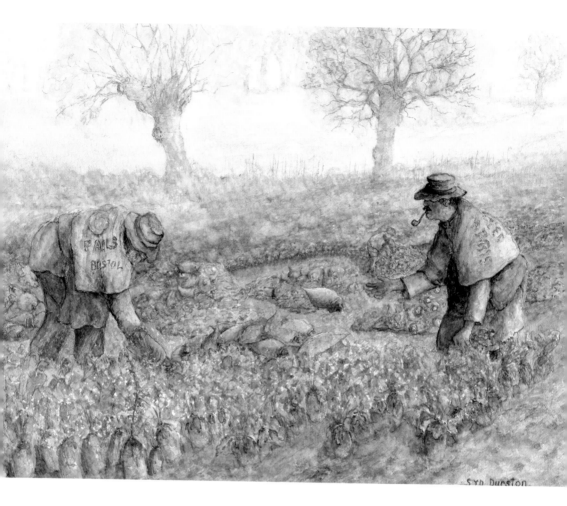

Pulling mangolds was usually done by men and boys, seldom by women (other than the strappers). I can't remember seeing land girls pulling mangolds. These men show the sacks the men wore to keep them dry and warm at harvest time.

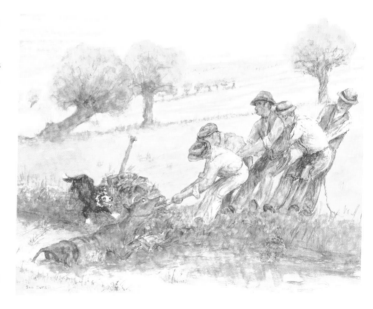

Pulling a cow out of a ditch. This was the only way to do it.

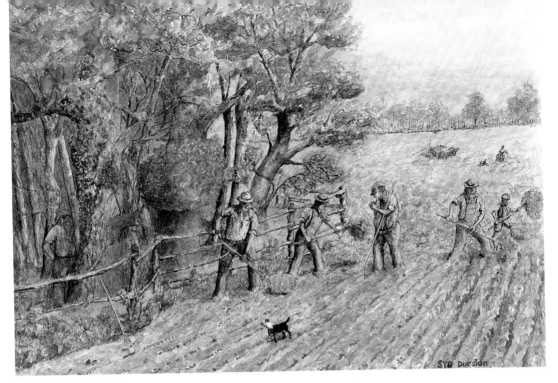

Shaking out the hay with short-handled pitchforks was a job done by everyone.

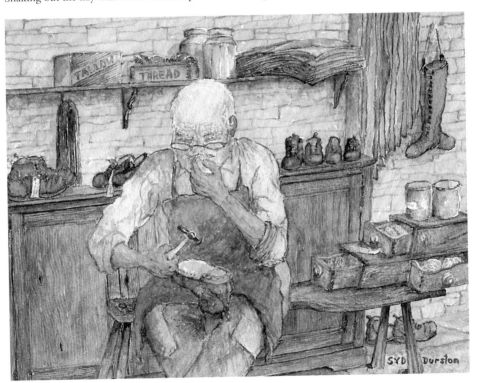

Sammy Elvers: you could hear Sammy breathing before you opened the door to his shop.

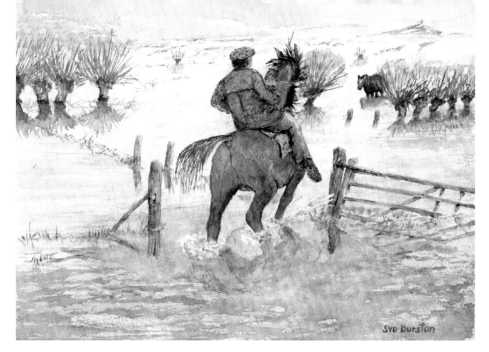

Animals often needed rescuing on the moor after heavy and prolonged rain had flooded the whole area.

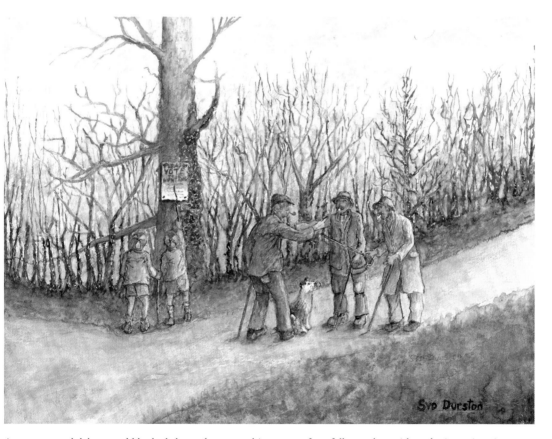

Arguments and debate could be had about almost anything – very forcefully too, but with no lasting animosity.

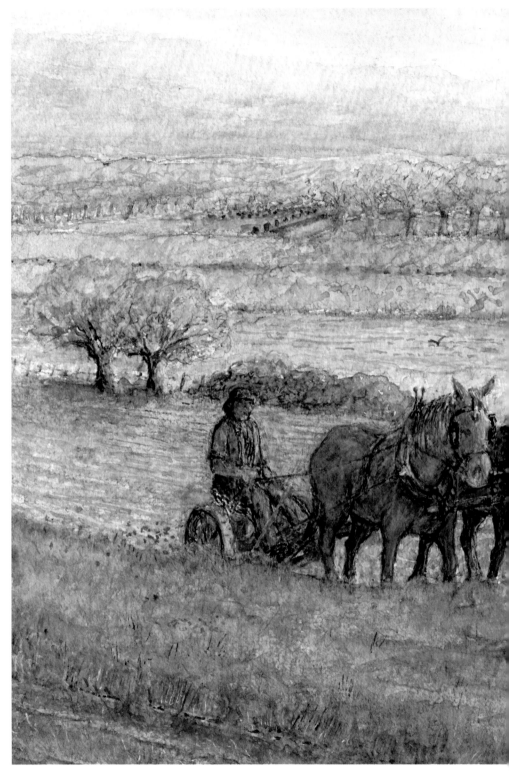

Grass was usually cut with one man, two horses and a mowing machine. The team cut about six acres a day.

SYD Durston

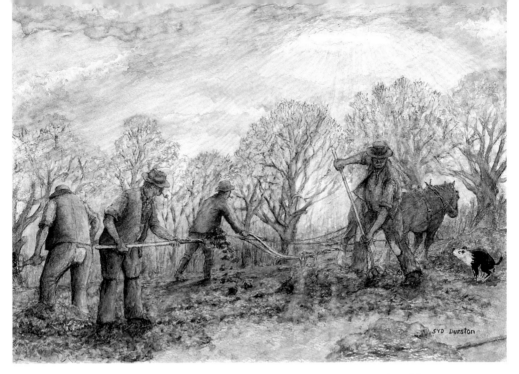

Spreading manure: this was usually ploughed on right away, especially if it was the fall of the year.

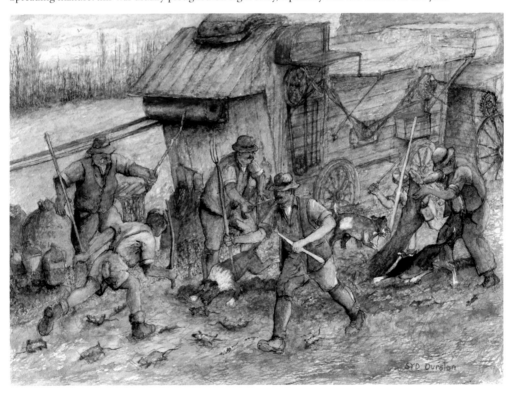

After the whole of the corn mow had been threshed, the stadle was moved to kill all of the rats.

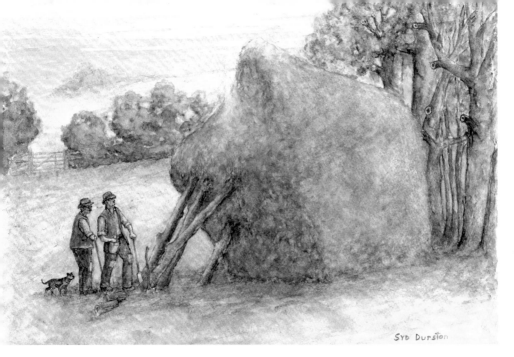

If a rick got hot and there was a stiff wind it would send all the heat to one side of the rick, and if it wasn't propped up it would tip over.

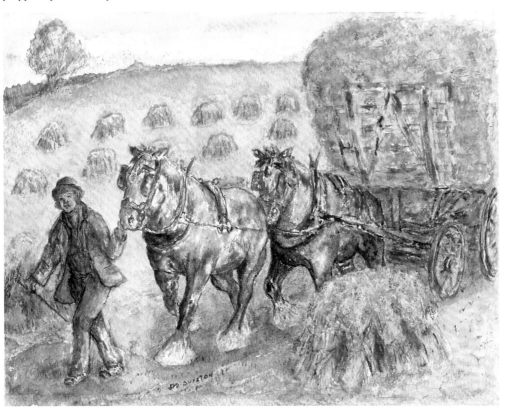

Land girls were usually good with horses, and it was easier work than pitching the corn onto the waggons.

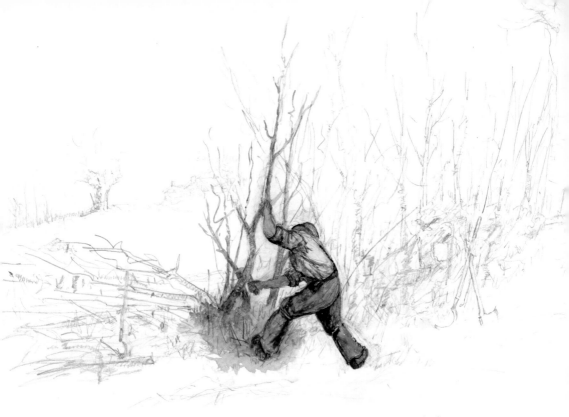

This is a painting I did for a video for the Holburne, to show people how I worked.

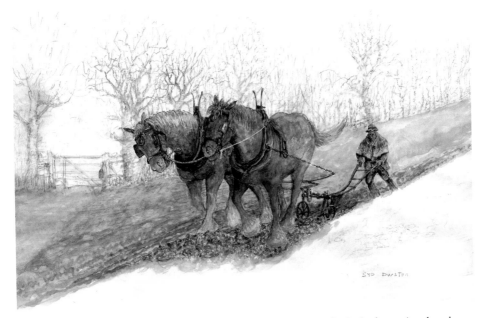

This unfinished painting was to show how the different perspectives looked when painted or drawn in pencil.

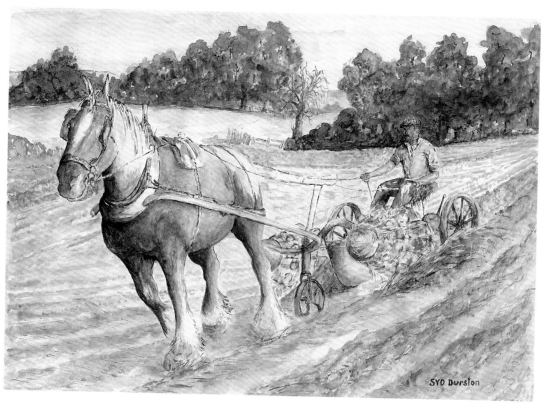

Hay was turned with a swarthturner to speed the job up; if there was white clover in the fields, it would sometimes be turned gently by hand to keep all the leaves on.

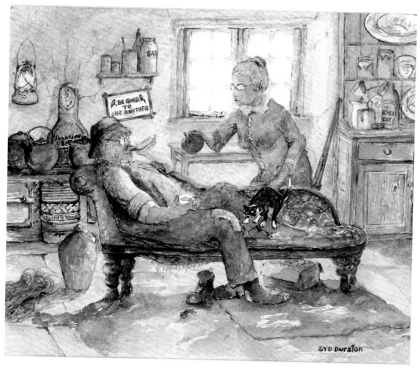

Drinking from a saucer was perfectly normal at the time, in whatever station of society.

Home after a long day in the fields.

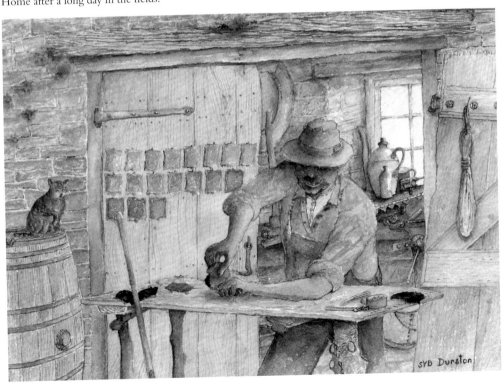

Skinning moles.

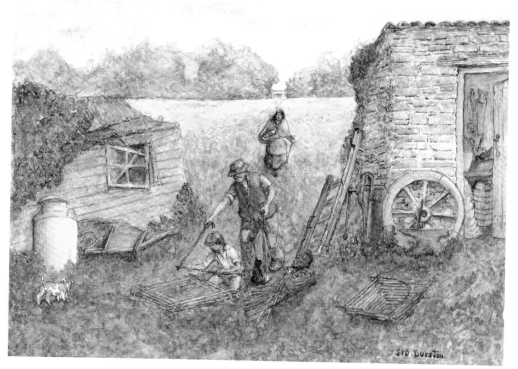

Hard at work, supervised whilst making the callyvan.

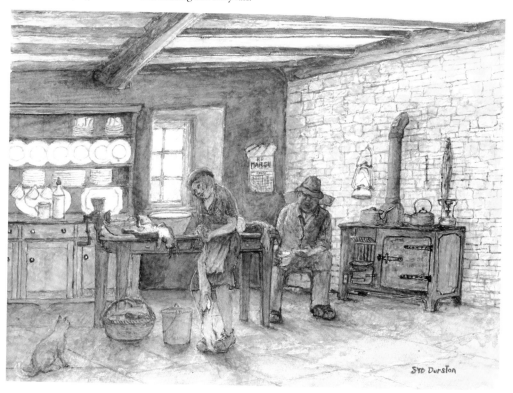

Preparing rabbits (whilst the cat looks on).

Pulling mangolds and putting them in heaps.

Winding wool. This pair are
unpicking an old jumper that was
worn out: the wool would be
knitted into another jumper, or into
something else, and nothing woollen
was thrown away. No man-made
fibres then, but only wool and cotton.

This is the scene I was greeted with at
Christmas, 1940. I had just come in from
milking the two cows I had to milk night
and morning; the day before I had also
been given a lamb by farmer Venn. My
mother was ill in bed, and my father was
holding the fort and feeding two at a
time.

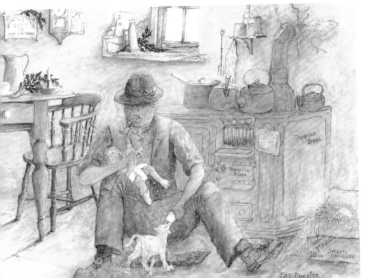

used in the old earth closet, it was difficult to know which was the worst smell, the closet or disinfectant! What you did notice was that all the massive spiders left their homes for a few days when the Jeyes fluid was used.

Vegetables were left in their dirty condition and were only washed before they were being prepared for cooking, as this was thought to be another source of unhealthy living, causing stomach upsets. Washing the veg affected the keeping quality, and it often went rotten soon afterwards. Washed swedes will keep only a quarter the length of time as unwashed ones, and most varieties of potatoes, parsnips and carrots are just the same.

All the clothes were either made of wool or cotton and were often washed with only warm water and a bit of soda to make the water soft. There was very little choice of soap. I remember blocks of brownish green soap for washing. Lifebuoy, Wrights coal tar and Pears were for if you lived in the big house. I can only remember the brownish green soap for washing and the red-coloured Lifebuoy, but my older friends assure me that there was a choice of soap. Before the war, I remember women rubbing goose grease into their hands because the soap and soda was so hard on them.

In the old wash house on wash days, all the white cotton bedding and clothes were boiled up in the old copper or furnace. This was usually the only means of getting a quantity of water hot. Once the whites had been boiled, it was transferred to a large tin bath and with a bit of soap given a good rubbing between the hands to get it clean. If this didn't get it clean it was rubbed up and down the rough wash board. Once clean it was put in another bath of clean cold water and rinsed thoroughly. It was then rinsed in clean water and Ricketts Blue to make it all look spanking white. Then it was put through the mangle, if you were lucky enough to have one, to wring all the water out. When this was done it was ready to hang on the clothes line. This was usually in the vegetable garden. When it was hung out, the pegs that would have been used would have been made by the gypsies from willow and a band of tin while sitting around their camp fire during the evenings and weekends.

During the hot summer months, the cooked meat was kept in a wooden bowl down the well or in a gauze cupboard in the cool, well out of the way of flies, keeping the meat fresh. This was common practice where people had an open well. The meat was either served up cold or it would be brought to the boil. It was never just warmed and served. The old crock that always hung over the fire, often without a lid, was never washed out – just added to and boiled well every day, replenished with any meat, rabbit, pigeon, carrot, swede and marrow bones there were to hand. A bowl of this in the evening with a hunk of bread was thought to be a decent meal and it was always ready.

Washing up the dishes, saucepan and cutlery was also done with very hot water and soda. This was very hard on the hands as there were no rubber gloves or hand cream, just a bit of the aforementioned goose grease.

Gazunders (chamber pots) were emptied and washed every morning. There were no toilets indoors; usually the nearest one, even in the big farmhouse, was at the top of the garden. A long way in the middle of the night!

The water for the house was either drawn from the well with a bucket, or pumped by hand again from the well.

The cutlery was made of steel and soon got rusty, needing cleaning at least once a week with a scouring material. This was made by scraping the soft Bridgwater bath brick, and using the dust, mixed with water, to make a paste. Giving the knives, forks and spoons a really good rub with it made them shine like silver.

Carpets and rugs were put on the clothes line and gently beaten until they were clean and all the dust had gone.

Starlings and sparrows' nests, of which there were hundreds, were ripped from underneath the tiles of the dwelling houses, and from off the wide wall plate, as these nests were breeding grounds for the fleas that could become a plague in the whole house and were often used as nests for rats and mice.

Woodworm was a problem, as there was nothing to combat it. I remember an old chap saying that some people are lucky they get woodworm in their furniture – my missus reckons we get moles in ours!

Lads learnt how to wash their hands properly when they were young, as they were always messing about with dead things like moles and foxes. Then there was the messing with the chicken's manure, cleaning out stalls; tending newborn lambs and calves. I think the worst thing was to have an addled egg break in your hand. It was important to get rid of the smell, at least, before you sat down to the table with other people. The Lifebuoy took away all the other smells.

For some reason, other than hygiene, children then got boils on their necks, or somewhere on their bodies, styes on their eyelids, or warts somewhere or another. I expect the reason for this was the poor diet most children had, but, whatever the reason, I seem to remember the boils and styes were very painful. Another thing that was very prevalent at that time was chilblains: most children were plagued with these on their toes, heels, legs or ears. The treatment we used for them was to burn common soda onto them, usually with a red-hot poker heated in the fire, holding a piece of soda in one hand and burning it with the red-hot poker and letting it drip onto the chilblain. It at least stopped the terrible itching for a time. Another cure for the chilblains was to dip your feet in stale urine, and the cure for a sore throat was to wrap a very smelly, sweaty sock around it while asleep at night.

All the sewage ran along the side of the roads in the open brooks. The toilets were a large piece of wide elm board with round holes cut in it, different heights and different sizes to suit all ages. These toilets were also designed and built mainly along the side of a brook, so that, when there was heavy rain, the water would flush them all out. This is when us lads would each pick out a large stool, have a good laugh guessing where it came from, and then with a stick race them down the brook. This seemed perfectly natural at the time, as it was all part of normal living to us. We would also go along the brooks with a long stick and dislodge any excrement that was lodged there. We got a few pence for this sometimes if it was hot and the place became a bit smelly.

CHAPTER FIFTEEN

HEDGING

Hedging was a job where you needed to have your tools razor sharp, because if they weren't you would finish up with what is known today as tennis elbow – but, unlike today, there was no way you could stop work because you had to pay for the doctor and you also had to put bread on the table. The cure for aching joints was to rub Driffield's oil into them. I remember Driffield's oil very well: it came from Day & Sons' Crew, Ltd. Keeping the tools sharp was done on wet days and in the winter evenings, with a few mugs of cider. There were all kinds of staff hooks, bill hooks, reep or rip hooks of all designs and shapes; slashers, hatchets and axes, all of which needed to be honed to perfection. The problem was that there was a lot of old barbed and heavy plain wire that had been left in the hedges for years and, if you happened to cut into any of this, the edge was ruined on whatever tool you were using in a moment, and you had to start honing all over again. The sharpening was usually done with a brown or blue (bawker) whetstone. Sometimes there would be sheep wire that had been put up to stop the sheep from breaking out,

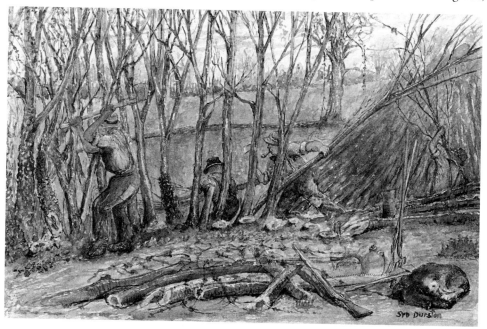

Men hard at work hedging, sharp tools at the ready.

forgotten and left to grow into the hedge. This was a nightmare, as, no matter how careful you were, you would always finish up cutting into it – with devastating effect.

A lot of the hedges, when the war started, were 10-12ft wide and 30ft high. All these were cut down by hand. In the beginning there was not even so much as a bow saw to use, just semi-crosscuts, hatchets, axes and bill hooks. The hedges were made up mostly of elms, ashes, whitethorn, brambles, maple, blackthorn, privet, elder and the occasional spindle-berry to give a wonderful show of berries during the fall when all the other leaves had fallen. There was no holly in any of the hedges on the Poldens, but it grew in people's gardens. All the large hedges were dug out and pulled out with horses, cut off high and the stumps pulled out with a pair of horses, or torn out with a set of chain pulley blocks. You could pull out quite large trees with a good set of chains and blocks, but the ash trees proved very difficult and in most cases were left.

A line was left where the hedge was supposed to be. This was usually defined by where the large trees were, mostly elms as much as 70-80ft high and 4ft across on the high bank. As every hedge had a ditch, and the ditch belonged to the same field as the hedge, this caused lots of arguments as to whom the trees belonged to as they were quite valuable. When the ditch was cleaned out, the spoils were thrown up into the hedge. This was done after the smaller trees had been laid down. The old chaps knew exactly where to chop these very low and how much to make it split in exactly the right place. They used to say, 'Cut as low as theese can. Try to split the root'. When laid down, the tree or sapling needed to be higher on the small end than the larger end so that in the spring the sap could rise and not have to go downwards. If the small end of the tree was below the cut on the larger end it would not grow in size, and more often than not it would die back to the first cut. When hedges were being laid, this is when the old chaps made a few shillings for themselves by knowing what shapes were wanted by the blacksmith or carpenter for scythe handles, arms and bows of chairs, crinoline stretchers, and anything else that needed a shape. They cut them out, or tied them to formers to grow to the shape needed. It was a little industry growing spare parts. Branches of ash or yew were especially grown in this way. It was always said that you could cut and lay until the end of May, but by the beginning of April the blackbirds and thrushes had made their nests and laid their eggs; with this in mind, as soon as the first leaves started to break, we stopped.

After the 10-12ft wide hedges had been taken back to about 3ft wide, they were allowed to grow up again for about three years, and then laid down again. They would then be trimmed every year with a staff hook for a few years to get them into shape and make the hedge thick and cattle-proof. When the hedges were being cut back and the trees pulled out during the winter, the dog would mark a heap of leaves in the middle of the large hedge and start barking. You knew immediately that beneath the leaves was a hedgehog and sometimes, if you pulled the leaves away, there would be as many as three rolled up asleep in hibernation. If you put the leaves back on them and placed a few larger branches over them they would survive, as there were very few badgers then to have them for supper. Today there are hundreds of badgers and very few hedgehogs. When did you last see a dead hedgehog on the road?

Today the roadsides are littered with dead badgers. Most people seem to love badgers because they are so pretty when they are pups, and badgers are now protected. In my humble opinion, however, the badger may yet be proven to be one of the countryside – and man's – worst enemies. They have a craving for honey, and anyone who works the land, or is at all interested, will come across somewhere where a bumble bee or wasps' nest has been dug out and destroyed by the cuddly badger. With the rapid explosion of the badger

population, the bumble bees and the hedgehog will find it very difficult to survive. Bearing in mind that practically all of the early pollinating is done by the bumble bee, without them many of the early garden and orchard fruits, and also the hedgerow fruits that the birds rely on, will very soon disappear. Who knows what eventual damage will be done? The badger needs to be controlled: tomorrow never comes, so a date should be set for a start.

All the small trees and saplings were put into large tidy heaps and allowed to dry out for a while before they were set alight early in the morning so that the fire would be burnt out by nightfall. If it wasn't, it would be covered up with earth dug out with a spade. All fires had to be stifled at night: this was mandatory. Once the hedges were under control they were trimmed each year, as soon as the blackberry season was over. The blackberries were part of the economy of many village people, as it was a bit of extra cash and the blackberries were made into jam, and also used for the dyes for camouflage. They were collected by lorry twice a week. Some weeks as many as 3½ tons were stored in barrels ready for collection at Fred and Emily Bartlett's at the War Memorial in Catcott. Some of the hedges on the moors were grown as shelter for the cattle in the middle of the fields they were white thorn, allowed to grow fairly high but keeping the bottoms trimmed and thick. They were planted in the shape of a T as, whatever way the T was (and whatever way the wind was blowing), if the bottom was kept trimmed and thick, the animals had shelter, as all but a few animals, other than milking cows, were wintered out of doors in the fields and actually put weight on much quicker in the spring than animals that had been wintered indoors.

Nearly all the hedge shrubs grew food for the birds, and birds were in abundance as the hawks, crows and magpies were kept under control by the villagers and farmers. There were loads of old sheds, barns with ivy growing up the walls, and also holes in the walls for them to shelter in. If the cattle had food, so did the birds.

Most farmers had a little nursery where they grew white thorn, hazel, maple, blackthorn or any other kind of hedge sapling that grew in the hedges, using these to fill any gaps that came in the hedges when either something died or the cattle ripped out the hedge with their horns.

The large timber that was cut out of the hedges – unless it was burnt when the hedges that were mostly blackthorn were cut – was used by the sheep farmers from Shapwick, who would make all the thorns about the size of your fingers into faggots tied with willow or hazel, to stop gaps in the hedges to keep the sheep in the fields. They were transported with horse and wagons, and loaded right to the top of the lades using a pitchfork. This was done in this way because there was no wire available – all metal was needed for the war effort. Timber came in very handy as coal was rationed. It was always said that you got hot three times with the wood: once when you were cutting it down, again when you were sawing it up, and once more when you were sitting in front of the fire. There were enormous heaps of timber, but a lot of it went rotten as there was no way of covering it up – no plastic sheeting then. Some people did try to use the straight rails cut from the hedges and lay them in a way on top of the heap like thatch to shoot the rain off. This was successful to an extent but, nature being what it is, the rot started to set in quite quickly.

If you went to a sale and there were sheets of old galvanized iron they would make double new price: you simply couldn't get it, as all the steel was going to the war effort. Anyone who didn't have a hay barn in 1940 couldn't get one until 1947, and this is the time when things really started to change. From having nothing to use, suddenly farmers were bombarded with agents trying to sell all kinds of machines and equipment. The problem was that very few people had the money to buy – and this was the start of H.P.

CHAPTER SIXTEEN

THE EVACUEES

It was a big day. The evacuees arrived at the village after the seven-mile journey from Bridgwater station in an old charabanc, having made the journey from London to Bridgwater by train.

They were dropped off in Steel Lane at Acreman's old shop, which had just closed because the old lady who ran it had decided to quit because of the war. This old shop had sold anything from a ball of string or truckle of cheese to a gallon of paraffin. I remember I went there on my fourth birthday with a penny, and for that I got eleven caramels and seventeen brown dumps. She also sold cheese, sugar, tea, biscuits, and so on. This old shop was part of Cypress House, quite a large area with a wooden floor and galvanised roof. There were two large windows that went all across the front of the building, and over this was a galvanised veranda.

The evacuees were assembled in the shed-like building, all wearing their Sunday best clothes and carrying a small case in which was the rest of their clothes and belongings. All the children were labelled with a label with their name written on it and tied to them somewhere with a piece of string. Another brown cardboard box, about 8ins square, was fixed to their backs by way of a piece of string; in these boxes were their gas masks. For these children this must have been a very frightening experience, as everyone and everywhere was strange. As soon as the children arrived, they were greeted by the WRVS lady who was to take charge of them. Her name was Mrs Dewar. Her husband was a very prominent archaeologist in the South West. They lived at Lippets Way in the last house on the road to Shapwick. In a small paddock adjoining the house were two large wooden battery houses where they kept hundreds of laying hens in battery cages, though at that time only one hen was kept in each cage. Mrs Dewar was a short, thick-set woman always dressed in brown-green Harris Tweed costumes, with a trilby type hat, both summer and winter. She had no children of her own, but most of the evacuee children took to her straight away as she had a disposition seldom found in people at that time. She was intelligent, thoughtful and kind and treated the children the same as she would have treated adults. The older evacuees gave her a hand sorting out who was going to go where and with whom, with Mrs Dewar having the final say. When it was all sorted out, the children who were billeted away from the centre of the village were taken to their different destinations by horse and cart. The children thought this was great fun, riding in a farm cart drawn by a horse, but they had no idea of the danger of the horse's feet or the wheels of the cart. Another thing the children had to learn quickly was that farm dogs couldn't be messed around with like pets.

Mrs Dewar had reservations about billeting some of the children with elderly spinsters with no idea about how to look after them. I don't think this was fair on the spinsters or the children, but this is how it had to be.

When the children arrived at the school no provision had been made for them by way of desks, so we had to share, three children sitting at a desk designed for two. The old desks with the seat running all the way across were fine, but desks with individual seats were very uncomfortable. After a few weeks, however, we took no notice and thought it was ok. Then, as soon as we were settled to this way, new desks arrived and we were sorted out again. The only problem was now all the desks were pushed much closer together.

Some of the names I remember of the evacuees that came to the village were: Pat Laundy, Joan Clarke, Francis, Frank, Mary, Elsie and John Twitchett, Elsie and Ivy Denigrie, Lillian Makin, Joan and Joyce Mills, Sid Hawzen, Joe Venton, Robert Betty, Barbara Harper, and June Miles. There were about twelve at Cypress House, a house with five bedrooms that had been commandeered by the council for the evacuees. These were taught there and were looked after by a woman who came with them. I remember they contracted scabies and all of them had their hair shaved off.

Westbrook House was another place that was taken over by the council. Two women looked after these children as at Cypress House. Two of the boys here climbed over the high wire fence into the village sewage works: one of them fell into the deep sludge pits and was very lucky to have been rescued by a passing farmer. Things soon calmed down, however, and both sides cooperated with one another, the couple of evacuee hotheads being taken in hand and given some very strict discipline. Sid Hawzen, who was billeted with Mr and Mrs Harold Venn at Langlands Farm, went out on his own across the fields one day and found some khaki kamble ducks feeding in a stream. He killed three of them and took them back to the farm, feeling very pleased with himself. He told Mrs Venn there were lots more there, and couldn't believe it when he was told that they were someone's tame ducks.

I got home from school one day to be told by mother that we were going to have some evacuees. Our front room had been commandeered and a mother and daughter were going to move in. And move in they did, but had to share the range in the old flagstone floor kitchen to do their cooking. Any water they had was from a pump outside the back door, and the toilet was the other side of the farmyard. They stuck this way of life for about three weeks and then decided to go back to London. I don't remember all their names, but the little girl's name was Doris.

I don't remember any of the evacuee children taking up the voluntary Blue Card System. The most I remember any of them doing was feeding hens and picking up eggs, or feeding and watering small chicken and ducks. They did a lot of things that made people feel like pulling their hair out, but it wasn't their fault as they didn't know any differently. Later on, it was something for people to talk and have a good laugh about. I think we all got on well together, or that's how it seemed to me, and after the war most of them came back for their holidays, in many cases bringing their mums, dads and all of the family. So things couldn't have been so bad.

Francis Twitchett was billeted with Grace Acreman; her husband Cyril, the carpenter's son, was in the army. Frank, Mary, Elsie and John were billeted with my Uncle Edmond and Aunty Sarah across the road. Aunty Sarah cooked on an old black lead range, water drawn from the well and toilet across the yard, no bathroom. Lily Makin was billeted with Clifford and Elsie Bartlett next door to our place. She was there for a while before their

son Wilson, who was in the army, died. She was re-billeted with the Venns at Langlands Farm. Harold Venn is still alive. I went to see him a while back and he told me that Lillian had called around to see him not so long ago at his bungalow at Ashcott. He now lives at the Welfield Care Home in Catcott in the centre of the village, converted from what used to be the Royal Hotel Pub. It's been extended somewhat and has a very good reputation. Harold is very happy there, has all his faculties and can recall anything when his memory is jogged.

Pat Laundy, and Joan and Joyce Mills were billeted with Mr and Mrs Ern Wilkins at King William Road. He was the local builder. The Harpers were with relatives next door to the Wilkins. June Miles was also a relative staying at the King William pub. The Denigrie girls were somewhere on our corner, but I can't remember where. I remember one of them liked the older boys and they liked her. Joan Clarke was at the Begbies at the big house, now called the Old House in Manor Road. There were two girls with Tom and Mabel Vowles beside the school next to the poor house and the pound. There were lots of others too, but I just can't remember where they were billeted or their names. I do know that most came from the Chadwell Heath, Romford and the Stratford area. The school records show that in all seventy-three evacuees passed through the school.

When the war was over and the evacuees had returned home, Mrs Dewar approached the council about allowing her to use the old shop where the evacuees had first assembled to start a youth club for the village teenagers. She was by this time quite elderly and soon found the walk back to Lippets Way after closing the club at night too much for her. Without her thoughtful ability to lead, and the discipline that she commanded, everything that she had worked so hard for was soon in disarray and quickly folded.

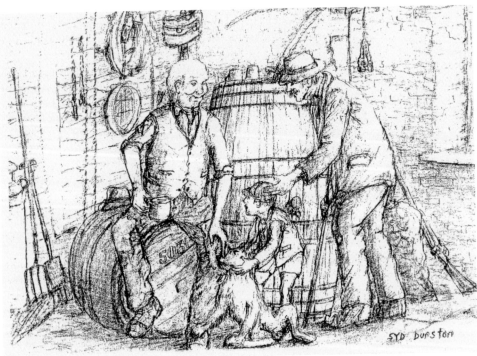

He might bite...

CHAPTER SEVENTEEN

CHARACTERS

Out of all of the local characters that were around, the first that always comes to mind is Harry Whitcombe. He had a grin from ear to ear and a rare humour. You never saw Harry without him doing something, or saying something, to make you laugh. He drank two gallons of cider during each day and took two quart bottles to bed with him at night. If Harry, like he sometimes did, came home inebriated, his wife would say, 'Oh dear Harry, you're drunk again,' and Harry would say, 'Never mind Mrs, so be I.'

Harry and his wife survived mostly on potatoes, cow cabbage, swedes, turnips, eels, pike and wild duck, eating the eggs of the moorhens and lapwing in the spring. They lived in an old brick house about a mile down on the moor in a field south west of the canal and the Somerset and Dorset railway line at Catcott crossing. It stood on a small high peat batch and it was surrounded by water most winters, often only accessible by boat.

Harry got caught up in a fight with the council about rates. Harry maintained that he shouldn't pay any as he had no drinking water and no toilet facilities. All he had, more or less, was a shed in a field only accessed by a footpath from one way and a half-mile long grass drove from the other. He walked everywhere along the droves and footpaths, and because of this he refused to pay any rates. During the war, if anyone fell behind with their rates, because of the shortage of labour, it was down to the local policeman to collect them. The local bobby at that time was Bill Smith. He lived at Ashcott, and was a big burly, heavily built man; the kids feared him. When we saw him coming, we all skedaddled out of the way.

Bill went to see Harry time and time again to collect the rates, but Harry always refused to pay. Then, one day, Bill went down to see Harry and became exasperated with Harry's attitude. Bill said, 'Now look here, Harry, I'm beginning to get worried. I've nearly wore out a set of tyres on this bike coming down here to fetch these rates.' Before Bill could say another word Harry said, 'You don't need to worry, constable, you will wear out the frame and you still won't get em.' And once again Bill had to go away empty handed.

Harry then let the house get in a terrible state. It was damp, few panes of glass left in the windows, the roof was leaking badly, no drinking water or toilet facilities, and the chimney had collapsed. The council came, took one look at the old house and condemned it. Harry and his wife were evicted. Now Harry was made of different metal than most, and he wasn't going to be beaten by the council. So he went off and bought a wagon and a large tarpaulin. He got a farmer to pull the wagon to the outside of his old house. As soon as it was there, Harry set to work putting up the lades, tying some elm rails across the top of the lades and roping them down. He then threw the tarpaulin over it, securing it down

with ropes and pegs, cut a hole in the tarpaulin and nailed an old window to the inside to keep out the rain and let in some light. Then he brought the old feather bed out of the old cottage and put it in the wagon ready to sleep on and said, 'Now let them try and evict us from here.' Harry and his wife lived like this for nearly three years, summer and winter, doing their cooking on the old grate in the cottage.

One day a woman came to visit Harry's wife and, or so the story goes, Harry was outside the wagon skinning some eels when the woman asked Harry where his wife was. Harry said, 'She's in there somewhere, probably upstairs dusting.' A typical Harry answer, real Harry humour – he was so dry. He had lots of ways and sayings. When he got to work in the morning he would have a good stretch, rub his hands together and say, 'I feel all full of work this morning, but I expect I shall take most of it home with me when I go home tonight.' Then he would have a good laugh. In the end the other chaps used to say it for him, and even this caused a lot of laughter with the jibes that came after.

One day Harry went missing; he had left without trace. It was unheard of for Harry not to come home. A woman out looking for Harry, describing him to a tradesman, said, 'He's a tall upright man, a little bit back over with a big grin.' I think this was a very good description of him. Harry wasn't missing for long, as he returned the next day. He'd been caught up in an extended card game, but, as soon as the cider ran out, Harry decided it was time to leave. After having a good time at the card game, Harry felt they were both missing out on life. He talked it over with his wife and they decided, if they could, that they would leave the old wagon and take the council's offer, of part of Cypress House at Steel Lane, Catcott, with an evacuee family and Fred and Gladys Farmer and their family. This family lived in the old shop and store room at the back.

Fred had been the carter at a farm at Cannington and was as much like Harry as chalk is to cheese. One day the farmer had given him his orders of what to do and he set about starting to do them when the farmer's wife asked him to clean her car. Fred said, 'Sorry madam, I take my orders from your husband,' and went on his way. When he got back to the farm with the horses in the evening his cards were waiting for him, and, as his tied cottage was part of the job, he had to find somewhere else to live. The council put him in the old shop and store at Cypress House, no tap or toilet inside and the rotten floor boards were covered with flat pieces of zinc. Derek, the eldest boy, was in the R.A.F. Alan was attending Dr Morgan's grammar school at Bridgwater and made the journey to and from school each day on the service bus, making the best of this time doing his homework during the journeys. As soon as he got off the bus he would drop a ball on the ground – and what he couldn't do with a ball wasn't worth doing. He had two sisters, Muriel and Shirley. Shirley was the youngest; both girls went to the school at Catcott. There were also two older sisters.

Fred got a job at the brick and tile works at Chilton Trinity nine miles away, leaving home at about 6.30 a.m. every morning on his old bicycle and getting home at about 6 p.m. in the evening. Sometimes he would cycle all the way to his workplace in heavy rain, and if it was still raining at 10.30 a.m. the boss would send him home with no pay – and all his clothes soaking wet, which he somehow had to dry for the next day! People accepted that this was how life was.

Gladys, with all her problems, seemed to always have a happy, smiling face, and Fred could never seem to be put down; after working long days as he did, and with bad feet and knees from all the walking behind the horses, he even found time to give a hand on my uncle's farm at weekends, and the large kitchen garden he had was immaculate. Once he

had grubbed out all the brambles and elder when he took it over. They eventually moved back to Cannington.

Harry, his wife and granddaughter stayed there for a while before they moved to a council house at King William Road, practically next door to the 'King Billy', as it was known. Small wonder that Harry became a frequent visitor! Harry was now in his element, telling all his stories about how he had lived in the wagon, and all his stories of the fight with the council and Mr Silver Buttons, as Harry called the policeman. He was now joined by a few more with the same kind of humour. Little wonder that the old King Billy rocked with laughter as they fed jokes one to the other. One day Harry had a bright idea: you had to think of something funny or unusual and then stand up and tell the biggest lie you could possibly think of about it. Some of these stories turned out to be so funny that they brought in more local characters. The lies got bigger and bigger, and the stories more funny. The old pub was always packed out, the cider flowed and everyone had a wonderful time, usually finishing up with a good old singsong. The music was supplied by Bert Bartlett with his old squeeze box and mouth organ. In later years Bert became the landlord.

There were so many characters in Catcott, and a few comedians, and the antics they got up to! A book could be written about each and every one of them. There was George Bryant, Cliffy Searl, Archie Norris, Bill Pole, Lionel Burrow, Fred Bartlett, Arthur Bargoyne, all telling stories about things I couldn't write about in this book. How different it was then: no background music all the time and no telly. Most people remember Harry.

Cliffy Searl was what was known as a likeable rogue; he was a bundle of fun, but was always trying to put one over on everyone. Like the time he told all the farmers that grazed their horses on the droves on Catcott moors that he was now legally renting the grass keep on the droves from Mr Bussell. He warned all the farmers off, and as they all knew that Mr Bussell owned the rights they all kept their horses off. Cliffy milked about a dozen cows there for about twenty years in the spring, summer and autumn. When Cliffy started milking on the moors he used an old Douglas motorbike and sidecar, carrying the churns and bucket in the sidecar. The old bike started to give a bit of trouble, and he then bought an old Morris 10 4 Dicky tourer, painted bright blue, and carried his churns, bucket, stool and feed in the dickey at the back. No one knew he had kidded them for all that time until he stopped milking cows and started keeping sheep on the land where he used to make his hay.

Fred Bartlett was a jovial man with a very strong and good singing voice. He had a big heart, feared nothing and was as strong as an ox. With his strong voice you could hear him singing in the chapel above everyone else. There were two other really good singers among the chapel congregation, Cliffy Searl's wife and Anny Gulliford – these three could lift the roof. You could hear Fred going milking at 6.15-6.30 a.m. each morning, yodelling and singing his head off come rain or shine. If he was ever late he always put it down to the same reason: Emily, his wife, had been lying on his shirt tail and he didn't like to wake her. He milked his cows at night and morning, grew mangolds and made his hay; the rest of the time he cut peat in his peat field at Shapwick moor.

One spring evening, as he was coming home from milking, he discovered that the gypsies had camped on the wide grass verge at the bottom of the Nydon Hill outside his field. He stopped, had a word with the gypsies and told them he didn't want their horses in his field. They assured him that they would not eat his grass as they had the beasts tethered on the side of the road. He told them he would be going to bed early as he had to make

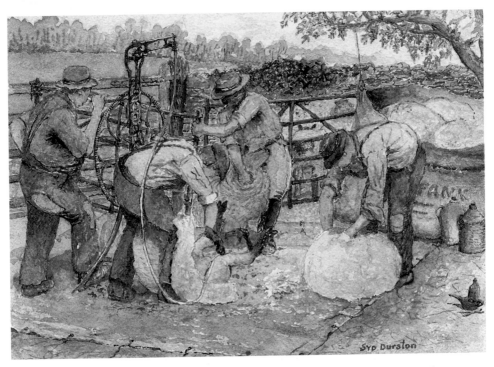

Shearing. No one realised the joke that Cliffy Searl had played until he started keeping sheep on the droves.

a very early start the next day. He went home to his house, next to the war memorial, unloaded his milk, took the pony out of the cart, un-harnessed it and turned it away to the field at Nuttingcombs where he always kept it at night. He then went home and had some supper, and afterwards decided to walk it off by going down to the moor to check on the gypsies' horses. When he got there he found the two gypsy horses tethered in his field. He walked quietly to the roll-top Romany van, caught hold of the back wheel by the spokes and tipped it on to its side. He then went to the field, caught the two horses, took them back to the van and asked the gypsies, who were by now out of the van, if these were their horses. He told them they could only have them back if they moved on; otherwise he would take them to the village pound and lock them up. They moved on.

He did the same thing to another gypsy family that ate his grass the following year. He never had any trouble after that, but many other people did. Usually, when you had a conversation with anyone in the village about anything at all, it would be very unusual not mention something that either Harry Whitcomb or Cliffy Searl had said or done.

CHAPTER EIGHTEEN

THE RAG AND BONE MAN

The rag and bone man has just come to mind; I don't know how this could have happened, as this was our only source of pocket money. He was a small man with shoes falling off his feet and all his clothes were in rags.

He came around pulling an old hand cart and shouting, 'Rag a bone – rabbit skin, rag a bone – rabbit skin' constantly as he walked along. He collected rags, bones, rabbit and mole skins, fox furs, and old long leather boots, the ones that came up to the knee, either laced or button-up.

I don't remember how much he paid for the rags, bones and boots, but I remember he paid £1 for a good fox fur and a little bit more if it was very red or had an exceptional bush. He paid 3d each for the rabbit skins and 6d each for mole skins.

A couple of men, Archie Norris and Frank Tratt, did little else in the winter when the threshing had finished other than catch moles and skin them. There were so many moles on the moor that, by the time they had set all their traps, many of them had moles in again. They caught hundreds a week.

The bones the rag and bone man collected were ground down and used for making glue. The rabbit and mole skins made beautiful fur coats for the rich and famous, the well to-do women of the large country houses, and the elegant, rich city dwellers. The fox furs, apart from the very best, were made into fur coats or shawls and the best ones were worn like a scarf thrown around the shoulders.

Most women wore a fox fur around their neck: they wouldn't feel dressed without one. My father caught foxes and he was always being asked for good fox furs. Just like today, some years there were lots of foxes, some years there were very few, so the price of skins fluctuated somewhat. The rag and bone man would always pay £1 for a fox fur, but sometimes you could make £3 for a really good one to someone in the village. The foxes had to be caught, as there were no hunts in operation during the war. Big shoots were organized to reduce the numbers. Large numbers were shot but it's not a satisfactory way to control them, as many get badly wounded. At least with a pack of hounds or a snare they don't have to suffer for months on end. About twenty years ago all the beautiful furs were put in heaps and burnt by animal rights activists, but while on holiday in Greece last summer I saw that real fur seems to be back in fashion again, and women are once again clamouring for them. Funny old world!

The rags in those days were all pure wool or cotton. Most of the woollen garments were knitted by hand, and when they were worn out, whenever possible, would be unpicked, the wool wound into balls, then left in hot but not boiling water for a couple of hours

Boys playing a game of conkers. Nothing was wasted then: even the socks these boys are wearing would be reworked and reused; the feet of worn-out socks would be cut off and sent to the rag and bone man.

before being taken out and left to dry. This was done to get the crinkles out of the wool. The wool, when dry, would be knitted into some other garment. Socks had the feet cut off and the feet were re-knitted. This was done because the heels and toes of the socks had had so many holes worn in them, and been darned so many times, that it was like walking with stones in your boots or shoes. The cut-off feet went to the rag and bone man. Other old clothing was made into garments for the children. Only after it was completely worn out was it classed as rags. They were what the rag and bone man collected, and he sold it back to the mills for recycling. Nothing was wasted. Today, there is more thrown away in a month than would have been thrown away then in a hundred years.

CHAPTER NINETEEN

THE CARPENTERS' SHOPS

There were two carpenters' shops in the village. The one next door to my grandfather's farm, Northbrook, made mostly doors, windows, door jams, window frames and did repairs. He also made wagon-, cart- and wheel-barrow wheels and shaped shafts for carts and traps (governess cars). His name was Tom Acreman.

The workshop was a large lean-to against the house adjacent to the road. Tom could do just about anything with wood. He had a sawpit at the bottom of the garden along the side of the road. There were trees beside it, but I can never remember seeing it used; this is where he cut his elm, oak and ash to do his jobs.

Tom was a nice old man and would let me in the workshop to pick up the little square blocks of wood around the shop floor that I would take home and play with, trying to build things, and my father would show me how to make the different size blocks fit together. It was a joy for me to watch him shape a piece of wood, to repair a piece of furniture and to watch the job progress, and also have it all explained: why things were done in a certain way. This explaining to me when I was a boy helped me no end when I became a man. I am probably one of the few who could still teach the way but sadly, as I have no written qualifications, I am not allowed to.

Tom, Mr Acreman to us boys, bonded the different types of wheels on the grass verge next to his workshop, using peat to make the fire to heat the bond. This was put all around the bond on the ground and then set alight. The wheel was placed on a series of stub oak posts in the ground, placed at intervals, so whatever size the wheel was it would rest on, say, nine hard points – Heath Robinson, but it worked. When the wheel was in place and the bond was hot, Tom always seemed to collar someone to help him lift the bond onto the wheel with two pairs of large pinchers; the hot bond was then hammered on to the wheel and cooled down with water. It was then that you could hear the joints crunching into place as the bond got smaller.

Tom had two sons: one was a plumber and one was very backward, but even he was given jobs to do. He would go around to the large houses in the village and run errands for them. These people would put money and a list and note in a purse into a basket, and he would be told where he had to go. When he got there, the person concerned would take the purse and the note, put the goods and the purse with the change into the basket and he would then take it back to the house. For this, he was given small change. He then went on to the next place. He was usually busy.

The other workshop was a completely different place. It owned by Fred Arthur, a very different man. If you went anywhere near the shop he would tell you to clear off.

This large wooden shed/workshop was down a dead-end lane, a lane where we seldom went, so I don't know a lot that went on there. Fred was the village undertaker and made coffins, mostly of elm but sometimes of oak, solid inch-thick boards. The bearers he used were all drawn from the village, and of course the same men were called upon to do the job the whole time, and they felt obliged to do so and would never refuse no matter how busy they were.

If the coffin was oak they would always charge for their time, but if it was a poor person they would never charge. There was always great reverence at a funeral; everyone wore black. You could feel the respect, no matter how humble the deceased.

I remember the bearers talking among themselves and saying that the coffin was enough to carry on its own, as sometimes they would have to bear it for half a mile or more with most of the people of the village following behind. All the men of this village had black suits, overcoats and bowler hats for these occasions, but sometimes couldn't get into them (as they had put on weight or for some other reason). They would then have to rush around and find a suit belonging to someone else that would fit them which they could borrow. As you couldn't buy clothes off the peg in those days, you chose your cloth, were measured up and then had to wait for the garment to be made up on the premises. The women also dressed in black in clothes and hats kept especially for the occasion of funerals. Lots of women borrowed one another's clothes for funerals as there were not enough coupons to buy everything you wanted; some of the people had very little money anyway. It was often a talking point, as everyone knew who all the clothes belonged to.

Back to Fred: I remember people talking about household things that he made – dressers, cabinets, settles, food cupboards, tables and stools. He also did work on the church.

The way I remember Fred, Mr Arthur, is in his most important roll – walking in front of the coffin like a sergeant major.

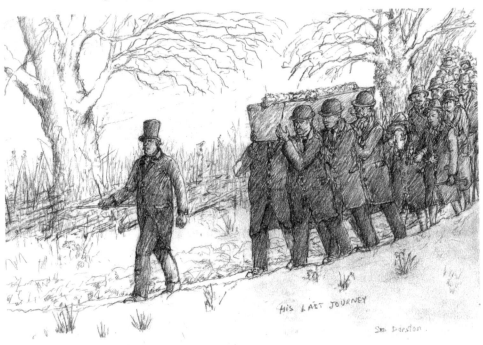

HIS LAST JOURNEY

Stan Dorston.

CHAPTER TWENTY

BUTCHER MARSH

Butcher Marsh had a butcher's shop at Chilton Polden. He also had a slaughter house there, and killed his own animals. Everyone called him Mr Marsh.

He came around twice a week with his horse and butcher's cart. This cart was like a showpiece, high and two-tiered, painted brilliant white inside, jet black gloss and very fine-lined in yellow on the outside, a real picture and spotlessly clean. The horse that pulled the cart was a horse that really stood out, also jet black with a coat that shone like silver, plaited mane and pulled tail, hooves clean and well oiled. The harness was out of the top drawer with gleaming, bright-shining brasses. Mr Marsh himself always wore breeches with brown boots and leggings, dark blue and white striped butcher's apron, and everything else, except his straw hat, white. He always looked very smart, as he was a tall figure of a man, and he carried himself well.

When Mr Marsh pulled up with his butcher's cart, the women would come out with their plates or dishes to carry their joints back to the house. The meat would then be put in a meat safe, a wooden cupboard with large panels of gauze in the front doors and side panels to keep the air circulating, or was instead covered over with a large sieve to keep the flies off.

To me the meat always looked wonderful hanging in the cart. Meat was always hung, never left on a flat surface. The customers told Mr Marsh which joint or what part of the joint they wanted and he would take it down, cut off what was wanted and hang the rest on a crook back on the rail. A damp cloth kept all the surfaces clean, as there was little blood left in the meat. While waiting for customers to come to the cart he would sharpen his knives. Dogs would always be around waiting for a morsel, but they never got anything.

Mr Marsh sent his bill once a year. My father paid by selling him a bullock to square his debt, as we never had any money. Most people were in the same boat: very few had money that they could put their hands on. The bill was about the size of fifty-two postcards folded like a concertina – one for each week of the year.

Every Christmas, at the school, the villagers would have a concert and Mr Marsh's bill would be the subject of many of the jokes and would cause a lot of laughter.

Many people only sent out bills once a year at this time and would only be expected to have to pay once a year.

I remember one man arriving at Catcott from Ireland; he came to live in the house now known as Framptons. He arrived at the end of December. He called himself Lord Clonmell, and hosted frequent drinks and dinner parties. He bought all his meat from Mr Marsh, and game from anyone he could get it from. He paid as much for a snipe as

for a partridge, and Uncle Edmond spent a lot of time shooting them for him. All the agreements stipulated that he would pay only once a year, the beginning of January, the same time as his money arrived. With him spending so much money and having the name Lord Clonmell, everyone was trying to get in on the act, all trying to help him spend his money as if it was going out of fashion.

At Christmas, at the annual Christmas concert at the school, in his jovial Irish way being the centre of attraction, he stood up and told a few of his many jokes, leaving the villagers in stitches, with the tears rolling down their faces. Then he made a little speech about how he hoped his money would arrive, and how he had enjoyed his first year living at Catcott and making so many friends. He finished up singing a very funny song about going away. It went something like: 'I'll be going, I'll be going in the morning. I'll be gone, seeking me out will be in vain, I shall never be seen again.' There were lots of verses and at the end he was given a standing ovation, and thanked by the Chairman of the Parish Council for the lively contribution he had made to the village. But, true to his song, in the morning he was indeed gone, leaving all his debts unpaid. What a difference a day makes! Some people were pulling their hair out, and others were laughing their heads off.

This taught everyone a big lesson, and from that time once-a-year payments were a strict no no for anyone who wasn't known.

CHAPTER TWENTY-ONE

SAMMY ELVER'S

The old cobbler's shop was known as Sammy Elver's. No points for guessing the name of the owner! The shop was at the bottom of the drang, an alleyway, joining the top and bottom of the village.

I had to pass the shop going to and from school each day. Imagine a door with gleaming, highly polished brass work; the door handle, letter box and knocker were all kept polished by Sammy's wife. Inside, against the back wall, was an old dresser base, on which Sammy tidily arranged the repaired shoes and boots, labelled and priced, ready for collection. Above this were shelves where Sammy kept the tallow, small pieces of leather, thread, nails, dubbin and polish. Then there were the large pieces of leather and reams of bootlaces, and long boots, hanging against the back wall. A heap of unrepaired boots and shoes lay in a corner.

The shop carried a smell you could never forget: the smell of leather, dubbin, tallow, old nails and polish, mingling with the smell of rising damp, decaying flagstones and old dust.

In spite of this smell, Sammy, although suffering from terrible asthma, kept going all day, sitting on his old cobbler's bench, in his specs and leather apron, with a mouth full of nails, spitting them out individually into his finger and thumb. Then, with one clout of his hammer, he would drive the nails right in. He worked just like a machine and the timing was immaculate.

When he wasn't hammering in nails he would be hard at work, sewing by hand. This meant making a hole with a bradawl, and having a needle and thread at opposite sides, reciprocating them through the hole and pulling the thread tight, but at the same time putting just enough tallow on the thread to make the holes watertight.

Sometimes he sewed the soles onto the boots – boots that were known as best boots or market boots – deeply scoring all around the outside of the sole, so that the stitching would be hidden and would not wear away as the leather wore out.

Sammy could do anything with leather, from small repairs to making a new pair of boots or shoes from scratch. He was always very busy, very conscientious, never gossiped and was very upfront.

CHAPTER TWENTY-TWO

THE LEVELS (MOORS)

The levels, on the north side of the Poldens, were an enormous flood plain, the type of which was found nowhere else in the country, running from Highbridge to Glastonbury and beyond, before they were drained to supply water to the Royal Ordnance Factory at Puriton. With the rain and the floods came hundreds of thousands of water birds, geese, every kind of duck, widgeon and teal. Many of the mallard stayed and bred and were always in residence, as were the snipe, curlew, swans, moorhens, lapwings and herons. I can't remember coot on the moor.

Father's younger brother, Uncle Ernie, and another man in the village, Frank Woodward, made a flat-bottomed boat out of elm, and after it was finished gave it a thick coat of pitch to keep it watertight. They made this boat to earn themselves some money. On the front of the boat they rigged up an old blunderbuss to shoot some of the thousands of wild fowl feeding on the water. They took the boat down to the moor, camouflaged it (and then themselves) with bits of white thorn, and launched it out onto the water. They loaded the old blunderbuss with black powder and shot right to the end of the barrel, then let the boat drift on the water to where the wild fowl were feeding. When they thought they were in the right position they released the charge in the old blunderbuss, and this is where it all went wrong! Because they had used so much powder and shot, the old blunderbuss was overloaded and blew to pieces, loosening some of the joints in their boat. It started leaking badly and quickly sank. Neither of them could swim, and they had to be rescued. They couldn't move from where they were because they had no idea where the ditches were. I seem to remember they didn't try making their fortune the same way again.

When the first rains of the winter came all the lowest land would get flooded overnight, but sometimes the farmers would be caught out. If there was torrential rain this would put the whole moor under water in twenty-four hours. The moor had peat (batches) or higher bits of land in parts of the fields; this was the land where peat had not been extracted thousands of years previously. The animals would take refuge on these but, if the rain was persistent and really heavy, they would be standing in 18ins to 2ft of water and then had to be rescued. Someone would ride a horse through the water, sometimes up to its stomach, and drive them out. If these animals hadn't been penned in the fields they would have, by instinct, moved to the hill; all the foxes, hares, stoats and moles moved to high ground before the floods arrived.

During the winter of 1941-42 the floods were very bad, the rains came early and all the cattle had to be moved off the moors; in turn, the moors became the normal feeding grounds for all the many kinds of water birds that always came with the floods.

About the middle of December 1941 the frosts started and then thousands upon thousands of water birds of all description flocked in. They must have known what was in store for them, as by the beginning of January 1942 the weather was so cold and the ice so thick you could skate all the way to Glastonbury. It seemed to constantly rain, and the rain turned to ice as it landed on the previous ice: often the roads were just like a sheet of ice. I remember my father having a spade and chopping a hole in it to see how thick it was. It was over 1ft deep.

When the water receded from beneath the ice, the sheet began to crack and the sound of this was like thunder all through the day and night.

This cold spell must have caused the death of thousands of water birds; tiny corpses could be seen everywhere on the moor with not enough meat on them to even tempt the many foxes.

There were batches at the bottom of the moor that would never flood as some of these were up to 12ft high. In the spring, these batches were where the vixens had their cubs, as the peat was easy for them to dig holes in. Some years there would be three or four litters in these batches. It was easy for the vixens to dig their dens, but it was likewise easy to dig them out and this is what happened. Some of the vixens would have six cubs, so you can see that if they weren't controlled, the place would soon be overrun with foxes.

When all the land was flooded, the sea wall sometimes broke. This would let in thousands of eels, pike and other freshwater fish from the canal, along the Somerset and Dorset railway line and the river Brue. This is why there were so many eels and pike in the ditches on the moor then and very few now, as they stayed in the ditches when the water receded. When the water was gone there was a thick layer of gunge left over the moor, a mixture of lime washed from the clay, old leaves, dead grass and grozen (duck weed). This was an excellent natural fertilizer and within about four to six weeks of the water going, the moor would be covered with thick white clover. Usually by this time the land was firm enough to stock, as it wasn't heavily stocked like it is today, but today there is no clover – just mostly ryegrass, vetch, and buttercups. Or, if the land is left and not sprayed, managed, or given a dressing of fertilizer, whole fields become one matt of rushes, as these were always cut by hand, digging out the roots with a very sharp spade; this was called cutting. Fields of rushes like this are no good for anything other than for the foxes to lie in; where you find rushes so thick you will never find wading birds, and even the snipe are present for nothing but roosting. The only fertilizer used on the moor when I was a lad was basic slag, a by-product from smelting iron.

When the moor was flooded, enormous flocks of starlings would start their flying displays early in the afternoon, and would carry on until nearly dusk, twisting and turning, diving and climbing and giving a magnificent display above the water, before eventually flying off to Bridgwater to roost in the reeds in the old clay pits. When it was going to rain you could still hear the starlings calling, screeching and screaming as they were settling in to roost, and that was from seven miles away. Now all the clay pits are filled in there are no more reed beds, and very few starlings; however, what few there are may be seen – for the few days that the floods last – at their evening displays. Heaven knows where they roost. I have often wondered if they saw themselves doing this display, as they always seemed to do it over water, suspended like an enormous mirror beneath them. Just a thought.

These same levels that held so much water in the winter would start to dry out in a hot summer, and the eels, pike and other fish would all go to the deeper water in the ditches. The herons had a field day gobbling down the eels and fish, and lads would go down to

the moors with pitchforks. We didn't spear them, but flicked these fish out of the water. Some years, in the summer, it became so dry that large holes had to be dug in the bottom of some of the ditches to collect water for the cattle. This was dipped out with a bucket on a rope, and put into old cider barrels cut in half so the cattle could drink. Farming at this time, on the levels, was done by people who loved the land; they needed very little money to live off, and usually wanted for nothing, and lived by the poem on the old cider mug on the mantle above the inglenook.

My Granfer Bartlett taught me this poem when I was just a little lad, and somehow I've never forgotten it;

> Let the wealthy and great, roll in splendour and state
> I envy them not I declare it
> I eat my own lamb, my own chickens and ham
> I shear my own fleece, and I wear it
> I have lawns and I have bowers
> I have fruits, and I have flowers
> The lark is my morning alarmer.
> So jolly up boys now
> Here's to God Speed The Plough
> Long life and success to the farmer.

His favourite saying – 'all you need in life is a good woman, a pocket knife, a shilling and a piece of string' – has now gone somewhat awry. The smallholding he bought in September 1918 for £730, known as North Brook Farm, the home where I started my married life with Margaret, would today cost more than twice as much as the whole village was then sold for: this lot included thirteen farms, thirty-two cottages, 1,400 acres of land, the manor house, two carpenters' shops, three pubs, the smithy, and all the manoral rights. What about this for inflation!

The sketch for 'Making the Callyvan'.

CHAPTER TWENTY-THREE

MACK HELLIER

Mack was the roadman in the village. He was a bachelor and lived with the Gulliford family, at a house called Dryclose. He seemed an old man all the time I remember him. Mack was very conscientious, arriving at work at 7.30 a.m. each morning and working on until 5 p.m. He always walked to and from work, no matter how far it was, and all his tools were razor sharp. He always wore brown corduroy trousers, khaki shirts and yorks (straps around the legs beneath the knees). When he wasn't smoking his pipe, it was always stuffed down the left york.

Thinking back, the amount of work he did was amazing. He cut all the grass on the sides of the roads in the village at least twice a year. He cut any stinging nettles and thistles that grew along the wide grass verges on the moors as far as Godwin's peat work at Burtle. He trimmed up the sides of all the hedges and dug out all the trough ditches that ran along the sides of the roads, cutting waterways into the banks as he cleared the ditches out. When he had done this, he put a tight line down along the side of the roads and put a straight edge to the grass verge, pecking the verge with a wide bisky (grubbing axe). All the hedge trimmings, ditch and verge spoils were loaded on to a wheelbarrow by Mack and pushed to three different places in the village. This was picked up with a lorry by the council. He swept all the roads and cleaned all the drains with rods. He always did this job when it was pouring with rain, using sack bags to keep himself dry. He was helped with the drains by the roadman, Hugh Sweet, from the next village, Shapwick.

When the roads were going to be tarred, it was Mack's job to make sure the roads were clean and free from cow manure. This was nearly impossible, because at that time the cows were moved from place to place by being driven about the roads, and as they were moved they always managed to make a terrible mess. The farmers with their horses and carts always stopped at passing places so that they wouldn't cut the grass verges about with the wheels of the carts. Mack kept the village like a park, and everyone respected that.

All along the sides of the walls, and houses that came against the road, he removed any weeds or grass that had been allowed to grow, getting all the roots out. Any bad places that came in the roads, he made up with a mixture of tar and stone. There was always a barrel of tar at each end of the three places where he wheeled the spoils, and also a heap of stones that had been cracked by hand that he used for mending the roads. His wheelbarrow was always left at one of these places on the side of the road, and no one ever touched it. With the help of the villagers, he cut up any trees that blew across the road; no chainsaws were available at this time, only cross cuts, axes, sledge hammers and wedges, and plenty of exercise.

One dull November day Mack's watch stopped, and he asked someone the time. They told him it was two hours later than it was. Mack took them at their word and went off home. It took him half an hour to walk home, only to find that he was an hour and a half early – so he walked all the way back again and carried on doing the job he was doing. When someone asked him if he was working overtime, Mack decided it must be time to finish. Mack was the only one who didn't have a laugh about this.

The village stayed very tidy until the farmers started using straight nitrogen on the grass land. They turned the milking cows out to graze after milking in the morning and brought them back into the stalls to be milked in the evening, where they would stay, being fed with hay, until the next morning. With cows being driven everywhere around the roads, and the tractors and trailers making a mess passing just about anywhere, the village was turned upside down. Today, there are so many cars parked on the roads in Catcott that at times that it would be impossible to drive a horse and cart along some, or most, of these roads.

Mack wouldn't have worried about this on a Saturday night, as the only thing he worried about was being able to walk the 100 yards from The Crown Inn to Dryclose where he lived; on a Saturday night he was usually quite inebriated (or should I say, the 'worst for wear'), and sometimes didn't make it. He was usually fit for another good drink on Sunday morning, but he never touched it on Sunday nights as he always wanted to be 100 per cent on Monday morning for his job.

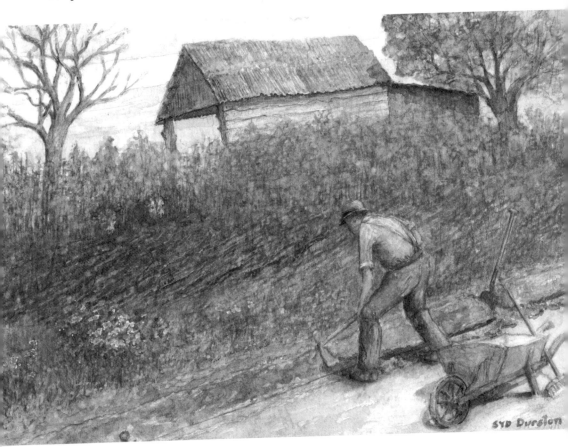

SYD DURSTON

CHAPTER TWENTY-FOUR

CATCHING VERMIN

There were lots of vermin, rats, mice, foxes, stoats and weasels and a few badgers. All of these, other than the badger, were very plentiful. The badgers were sought after for badger suppers. They were few and far between and were only caught occasionally in the winter.

Foxes were caught for their furs and to keep the population down. In our village alone there would be at least a dozen or more caught each year. One year twenty-three were either shot or snared.

The stoats and weasels were very hard to catch unless there was a long cold spell with snow hanging about. During this time they would all seem to get together, and this made things much easier as you could find a hedge that had been kept well trimmed and topped: you could be sure the stoats, at least, would run along the top of any hedges like this making runs. Why I don't know, but with small gins they weren't hard to catch. The weasels were more difficult, and usually the only way was to shoot them when you saw them. When the winter was long and hard with a lot of snow, the stoats would change colour to nearly all white, or a creamy white except for a bit of beige brown around the eyes and the back of the neck, but as soon as the snow thawed they would be back to their normal colour again. When they were white, they were called ermine and were very sought after for their fur.

The rats! There were thousands of these everywhere. While you were sitting on a stool milking the cows in the stall, with just the light of a hurricane lantern to see by, the cows' breath like fog in the cold air and the strong smell of kale surrounding you, you would see the rats' eyes shining as they ran along the top of the walls. The walls of the stone built stalls were 2ft wide, with a 9ins wooden wall plate on the outside that the roof rafters were nailed to. The rats used these like a motorway, running backwards and forwards and sometimes coming down the wall to pick up a bit of concentrate that was fed to the cows while milking them. The rats weren't hard to catch, but there were just so many of them. If you set a gin trap in a drain in the zig and sludge of the spoils from the stall at night, you would be sure to have a rat in it by the morning. Sometimes it would take at least an hour every day to take the rats out of the many gins and reset them again. The gins had to be set in places where the cats wouldn't get caught in them, as they caught a lot of the young rats (and of course some of the big ones). Another way of catching them was to leave a barrel with the top taken out, a bit of corn in the bottom and a piece of wood leant against the outside: the rats would run up the wood and jump down to the corn and then couldn't get out. Sometimes there would be half a dozen in there.

The best time to catch any of the vermin was when the snow was on the ground, as at that time everything was very hungry and made very visible tracks – so you could also see exactly how far they had come from.

The fox would travel miles and would go round the hen house several times before going away again, but if children or adults urinated beside the hen house the fox would seldom come near it, so this was a little job you carried out. It was easy to tell a fox trail because the fox always walks or runs putting one foot exactly in front of the other, leaving a straight line of footprints. The only time this is not the case is if a fox is lame, or has been wounded by shooting. These foxes are the ones that will come in the middle of the day and take chickens or any poultry, or even a cat.

The rats lived in the drains and stone walls, or in heaps of manure or mangolds, and travelled from one place to another leaving visible runs. This gave you many more places to set the gins. This may sound very gory to some people reading this, but if you had lived through that time, as I did, and had seen all the ways of containing the rats ever since, you would realise that the ways that rat numbers are controlled now are no less painful. Sometimes they linger for days after eating poisons, and sometimes even get over

Aunt May fleeing from
the mice.

it and become immune. The most painless way, to my mind, is catching them with terriers. This way it's nearly instantaneous, as one snap and shake by a terrier means it's all over. Sometimes people who get uptight about killing rats don't have a clue, when I question them, what they are talking about.

The first badger that I ever saw was when I was fifteen years old. It had been shot after letting itself into the hen house by biting a hole in the wooden floor. It was twenty years until I saw another. Now I live in a different area and see at least one every month. Catcott, where I originate from, now has its fair share of them as well, I am told, and there are three large sets there.

The mice were left to the cats outside; inside they were caught in the many traps left around. They were such a nuisance, making their nests in clothes, in the chest of drawers or in the linen chest. People nearly had a fit when they saw that the mice had bitten holes in their best clothes or linen to make a nest, or used the paper that the drawers were lined with. It wasn't unusual, when sitting down at night, to see a mouse scamper across the floor. Some women were terrified of them and would jump up onto the table, screaming for help.

Mice were an awful nuisance in the dairy as this is where the cream was made, the milk having been left in the large shallow creamers so the cream would rise to the top. Then it would be very slowly scalded, usually on a primus stove on a very low heat. Then put back onto the flagstone floor to settle for twenty-four hours. What was left beneath the head of cream then was more or less water. There would be anything between four and a dozen of these creamers on the dairy floor and sometimes three or four mice would somehow get into one of these, break through the cream and drown themselves. The only reason I can think of for this to happen was males chasing a female that jumped in – perhaps all the males followed her. There were numerous mouse traps all over the floor between the pans.

Crows and magpies were also classed as vermin as they took the chickens and young ducks, so they were shot and hung up as an example to keep the others away. Sparrow hawks were also high on the list, as these would come like exocet missiles and take quite big chickens. When the sparrow hawk came in, it didn't fly around the apple trees in the orchard where the chickens were – it would just fly straight through the trees like a dart, pick up a chicken and be gone, all in a flash.

If country people didn't catch up all the magpies they could in the spring, there would be very few small birds left. Some people say this isn't true, but it's not unknown for one person to catch as many as forty magpies in a single spring, and if people didn't catch them they would take over.

CHAPTER TWENTY-FIVE

GETTING READY FOR D-DAY

In 1943, things made a sudden change as the American soldiers and airmen arrived in their smart uniforms, driving around in their jeeps. In the evenings you could see them driving from pub to pub trying to find some beer, but usually all they could find was cider. The jeeps were often overloaded with soldiers. The girls were in big demand – and the girls thought the Americans were great. Us kids were more than happy they were around, as they always threw us long pieces of chewing gum, something we had never had before.

Some of the airmen were stationed at Westonzoyland, learning to fly. From there they flew Lysanders and would often fly very low over where horses were being used to deliberately frighten the horses. The farmers took a dim view of this and very soon got it stopped. At the end of 1943 new things came into the sky, gliders that were towed by aeroplanes. In the beginning they were mostly pulled by Dakotas, but later on by four-engined planes. In some cases the gliders were towed two at a time. This was the start of the training for the D-Day landings. Us kids couldn't comprehend what was going on, as the whole place came alive with soldiers, lorries, and guns training for the big day. They commandeered anything they wanted. I remember them having about four gallons of milk three days running; then, when they left, they dropped off a 28lb case of margarine. The occasional glider broke away from the plane that was towing it. News got around where they were, and of course this was something you really wanted to see – a glider! Sometimes you would walk about four miles to see it: the disappointment was such that the four miles home again seemed like ten.

Then one day, in June 1944, the sky became full of planes towing gliders, but no one suspected that this was the real thing: they thought it was just another practise run, as all the planes were flying the wrong way towards the west coast, not the east, going towards Ireland and not France. This must have been a decoy, as on the news the next morning it was said the allied forces had made a very successful landing in Normandy.

Everything had very quickly changed from troops everywhere to none at all. The mood of the people changed, but we were always wary of what Hitler might have up his sleeve, having tormented and terrified us with the doodlebug, and more recently the deadly V2 rocket. All the time the news was getting better and better, apart from the news of the concentration camps. People were making plans for when the war was over. Then one morning, at about 7 o'clock, and I seem to remember the date being 7 May 1945, a man from Chilton Polden – I don't remember his name – came around with a horse and cart with a loudhailer, shouting out that the war in Europe was over, that the Germans had surrendered.

Even though it was expected, it came as a great relief to everyone when it finally happened, and people started to celebrate right away. There were thanksgiving services in the church and chapel. There were thanks to God that the ornate iron railings around the chapel, taken away in 1941 for the war effort, had not been taken in vain. A street party was organised for the Friday and Saturday, with more thanksgiving on the Sunday. Steers, pigs and sheep died mysterious deaths, but the meat was good for the party. Everyone, to a person, joined in the celebrations. The blackouts were torn down and the lights became visible again. There were massive bonfires, people baking potatoes and a bit of fat bacon on a pointed stick while trying not to burn their hands. Everyone who could play an instrument was there, playing pianos, squeeze box, violins, mouth organs or whatever. Everyone was having a great time, all joining in as one. Jars and jars and barrels of cider were drunk, plus a drink that was made from molasses and cider. It took some weeks to get over it.

The masks on the headlights of the cars that only allowed the light through a tiny slit, this slit covered by a hood over the top of the slit so it could not be seen from the air, came off, and soon the signposts were put up again; then once more you really knew what the distance was to 'Burgewader' and 'Glassenbry', and how the name of the next village was really spelt. It was no longer Shabbick, Merlynch, Cusseton, Edeeton, and Westy – or Burgewader and Glassenbry. Trevor Jones no longer gave his news bulletins under the old oak tree, as by now most people had a radio.

The war was over, but now we had to feed the people in Europe who had been our enemies. For some, this became difficult. There was no choice, however, as for the first time now bread became rationed and the things that we thought would soon be back on the shelves seemed further away than ever. We were told we would have to tighten our belts, and this is what happened. The Dig for Victory spirit now paid off. Everyone grew as much veg as possible, sharing everything and wasting nothing. Two or three whist drives a week, with plenty of cider, and a few veg for prizes, were the norm. The money raised went to the Red Cross. There was great camaraderie: the war was over, and that was all that really mattered to everyone. After a while the men started to return home in dribs and drabs, though some were unable to handle the situation they found when they returned. Then everyone just gave what they could to help.

CHAPTER TWENTY-SIX

CATCOTT NOW

The village is still situated in the same place, but the number of houses has grown enormously, and all the elm trees have gone. Anyone coming back to the village after sixty years would be hard pushed to know if they were in the right place; most wouldn't recognise it. My own contribution to changing things was building seven new houses.

The population, even though there have been so many new houses built, has only risen by about 100.

The primary school has been extended and now has well in excess of 200 pupils, as children are bussed in from Burtle Shapwick and Chilton Polden, and the locals usually arrive by car.

The twenty-three farmers have now been reduced to three.

The village doesn't have a road man anymore, and even if it did, with the amount of cars parked on every road he wouldn't be able to do anything.

The three farmers should be given a bit of sympathy though, as for three-quarters of an hour in the morning, and again in the afternoon, the village becomes gridlocked with buses and cars, dropping off and picking up children from school. Some of the young people think nothing of parking their cars in the middle of the road and leaving it to go and talk to a friend for ten minutes or more, with complete disregard for anyone else. Consequently, the farmers have to drive all around the narrow lanes on the outskirts of the village, with their massive tractors and machines, to get anywhere.

The Royal Hotel is now a care home and has been extensively extended, taking in many elderly people from the adjacent villages. The Crown Inn is now about four times as big as it was when the Norrises kept it and is more of a restaurant than a pub.

The King William, where I used to train three nights a week, has had a complete makeover; it has an extension that can quite easily seat 100 or more for a meal at any one time, but the fun that the old characters gave us while drinking their cider during their evening get-togethers has disappeared. The cider is now sold from five-gallon cardboard cartons or bottles and doesn't one bit resemble the real stuff from the barrel; consequently, there are no big cider drinkers or real characters anymore.

Both the shop and post office in Manor Road have now closed and have become private houses. The opposite side of the road, where George and Libby's bake house and barns stood, has all been flattened, replaced by half a million pound houses with postage-stamp gardens. The planners refused the development, but the refusal was overturned by John Prescott.

The garage is no longer a working garage, but restores old classic and vintage cars.

The sewage works have gone, and now the sewage is piped to an enormous sewage plant at Burnham on Sea. No more chasing the sewage along the side of the road.

Both the carpenters' shops have gone. Fred Arthurs at Langlands Lane is now the home of about a dozen vintage cars which are hired out all around the area for weddings.

Tom Acreman's workshop has been completely demolished, and the house has been extended on to where it stood; the old sawpit has been filled in and levelled over.

The cobblers' shop is now a private house. The old slaughter house at Steel Farm, Steel Lane is now part of a private dwelling.

The Methodist chapel has been replaced by a hairdressing salon and car park. I must admit that I was the person responsible for the demolition of the chapel, but, as I did, I reclaimed all the tiles, timber and stone and used them to build other properties.

All over the village, practically all of the ponds have been filled in – and in some places they even have houses built on them. This causes terrible problems when there is heavy rain for any length of time.

I did a large restoration job on the church, overseen by English Heritage, carving the kneeler stones and adzing the timbers for the balcony. They were infested with about every kind of wood beetle you could imagine. I copied all the mouldings of the beams and balustrades that had to be renewed, doing all the work by hand on site. I also dressed the stonework in the large archway in the tower and pointed it, and also repaired several pews at the same time. All of this for the few people who now attend, and the tourists that come to gaze.

I have been away from the village now for twenty-three years, and when I go back I can walk all around the village and not see one person I know. I have had a long think about this, and I reckon that there are only about twelve people over fifty-five that were born in the village and still live there today.

The ditches on the moors, once so full of wildlife, are now a place where wildlife is practically non-existent. These ditches, which used to be cleaned by hand, are now cleaned with massive mechanical diggers, and consequently practically everything in their path is killed. When we came to frog spawn or when we pulled out newts or sticklebacks we would make sure that they were put back in the water – but can you imagine anyone driving one of these machines would be thinking of the wildlife they were destroying? The frogs, newts, sticklebacks, frog spawn and our dear friends the water voles have very little chance of survival with the power of the machine, and even the frogs that survive seem to die shortly afterwards.

My late cousin Edwin tried so hard to get something done about this, but to no avail. I myself have tried to get to the 'powers that be' to take a hard look at what is happening with modern farming practice, and how it is drip feeding the destruction of our wildlife. In the fields, when grass is being cut for hay or silage with a modern machine, the only thing left alive is the roots of the grass: mice, voles, rabbits, hares, pheasant, partridge, grass hoppers – bees or any other insect living there – are destroyed.

The roads on the moor, which were unable to take more than five tonnes in 1945, are now expected to carry massive loads of silage bales and loads of peat, up to twenty tonnes. Now driving along the roads it is more like a fairground swishback than a road. All the posts along the road – which used to carry signs that gave you some idea where the edge was when it was foggy – are now gone. Most of the willows that grew about 6-7ft from the roadside have all been deliberately destroyed by cutting them back hard with chainsaws in July for two years running. The roots of these trees kept the road up. Most of the ducks

have gone from the moors, once home to so many. Before the laws came in preventing the shooting of crows and magpies, any wild mink that were about at the same time were also killed. Now the moor is rife with mink and it's difficult to find even a moorhen on Catcott moor. The ducks that do come back in the spring to breed cannot survive: as soon as the ducklings are hatched, the mink clear them up. This is all supposed to be progress. I've been to the moor in the early spring, in the early morning, where there was once so much wildlife in the way of fish, eels, frogs and snakes and a constant call of birds. To my surprise, I haven't heard a sound other than the crows and magpies. No sign of a snipe, duck, moor hen or curlew, not even a bunting or a blackbird. But in the middle of a couple of fields, I once saw a lone heron waiting for the movement of a mole or a mouse (as these are now their main source of food). Where are we progressing to, I ask myself, and for whose benefit?

I have done my best, but if there is someone who has the platform and the guts to do something about this before it is too late, step forward!

<div align="right">Thanking you in anticipation,
Syd Durston</div>

P.S. I hope there has been something in the book you have enjoyed.